UNTOLD HORROR

UNTOLD HORROR

Written by

DAVE ALEXANDER

Featuring interviews with

George A. Romero • John Landis • Joe Dante • Brian Yuzna • Vincenzo Natali

Jim Shooter • Tim Sullivan • David J. Skal • Jared Rivet • John Goodwin

Brandon Wyse • Matty Simmons • William Lustig • Buddy Giovinazzo • Stephen Romano

Pierre David • Christine Conradt • Lee Demarbre • David Bond • Bob Layton

William Malone • John Penney • Steve Johnston • Robert Parigi • Amro Attia

Doug Taylor • Richard Raaphorst • Bart Oosterhoorn

<table>
<tr><td>Cover Art by
JUSTIN ERICKSON</td><td>Development Editors
KEVIN NICKLAUS
TIM SULLIVAN</td><td>Cocreator and Researcher
MARK POLLESEL</td></tr>
</table>

DARK HORSE BOOKS

SPECIAL THANKS TO

New Rebellion
ENTERTAINMENT

Publisher
Mike Richardson

Editor
Daniel Chabon

Assistant Editor
Chuck Howitt

Designer
Jimmy Presler

Digital Art Technician
Adam Pruett

Facebook.com/DarkHorseComics • Twitter.com/DarkHorseComics
To find a comics shop in your area, visit comicshoplocator.com.

UNTOLD HORROR

A Nightmare on Elm Street and Friday the Thirteenth and all related
characters and elements © & ™ New Line Productions, Inc. (s20)

First hardcover edition: August 2021
Ebook ISBN 978-1-50671-903-0
Hardcover ISBN 978-1-50671-902-3

1 3 5 7 9 10 8 6 4 2
Printed in China

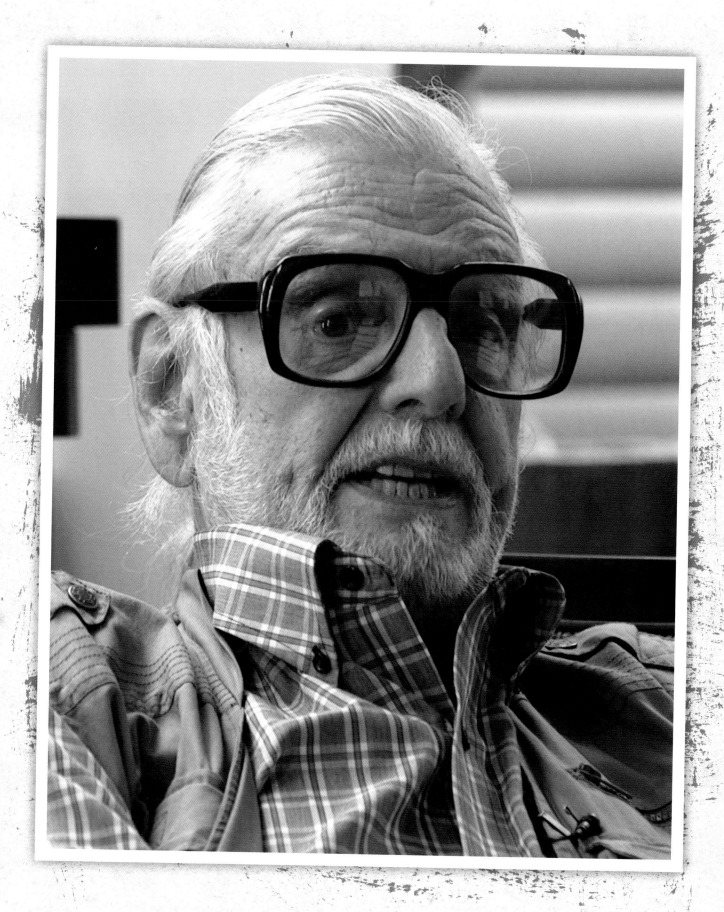

Untold Horror is dedicated to George A. Romero, whose support and candor regarding his many unmade movies helped kick-start this project. His incredible talent, fierce determination, and work ethic are truly inspiring. His passion, generosity, and sense of humor are greatly missed.

FOREWORD
BY JOHN LANDIS

Historically, filmmaking has been expensive. As the cinema (a part of show business) has evolved, it has always been called "the motion picture industry." Please note those two most important words, *business* and *industry*.

All directors need financial backing to actually make a movie. It's that simple. With the new technologies, motion pictures (no longer film but digital) are growing less and less costly to make, except for the costs of all the actual personnel needed to shoot the damn thing. Cast and crew remain the big-ticket items.

Every filmmaker has a number of movies that for whatever reasons never got made. I am confident that every filmmaker has at least one unrealized project.

I have been involved with dozens of films that have fallen apart before principal photography. It is a sad but extremely common tale. A couple of these projects in particular come to mind.

The great Fred Zinnemann (*High Noon*, *From Here to Eternity*, *The Day of the Jackal*) spent decades trying to make a film based on André Malraux's novel *Man's Fate*. Fred got very close but it never happened.

And then there was Stanley Kubrick, who spent years researching and preparing for his never-shot epic *Napoleon*.

I've spent many a lunch and dinner with the likes of Alfred Hitchcock, Orson Welles, Costa-Gavras, Federico Fellini, George A. Romero, Joe Dante, Walter Hill, Michael Mann, Michael Ritchie, Billy Wilder, and so many other directors telling very funny and tragic stories of their films that got away. The history of cinema is littered with stories of the movies never made.

Whether because of cost, casting, fashion, politics, or just bad luck, all directors have projects waiting to be produced . . .

Untold Horror tells the stories of some wonderful horror films you will never see and the explanations why. Read it and weep.

—John Landis

INTRODUCTION
BY DAVE ALEXANDER

It's both a cruel irony and a creative triumph that the horror genre attracts imaginations that are much bigger than budgets. Filmmakers obsessed with incredible creatures, grand apocalyptic visions, and shocking ideas for bodily destruction and mutation rarely have the resources to realize the full scope of their ideas onscreen. That's not necessarily a bad thing. It usually forces them to get creative with the tools at hand, to focus their story, and be suggestive in a way that allows their dark ideas to flicker away in the theater of the mind.

Making movies is expensive, audiences are fickle, and, for a studio or producer, risk is the most terrifying thing about making a horror film. Well, that applies to any film, really, but since horror pushes boundaries, it also pushes buttons that either expand its cachet with audience members or shrink its potential market with distributors. Simply put, it takes bigger risks, so sometimes the beast tears through the business, and sometimes the business tames the beast. Or slays it entirely. For every project that gets shot, many, many more don't make it into production.

The reasons for their deaths are endlessly fascinating once you start nosing around the grave dirt. My own curiosity in the subject was stoked while working as the editor in chief of Toronto-based *Rue Morgue* magazine, which focuses on "Horror in Culture and Entertainment." During this period, we would run stories on movies that would get announced and then simply disappear, interview filmmakers who would mention projects they had worked on that never came to fruition, and hear tales of radically different versions of films that did get made.

Being outside of the California sphere where most of these movies are (not) made, it didn't feel as much like a regular ol' part of the business to me. I had questions. Why announce so many movies that aren't a lock? What happened to all the tantalizing titles that seemed to just disappear from the Internet Movie Database? Do some of the rumored original cuts of certain films still exist somewhere, waiting to find an audience?

I was captivated by Clive Barker's near-mythical *Cabal Cut* of *Nightbreed*. I wondered if I'd ever see a version of *The Exorcist III* with the shocking sequence that featured a priest with his severed head in his lap. I'd watched the jaw-dropping trailers for Richard Raaphorst's *Worst Case Scenario* and was gobsmacked at the artistry and wondered why the Nazi zombie movie hadn't been made. I was dying to know what happened to projects such as *House of Re-Animator*, *Bubba Nosferatu* (the sequel to *Bubba Ho-Tep*)—and was there really a proposed *Jaws* sequel that was a comedy (well, an intended comedy, anyhow—I've seen *Jaws 4*)?

I certainly wasn't the only one who was obsessing over this stuff, either. Sometimes it was the water cooler talk at the *Rue Morgue* office ("I heard Universal nearly made *The Wolf Man Meets Dracula*!"). Once in a while I would interview filmmakers who made references to projects they were on that went away, such as when Breck Eisner casually mentioned previously being in preproduction for a new *Creature from the Black Lagoon* while we were discussing his remake of *The Crazies*. Occasionally there were traces of what could have been in some DVD extras, such as on the

Land of the Dead special edition release, which has a feature that briefly covers the original concept for George A. Romero's *Day of the Dead* with an accompanying preproduction sketch for an entire set piece that was excised when the budget was cut in half.

And then the 2015 edition of Montreal's legendary Fantasia International Film Festival happened. I was there with my screenwriting partner Mark Pollesel, and after a week of movies, panels, and pitch sessions, we decided to go somewhere quiet to talk. Our conversation turned to the films that we'd seen being pitched and how many of them would actually get made, and what happened to all the ones we'd heard about that hadn't been made. Soon we'd spun it into an idea for a documentary named *Untold Horror*. As we started working on it, we realized how rich the topic was, so it morphed into a series. We brought onboard director and cinematographer Robert Barrett and coproducer/editor Kevin Burke (who made the documentary *24x36: A Movie about Movie Posters*), and then we started shooting interviews and putting together clips.

At next year's Fantasia film market, we were actually pitching the project, and found others with our same passion for these stories. As we began working with producers on the long, arduous process of shaping and pitching our project, we kept researching, shooting interviews, and finding intriguing remnants of genre movies that never made it to camera— and even a few that did but were never released . . . A couple years later, we were presenting an *Untold Horror* panel at Fantasia with some of our favorite filmmakers, including Buddy Giovinazzo (*Combat Shock*) and Gary Sherman (*Dead & Buried*).

And after that, we found ourselves going out to LA to interview directors, writers, and former studio executives about their wild adventures fighting to make movies in the Hollywood meat grinder. It was clear that blood, sweat, and tears go into absolutely incredible projects that come very close to being greenlit and then fall apart for myriad reasons: studio politics, bad timing, money, ego, scandal, death. There's an endless number of circles in development hell.

The stories they leave behind are often jaw dropping— sometimes amusing, often heartbreaking, and always fascinating. And in many instances these ghosts tell us more about one of our beloved filmmakers than the work that did get made.

Romero is an excellent example. As he told us, for every film he got made, there were about ten he tried to make. The ratio varies among filmmakers, but the dead always outnumber the living. It speaks volumes about the business of filmmaking and the heart of the filmmakers. Romero could've had an entirely different career had he been able to realize some of the passion projects that really embodied his artistic drive. He could've changed the course of film history in a substantial way by making the first Marvel superhero movie, as you'll read in this book.

Most of the filmmakers we've encountered have been very forthcoming about this part of their pasts because many of them are still haunted by these ghosts; some haven't given up on the projects, and every one of them has been changed in some way by the experience.

One of them, Tim Sullivan (*2001 Maniacs*), has been an instrumental partner in *Untold Horror* and had the idea of spinning some of our interview material into a book for Dark Horse. Tim, along with producer Kevin Nicklaus (who loves comics as much as I do), approached company founder Mike Richardson about a book. Turns out Mike had his own untold horror story in the form of an abandoned John Landis vampire movie he tried to revive in print form. (Read on to learn more . . .)

So here we are.

While a global pandemic has temporarily thwarted efforts to bring *Untold Horror* to the screen, I couldn't be more excited to bring some of the stories to print via my favorite comic publisher. And in case you're wondering, there are many, many more stories than we could fit in here. The goal was to present a variety of filmmakers with entertaining tales about unmade movies that have really fun visuals. The aesthetic of horror has always been eye popping (sometimes literally), so we wanted that to be represented.

Lastly, if there's one word to sum up *Untold Horror*, it's *passion*. The passion of the creators interviewed here, the passion of horror fans whose unrivaled devotion to their favorite filmmakers sparked this idea, and the passion it took to create this book. It shines through in the years of work Mark and I put into researching the topic, the months of travel and shooting we did with Bob to capture some of these stories, the weeks of digging through files that filmmakers provided in order to track down the rare art you'll see, and the endless days of meetings and calls on behalf of Tim and Kevin to build bonds with several of our subjects so that they would trust us to tell their stories.

I hope we've honored their efforts.

—Dave Alexander

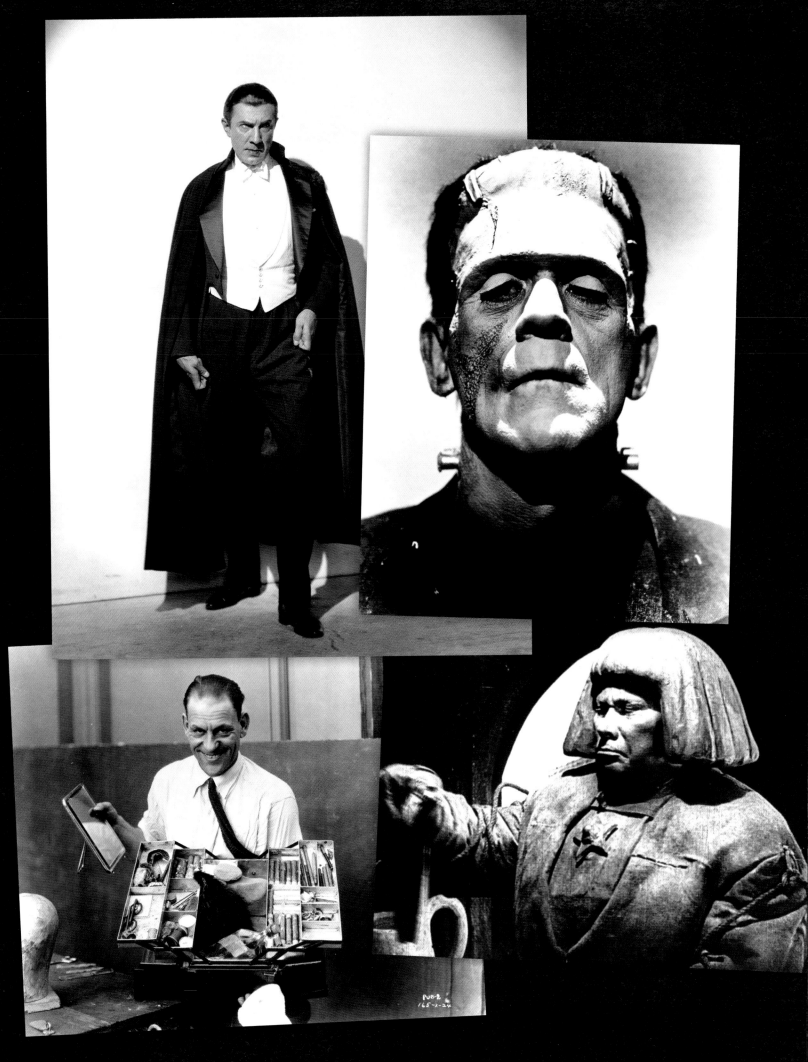

Clockwise from top left: Bela Lugosi as Dracula in the 1920s stage adaptation, Boris Karloff in the iconic Frankenstein makeup, Paul Wegener as the title creature in 1920's The Golem, and Lon Chaney shows off his makeup kit.

All images in the public domain.

UNIVERSAL'S ALTERNATE AND UNMADE
DRACULA AND FRANKENSTEIN FILMS

Film historian David J. Skal reveals how different versions of the iconic movies could've altered horror history

INTERVIEW WITH DAVID J. SKAL

Dracula and Frankenstein—name a more iconic monster duo, I'll wait . . .

There are no more-recognizable creatures in the entire world than these two, thanks to Universal's iconic films, both of which were released in 1931. Though there have been many versions of the stories told in a variety of mediums, Bela Lugosi as Count Dracula and Boris Karloff as Frankenstein's monster are the definitive iterations of these characters, appearing on everything from underpants to postage stamps, Halloween masks to liquor flasks.

Today, horror is a big business, but a century ago it wasn't even on most people's cinematic radar, at least in North America. Both Bram Stoker's *Dracula* (1897) and Mary Shelley's *Frankenstein; or, The Modern Prometheus* (1818) were already enshrined as classic novels and had been adapted often into successful stage plays. But, as David J. Skal—author of several highly respected horror history books, including *Hollywood Gothic: The Tangled Web of Dracula from Novel to Stage to Screen* and *The Monster Show: A Cultural History of Horror*—explains, putting bona fide monsters on the silver screen at the time was a challenge.

"Hollywood didn't really know what to do with horror movies in the beginning. There was no tradition in the silent era of supernatural stories. The fantastic, the irrational, and the supernatural were part of European cinema from the very beginning. But American audiences, producers felt, wouldn't accept this, and so when there were strange occurrences or frightening characters in the silent era they were always revealed to be human, very frequently part of a massive criminal conspiracy to embezzle an inheritance or cover up a murder, or something like that. The term 'horror movie' wasn't really used up until the 1930s. Films like *The Hunchback of Notre Dame* and *The Phantom of the Opera* weren't called horror movies. They were prestige pictures with an A star: Lon Chaney Sr."

Skal points out that studios were at least curious about adapting *Dracula* from their very early days. There are internal memos from Universal dating back to 1915 that indicate the company was unsure about the copyright because the novel hadn't actually had one filed for it in the United States. But they did publicly announce that they were going to do their take on the story as early as 1920, with Chaney starring and direction by his frequent collaborator Tod Browning. (Their work together includes 1925's *The Unholy Three*, as well as *The Unknown* and the now-lost *London after Midnight*, both from 1927.) In general, *Dracula* was considered a hot property at the time due to its success on Broadway and as a touring play in both the US and England.

"It broke the tradition of explaining away the terrors," says Skal of its popularity. "It wasn't the traditional drawing room mystery melodrama where all the spookiness was exposed as a criminal conspiracy— this was a five-hundred-year-old demon from hell, and audiences loved it. This wasn't Hollywood formula; the studios that looked at it—you can see the readers' reports—said, 'The audience will never buy this. It's a disgusting story, to begin with, this idea of walking dead people drinking blood and staying young forever, and the censor wouldn't let you do half the big scenes in the book,' and on and on and on."

Despite this, it caused a bidding war between Universal and MGM, simply because Universal head Carl Laemmle, who didn't like horror, refused to be outbid by his rival. So, thanks to his ego, as of June 1930 the studio had a property it didn't seem to actually want. Luckily, his son, Carl Laemmle Jr., who "loved everything macabre and strange," fought for the picture and was eventually handed the reins, as long as Chaney—who by that time had left the studio following his unhappy experience making *Phantom of the Opera* in 1925—starred in it. The plan was to woo him with not just *Dracula*, but also a sequel to *Phantom*.

"They thought they might entice him back to Universal with *Return of the Phantom*, on top of *Dracula*," says Skal. "Some of the memos suggested that in *Dracula*

he might play a dual role. We can only assume that might be Van Helsing and Dracula. He did something similar in . . . *London after Midnight*, where he played a fake vampire and he also played the police inspector who got to the bottom of the mystery."

It's detailed in two books by the late Philip Riley: 1990's *Dracula* and 2010's *Dracula Starring Lon Chaney: An Alternate History for Classic Monsters* (both published by BearManor Media). They include copies of studio correspondence, treatments, scripts, and other relevant documentation that demonstrate the initial vision for the adaptation was more in the, er, vein of a massive blockbuster than the stagy version that hit theaters.

Before the studio had even secured the rights to make the movie, Laemmle Jr. commissioned a thirty-two-page treatment for the project in the summer of 1930. Written by Frederick "Fritz" Stephani, it begins with John Harker traveling to Dracula's castle, rather than Renfield, as in the finished film. After the Count traps his unwitting guest in one of the rooms, Harker watches the vampire crawl down the castle wall, load seven coffins into an airplane, and fly it away instead of taking a ship overseas (one assumes his bat wings would get too tired). Harker later returns to England and destroys Dracula's plane, forcing the fiend to return to Hungary via boat. The climax has Harker, the bitten Mina, Dr. Seward, and Van Helsing chase a gypsy boat on the Danube in a race to intercept the Count before he can return to his stronghold. As they close in on the monster, there's a gunfight and a stage chase, which ends in a crash at sunset. Just as the Count awakens, Harker drives a wagon wheel spoke through his heart.

Not only would the Stephani story have been a much pricier production, but it would have been shocking for its violence, bloodshed, and sexuality. Aside from Dracula's death, the heroes find a river trader with a slashed throat; and then there was this scene: "Dracula stands in the middle of the room, his arms around Mina—sucking blood from her throat."

This was all simply too much, so while Universal negotiated to get the rights to Stoker's book and secure Chaney, it also commissioned Pulitzer Prize winner Louis Bromfield to write a treatment in July of 1930. As the project moved forward, Universal added screenwriter Dudley Murphy to the mix to speed things up. Their take on *Dracula* was tailored to Chaney, who apparently preferred scripts that hewed close to their literary source material. Bromfield and Murphy's script does indeed follow the novel more closely, incorporating more locations, violence, and sensuality. Universal was planning the movie to be a prestige picture in the vein of *Phantom* and *The Hunchback of Notre Dame* (1923)—another hit for them starring Chaney.

Lon Chaney in the lost film London after Midnight, *which is thought to be the closest approximation of how he might have looked playing Dracula. Image in the public domain.*

"Hollywood didn't really know what to do
with horror movies in the beginning."

—David J. Skal, author of *The Monster Show*

But the most evident aspect of the script being a vehicle for its star is in the look of the Count, which is a world apart from the debonair Lugosi version. An initial description of the character is more in step with Chaney's "vampire" in *London after Midnight*: "a tall man, dressed in musty and unpressed trousers and morning coat. He has a very pale face with drooping white mustache and long, unkempt white hair. . . . He wears, also, a long black cape, which floats about him as he moves forward to greet Harker."

And then Drac really becomes monstrous with this more visceral description: "(1) the hands, coarse and covered with hair almost like the bristles of an animal. The nails are long and pointed in needle-like fashion.

As one hand turns over you see hairs growing out of the palm. (2) the eyebrows, very dark and bushy. (3) the ears, very pointed at the tips with a suspicion of hair on them."

It's easy to see Chaney in the role. After all, he built his fame on acting with his face and body as "the Man of a Thousand Faces." Undoubtedly, this version of the Count would've been less romantic, more frightening, and certainly more feral. But all that is ultimately irrelevant, as the actor was gravely ill with terminal lung cancer at the time of negotiations. He died on August 26, 1930, at age forty-seven, after doing his one and only sound film, a 1930 remake of *The Unholy Three.*

Film historian David J. Skal.
Image provided by author. Used by permission.

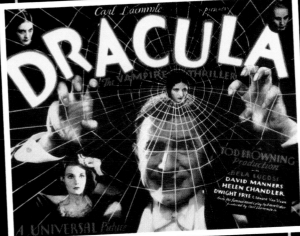

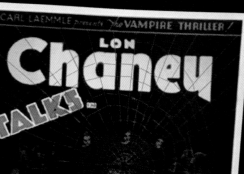

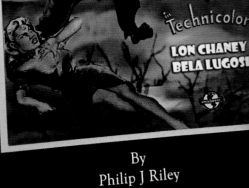

Philip J. Riley's books for BearManor Media, featuring unmade and alternate scripts for Universal Dracula movies, and the front page of Bela Lugosi's personal shooting script for the version that was shot.

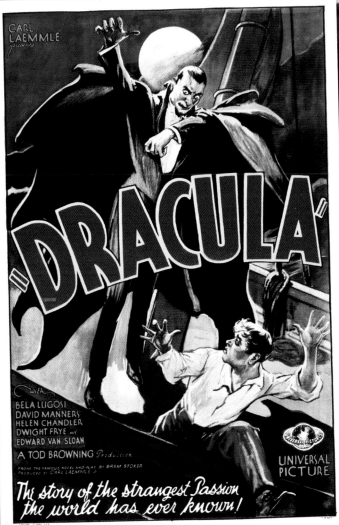

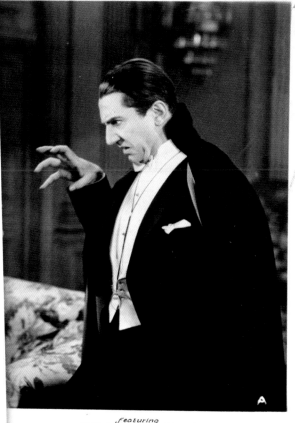

Surprisingly, Lugosi, who had been playing Dracula onstage for several years, wasn't high on the list of performers to replace Chaney, despite him letting it be known publicly that he wanted the role. Universal only settled on him after considering a variety of actors, including Conrad Veidt, who had starred in *The Cabinet of Dr. Caligari* (1920) and *The Man Who Laughs* (1928), and John Barrymore, who was known from his roles in *Dr. Jekyll and Mr. Hyde* (1920) and *The Sea Beast* (1926).

In addition, the film itself had to be scaled way back.

"The plans to produce *Dracula* coincided with the stock market crash and all the studios were struggling," points out Skal. "Without the success of *Dracula* and *Frankenstein*, Universal likely would've gone under. . . . They originally had plans for what they called a 'Universal Super Production' along the lines of *All Quiet on the Western Front*, which had been a huge, prestigious success for them. They thought this would be that kind of literary adaptation as well. They had to start pulling it all back in, though, because of budgetary concerns, and you can see it in the film. They invested a fortune in these really impressive huge

sets—the interior of the castle and the abbey and the crypts and all that—and ended up ignoring most of what they could've done with the book. In the end, for financial reasons, they filmed *Dracula* more or less as a stage play, and it has still some wonderful moments, and of course it has Lugosi, but it creaks today."

Nevertheless, the movie was a massive hit and opened the floodgates for the Universal monster movies that came to define the studio in many ways.

"It detonated this whole dormant impulse in the American cinema for the fantastic and the macabre and the crazy, irrational things that are now a part and parcel of some of the biggest blockbusters of all time," says Skal. "But back then it was a risk, people didn't know what to expect, and *Dracula* was a surprise hit, and they immediately started calling Lugosi 'the new Lon Chaney' but it wasn't clear that's what he was going to be, and they wanted to rush some other films into production."

One of those films was an adaptation of Edgar Allan Poe's "The Murders in the Rue Morgue," and the other was Shelley's *Frankenstein*. The studio wanted Lugosi in both movies initially and intended him to play the monster in *Frankenstein*, hoping to indeed shape him into the next Chaney. Lugosi, on the other hand, had different aspirations.

A movie poster for Dracula, *depicting the vampire attacking a sailor (no such scene exists in the finished film), and a press photo for the movie featuring Lugosi as the vampire.*
Images in the public domain.

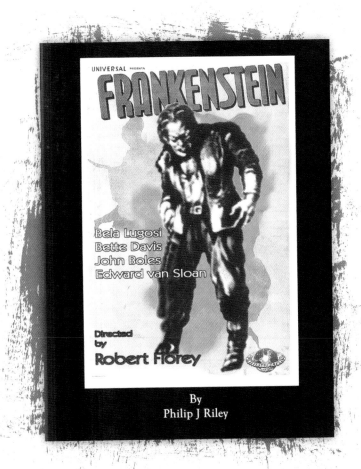

"I think Lugosi originally thought he was going to play Dr. Frankenstein, and he was going to play this wonderful romantic antihero kind of guy, and when he realized they wanted him to take this nonspeaking role of the monster that just grunted, he said, 'I'm an actor, not a scarecrow,'" says Skal.

Regardless, teaser art for *Frankenstein* starring Lugosi as the monster was created, and he did a makeup test for the role. Skal isn't aware of any surviving photos of the design but, based on his research, thinks it may have been informed by the hulking, square-headed creature in Paul Wegener's 1915 movie *The Golem*, which was based on Jewish folklore. He adds that additional inspiration for it likely came from the stage version of *Frankenstein*, which Universal bought the rights to, and the monster from Edison's 1910 *Frankenstein* short. The studio even had a test reel shot (featuring Dwight Frye as lab assistant Fritz and Edward Van Sloan as Dr. Waldman—roles they took when the film eventually got made), but it was recorded on nitrate film and ended up in the cinematographer's garage, where it disintegrated.

Universal's famous makeup artist Jack Pierce created the look for Lugosi as the monster, but according to Riley's book, Laemmle Jr. gave it a thumbs-down. Of course, his rethought design for Karloff's creature is the bar against which all other Frankenstein's monsters are judged.

During this period a script was in development, written by Robert Florey (along with Garrett Fort, a cowriter on *Dracula*), who was also going to direct the movie. They penned it also believing that Lugosi would play the Henry Frankenstein role. Like the Chaney *Dracula* script, it was released by Riley in a 2010 book titled *Robert Florey's Frankenstein Starring Bela Lugosi* (also from BearManor Media) that includes supplementary material that details the project. While many plot points and the basic structure remained intact in the finished film (despite this, Florey received no credit for the released version), there are significant differences that would've made for a very different *Frankenstein*.

"It didn't have the monster as in any way a sympathetic character; he was a killing machine," states Skal.

Florey, who had experience stage directing for the Théâtre du Grand-Guignol in Paris—infamous for its lurid, gory productions utilizing gobs of stage blood and other morbid special effects—envisioned a more adult story. His script has the creature walking in on two villagers having sex and implies the rape of the little girl the monster encounters at the lake! Additionally, the monster is described as "chalky white, and expressionless—molded so as to be just a trifle out of proportions, something just this side of human—but that narrow margin is sufficient to make it insidiously horrible," Fritz is a mute, and Henry is killed in the windmill fire, rather than by his creation. Unlike the Chaney *Dracula* script, the *Frankenstein* script was more like, well, a slasher movie than anything resembling the source material.

> "When [Lugosi] realized they wanted him to take this nonspeaking role of the monster that just grunted, he said, 'I'm an actor, not a scarecrow.'"
>
> —David J. Skal, on *Frankenstein*

"That was the part that Lugosi turned down," Skal points out. "He didn't turn down the Karloff version; that script was further developed by James Whale, who directed the final film. Often people have said that Lugosi was just too vain an actor and he didn't see the potential in the part, but he didn't read the script that was given to Boris Karloff at all."

Early promotional art for Frankenstein by Universal in-house artist Fred Kulz,
which announced Bela Lugosi as the creature, before he turned down the role.
Image in the public domain.

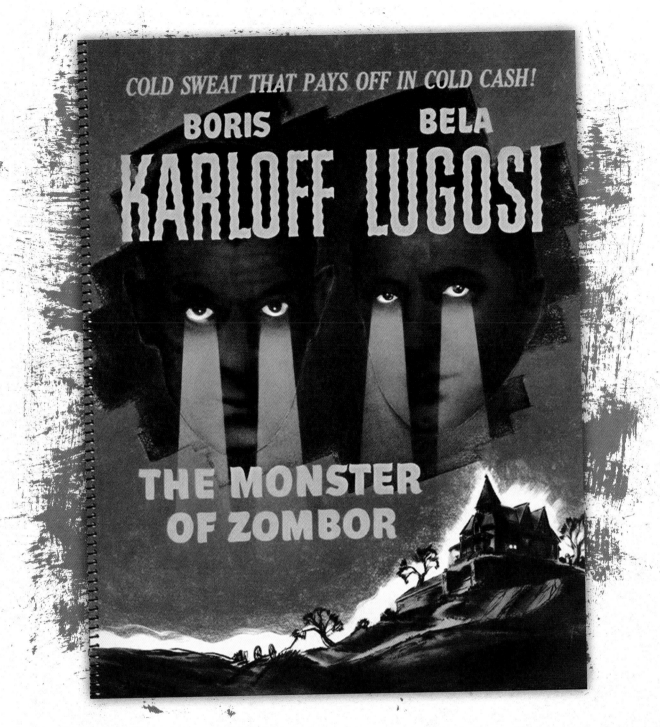

COLD SWEAT THAT PAYS OFF IN COLD CASH!

BORIS KARLOFF **BELA LUGOSI**

THE MONSTER OF ZOMBOR

Universal had brought Whale over from England and he was interested in taking over the *Frankenstein* project, so Lugosi followed Florey when he moved over to the studio's production of *Murders in the Rue Morgue*, a classic creeper but nothing in the league of *Frankenstein*. As Skal points out, turning down the film would permanently haunt the actor.

"*Frankenstein* was a huge success, beyond anything *Dracula* had achieved. Boris Karloff was suddenly the new Lon Chaney, and that set in motion kind of a professional rivalry between Lugosi and Karloff that persisted to the end of Lugosi's life. He resented Karloff—not to his face, but he told so many people on so many occasions he felt that he was cheated out of the stardom he was due because of Boris Karloff." (Lugosi would eventually get to play Frankenstein's monster, in 1943's

Frankenstein Meets the Wolf Man, after Karloff had given up the role.)

Once Whale got involved with the project, he agreed with the studio that the monster had to be given back the humanity he displays in Shelley's book. It was obviously the right choice.

Despite their rivalry, having both Lugosi and Karloff in a film together was a draw, and they appeared in several releases together, including the notable titles *The Black Cat* (1934), *The Raven* (1935), *The Invisible Ray* (1936), and *Son of Frankenstein* (1939). In addition, there's one film they were slated to costar in that never happened. A movie called *The Monster of Zombor* was advertised in the 1940–41 Universal promotional book. It features the two actors looking spooky, their faces floating above a foreboding house on a hill.

The front page of a Universal exhibitor's catalog touted its biggest horror stars teaming up for an ultimately unmade movie called The Monster of Zombor.

Image in the public domain.

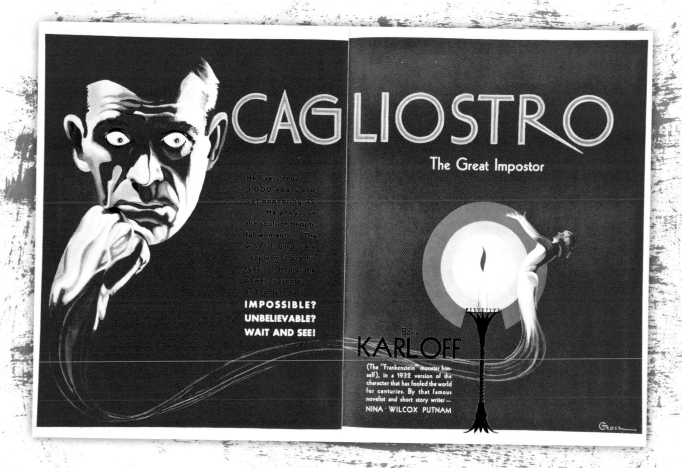

CAGLIOSTRO
The Great Impostor

He lives today 3,000 years old . . . yet appearing 35! He preys on the souls of beautiful women! . . . The world and the people in it are his toys! . . . He has the power to create . . . and to destroy!

IMPOSSIBLE?
UNBELIEVABLE?
WAIT AND SEE!

Boris
KARLOFF

(The "Frankenstein" monster himself), in a 1932 version of the character that has fooled the world for centuries. By that famous novelist and short story writer—NINA · WILCOX · PUTNAM

"The image exists, and that's about it," says Skal. "We don't know what *The Monster of Zombor* would've been like. I've never been able to come across a script for it, but the idea of pairing Karloff and Lugosi, it worked—before it had worked with *The Black Cat*, and it had worked with *The Raven*."

In addition, there were other versions of Universal monster movies that were floated but changed, notably *Cagliostro*, which was based on a story by Nina Wilcox Putnam about an Egyptian magician who achieves immortality by injecting himself with nitrates and can kill with "rays." In light of the era's fascination with newly unearthed Egyptian tombs, it evolved into *The Mummy* (1932), featuring Karloff.

In addition, there was a version of *The Invisible Man* that went through many revisions (some by Whale) and was to also star Karloff, but instead the role went to Claude Rains; and *Return of Frankenstein*, an early incarnation of *Bride of Frankenstein* that had a "brutish and evil" take on the creature. And there were Universal monster movies that were scripted and never made at all, such as *The Wolf Man Meets Dracula*, which had the two creatures dukin' it out (all of the above screenplays were put out by Riley through BearManor).

The takeaway is that the versions of *Dracula* and *Frankenstein* that didn't get made were vital in helping Universal figure out the key ingredients for their horror slate, which shaped the entire Golden Age

of horror cinema. The Universal monster movies are known for having sympathetic "monsters" with very human qualities, tortured protagonists, and content safe enough for kids to watch, which allowed them to be rereleased years later on television, which in turn spawned an entire generation of "monster kids" who would go on to read monster magazines, create conventions, and sometimes even make their own creature features, thereby building the fan culture that thrives in the genre today. To horror fans, the influence of these movies cannot be overstated.

That said, Skal cautions that not every project sitting in the studio's vaults would make a monster kid salivate.

"I've worked with Universal many times over the years, and had access to their files, and I don't know how many hours I might have spent scrolling through microfilm and reading some of the treatments for these films—scrolling through unproduced treatments and full scripts in many cases. They're not lost masterpieces by any extent; they're an example of what happened in the studio system when staff writers were just assigned to churn out things. Even though films would often be accredited to more than one writer, very often they wouldn't work with each other."

But that certainly doesn't mean there aren't a few gems he wishes he could see in a theater. When asked what his top pick would be, he doesn't hesitate to bring up a proposed take on *Dracula's Daughter*, which was eventually directed by Lambert Hillyer in 1936.

Karloff's popularity after Frankenstein *led him to roles in other monster movies, such as* The Mummy, *an earlier version of which was advertised in an exhibitor's catalog as* Cagliostro.

It stemmed from the situation where the success of *Dracula* and *Frankenstein* was essentially driving Universal in the '30s, so pumping out sequels was a priority. Whale had also directed *Bride of Frankenstein* (1935), and the sequel is considered by many to be the best Universal monster movie. Period. Laemmle Jr. wanted him to make *Dracula's Daughter*, but Whale didn't want to get pigeonholed as a horror director and was focused on his adaptation of the Broadway hit *Show Boat*, which he had in preproduction. The studio previously had tried to put *Dracula's Daughter* into production but had issues rights and concerns about the script, so Whale was being pressured to step in and take over the project before he made *Show Boat*.

His response was to run down the clock by delivering a script that would never get past censors and would've cost a fortune to make. It also would've featured both Karloff and Lugosi. Skal says that's not why he wishes it somehow could've got made, however. One scene in particular blew his mind.

"The one that I really would've liked to have seen done was a scene in which the backstory of Dracula is told—how he became a vampire, how his daughter became a vampire. Both Boris Karloff and Bela Lugosi would be in this version—Lugosi as Dracula again and Karloff as a Transylvanian wizard who was at odds with Dracula and was trying to bring him down. And Dracula, in this iteration of the story, was fond of throwing Bacchanalian orgies with all kinds of decadent aristocrats

and that would bring us to the present day and the story of Dracula's daughter would continue. Wow, wow, wow—I just would've loved to have seen that."

And while that jaw-dropping sequence would've been considered as offensive as it was expensive, there was another scene that would've absolutely shocked audiences of the day. In it, Dracula kidnaps a young engaged couple from the village and separates them in his castle.

"He is trying to have his way with the girl, and he says, 'Do what I tell you and the strong arms of your lover will be restored to you,' and she agrees to do whatever he wants, and lo and behold, suddenly a figure appears, mysteriously draped," says Skal. "But she recognizes the ring on her lover's hand, and he tells her to be quiet. When she does go to him, his arms are put around her, but it's Dracula—he's got the severed arms of the boyfriend! It's so over the top. She faints, and the arms are described as 'disappearing like the arms of a sailor in a tempestuous sea.' The description was just ridiculous."

Skal stresses that it was never meant to actually get made.

"It was meant to buy more time for James Whale to work on *Show Boat*, and finally *Dracula's Daughter* was assigned to another writer, and he went on to do *Show Boat*. But he loved playing with the censors."

"It's Dracula—he's got the severed arms of the boyfriend! It's so over the top."

—David J. Skal, on an early version of *Dracula's Daughter*

from all over Europe coming and glutting themselves on his wine and his food and all the women he would procure from the village and kidnap and have them there for their delight. Karloff comes to the castle in the middle of one of these revels and puts an end to it. He puts a curse on everybody and says, 'You wanna behave like animals?' Poof! 'You're animals!' and the guests devolve into pigs and snakes and rats and horrible things. The whole banquet just comes crashing down, and then Dracula himself is turned into this immortal vampire. And then, in what would've been the coup de théâtre of great horror films, the hall of Dracula's castle crumbles into dust, centuries pass in a time lapse, the walls cave in, cobwebs form all over the table and the dead guests. It's just a brilliant concept,

Skal becomes really animated while discussing the excitement of uncovering the secret history of classic horror movies. That combination of the sense of discovery, the preservation of the past, and the speculation of alternative histories of our favorite films creates the stories behind the stories that fan culture thrives on.

"We're really fascinated by all the lost possibilities because they can't be verified, so we spend a lot of time projecting our own preferences onto them," he muses. "The stuff that got left on the cutting room floors is sometimes more interesting than the stuff that got made."

And sometimes, the films that didn't even make it that far are the stuff of legend.

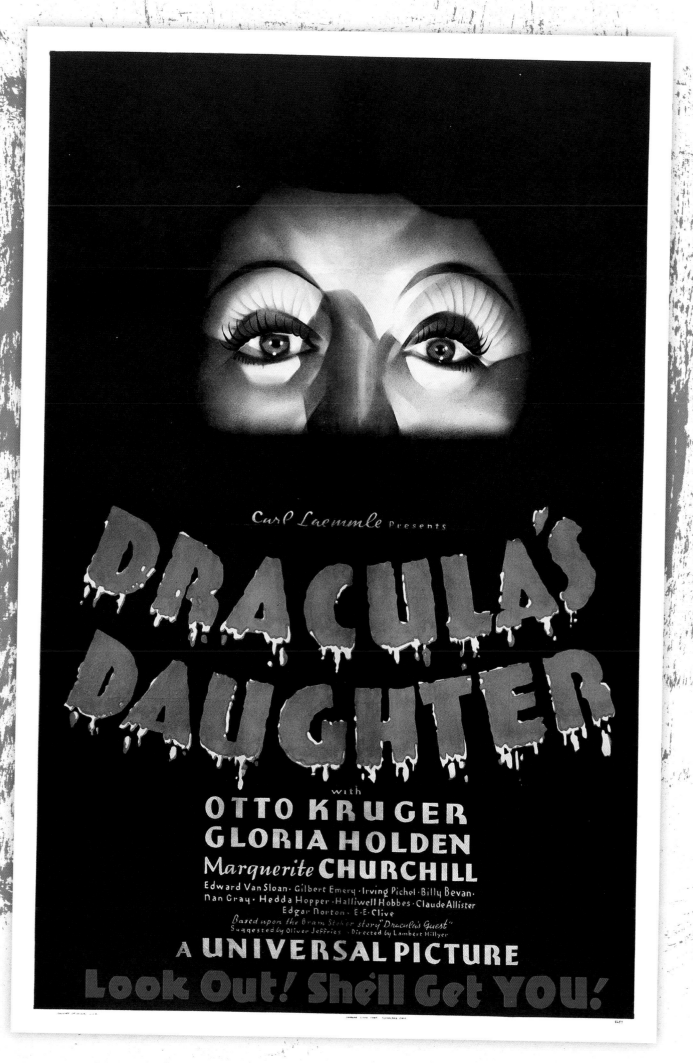

Poster for Universal's 1936 Dracula's Daughter, an earlier version of which, written by Frankenstein director James Whale, was much too gruesome for the era.

Image in the public domain.

WHITE ZOMBIE

A wild remake of the 1932 Bela Lugosi film succumbed to some bad mojo

INTERVIEWS WITH JARED RIVET, JOHN GOODWIN, AND BRANDON WYSE

"For about ten seconds in the mid-2000s, I was kinda hot shit," says Jared Rivet, laughing.

At the time, the writer of the 2017 cult-themed horror film *Jackals*, and cowriter of the 2019 *Are You Afraid of the Dark* miniseries, had caught the attention of Scott Kosar, writer of the successful 2003 *Texas Chainsaw Massacre* remake, with a script titled *Killers of the Dead*.

"We weren't in the zombie renaissance that we're in now," explains Rivet. "Zombies, no pun intended, had died. They were a dead subject. So I had written this George Romero zombie movie that was set in Mexico, and it was about a zombie plague breaking out there, and the National Guard and army basically show up to build a wall between the US and Mexico, to keep the zombie plague out, and two Walter Hill–esque tough-guy US Border Patrol agents hop the fence and go into zombie-infested Mexico because one of them has family there."

Kosar took the project to Endeavor Talent Agency (this was before it merged with William Morris to become William Morris Endeavor), and Marcus Nispel, director of the very successful aforementioned *TCM* remake, became attached to it. That film didn't happen, but—as is often the case with scripts that aren't produced—it helped build a buzz. This led to Rivet being signed with Evolution Entertainment, which had a lot of well-known

horror filmmakers, including Tobe Hooper, who, of course, directed the original *Texas Chainsaw Massacre*. When Rivet discovered this, he had his agent get him the script for *Sacrilege*, which eventually became *Jackals* (and was directed by Kevin Greutert, who helmed two of the *Saw* sequels). It got Rivet in a room with Hooper.

"They put us together, and we hit it off," says Rivet. "And I was fanboying all over the place like an idiot, but at the same time he could tell I was passionate about telling stories and passionate about cinema. It wasn't that I was just this big Tobe Hooper fan—*though I really was*."

He adds that it was a strange time in Hooper's career. "Tobe was in kind of a limbo, where he had dipped mostly into television and straight to video, and a lot of his stuff was kind of being ignored or overlooked. And he did a couple episodes of [the TV anthology series] *Masters of Horror* that were really attention getting, and everybody was kinda like, 'Oh wow! Look at this work.'"

Hooper decided that he wanted to develop multiple projects with Rivet, which is where *White Zombie* came in. Rivet notes that at the time horror remakes were really becoming a trend, and Hooper was approached by producers Steve Whitney (*The Amityville Horror* remake and *The Haunting in Connecticut*) and Mike Menchel (*Only the Brave*) to do one for the 1943 Jacques Tourneur film *I Walked with a Zombie*.

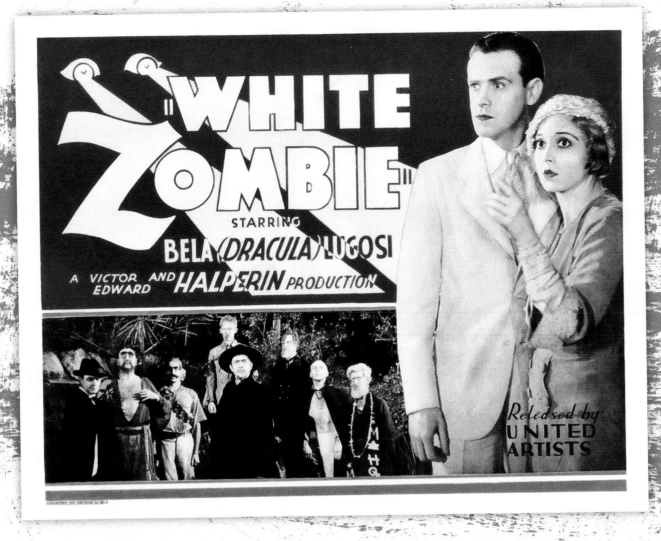

"RKO Pictures rose from the ashes and was going to come back and do remakes of their entire catalog slate," says Rivet. "Strangely enough, he was called in to pitch for a remake of *I Walked with a Zombie*. He called me up after that meeting and said, 'Hey, dude, you should really take a look at *I Walked with a Zombie*.'" But they soon found themselves more interested in a remake of the 1932 film *White Zombie*, which conveniently was in the public domain, and which Rivet sees as almost a prequel to *I Walked with a Zombie* (both are set on sugar plantations and involve voodoo zombies).

Based on the 1929 book *The Magic Island*, by William Seabrook, *White Zombie*—adapted by Garnett Weston and directed by Victor Halperin—is considered to be the first feature-length zombie movie. Made for only $50,000, starring Bela Lugosi in his heyday, and shot on recycled Universal monster movie sets, it's a stagy attempt to capitalize on the popularity of *Dracula*, which shot Lugosi to fame after he starred in it the year before.

In *White Zombie* he plays a similarly over-the-top villain in the form of Murder Legendre (yep, they actually named the bad guy "Murder"), a smarmy voodoo practitioner who uses a white powder and his hypnotic gaze to enslave and control a gaggle of zombies. The story unfolds around Madeline Short (Madge Bellamy) and her fiancé Neil Parker (John Harron), who travel to a Haitian sugar plantation owned by Charles Beaumont (Robert Frazer). Charles is secretly in love with Madeline and convinces Murder to help him get her for his own. Their plan sees Charles slip her some poison so she dies just after her wedding ceremony. After she's entombed, Murder revives her as a zombie. The plan unravels when Neil gets drunk and visits the tomb later that night and discovers it empty. He enlists the help of a missionary named Dr. Bruner (Joseph Cawthorn) to get to the bottom of things. Meanwhile, Charles is at Murder's cliff-side castle, where he begs him to reverse the effects of the powder on Madeline, realizing he can't live with a soulless version of her. But the flamboyantly browed baddie starts to zombify him instead, and then sends his zombies to kill Neil. Luckily, with the help of Dr. Bruner, they send the shufflers off the cliff, with Murder and Charles soon following, which breaks the spell on Madeline, reuniting the happy couple.

"Taking a close look at it as an adult, I was blown away, not only by how good it was and how creepy it was, but also the undercurrents and everything that was being implied," recalls Rivet of the film, which was made before the puritanical Hays Code was

Lobby card for the original White Zombie.
Image in the public domain.

introduced in Hollywood in order to curb anything that might be deemed as morally objectionable. "There was a lot of perversity, there were a lot of weird things that were not being said. . . . Madeline at one point is wearing a nightie, and it's 1932—it was incredibly risqué. We discussed what we'd do, what would our take be, what would we want to accomplish with it, and Tobe didn't want to stray very far from the original movie. He thought the original movie was great. So we kept hitting on, let's do it but let's do it really weird, let's do it really scary, and let's do the things that the original movie was kind of holding back or only implying. So he gave Mike and Steve . . . his endorsement of me."

The next step was to work up a treatment for the film. Rivet created a detailed breakdown of the story that basically followed the original film but had more characters, some key twists, and a more modern take on the zombies. It has Neil and Madeline arriving in the Bahamas on a private plane, along with his younger brother Kevin and five of their closest friends, for a destination wedding and honeymoon. They travel to her uncle's sprawling gated property, where he's in the midst of building a lavish resort, along the way nearly getting attacked by locals who are burying someone in the middle of the road—a superstitious act to ensure no one steals the corpse. Madeline's uncle, Charles Beaumont, greets them, stealing Madeline's scarf in the process. As the newcomers settle in, they also meet Charles's assistant, Silver, and Father Bruner, who's going to perform the wedding ceremony. They also notice the strangely robotic workers building the resort . . .

Beaumont visits Rene Legendre (known as "Mr. Murder" by the locals) to give him the scarf and take a vial of powder, which he uses to poison Madeline. She dies in the midst of the wedding and is secretly resurrected by Legendre so Charles can have his way with her. But the plan is complicated when not only is Charles horrified by Madeline's transformation into a soulless automaton, but Neil and the others refuse to leave the island without Madeline's body—and soon discover she's still "alive."

Legendre then takes matters into his own hands and poisons Charles with his zombie powder, takes Madeline for himself, and releases his undead army. The rotters attack the wedding party and start ripping them apart (though they don't eat them; they're not cannibals). With the help of Father Bruner and Charles, who manages to get them the controller for the zombies' shock collars, they go after Legendre, who's eventually ripped to pieces by his own zombies after Kevin releases their souls from the jars they were trapped in while housed in Legendre's lair. Although Neil saves Madeline, she throws herself off a cliff and Charles escapes with Silver in the private plane.

Various zombies from the 1932 White Zombie *(top), and (bottom, from left to right) the film's stars Madge Bellamy (as Madeline Short Parker), Bela Lugosi (as Legendre), and Robert Frazer (as Charles Beaumont). Images in the public domain..*

"There was a lot of perversity, there were a lot of weird things that were not being said."

—Jared Rivet, on the original *White Zombie*

"I wrote this thirty-three-page treatment thinking [Tobe] was going to think it was awesome," recalls Rivet. "It was very *Serpent and the Rainbow* meets Fulci's *Zombie*. And very George Romero; it had a lot of George Romero in it. . . . He read it and called me a couple hours later and said, 'This is not what I want to do at all. I don't think this is great, and if this is what you wanna do, then I think we're gonna part ways.' And I was like, *Whoa, whoa, whoa!* It was me realizing he wanted to be very hands on, he wanted to be very involved with the creative part of the screenplay, and it wasn't gonna be something that was up to me to come up with. And that began a very collaborative process between the two of us, working very closely on the script."

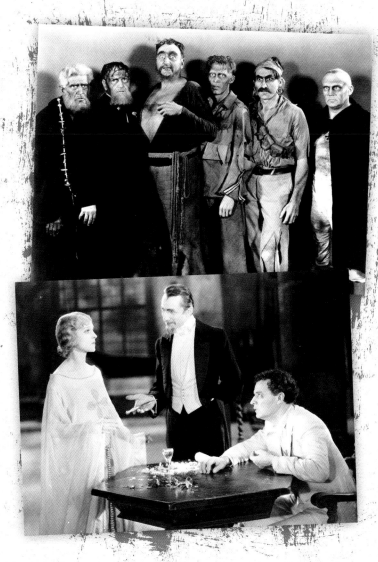

They started from scratch, making sure to hit all the major plot points of the original film.

A draft of the project from 2009 opens with a voodoo definition of a zombie as "the body of a dead person given the semblance of life, but mute and will-less, by a supernatural force, usually for some evil purpose." A narrator explains the origins of the noncannibal "true zombie" as coming from late-nineteenth-century Haiti as the work of a Bokor, "a practitioner of black magic." Having differentiated itself from the dominant flesh-eater-zombie films, it takes us to Haiti. Madeline, her best friend Shelley, and Kevin (her fiancé Neil's brother) are flying into the island along with Charles Beaumont, whose jet they're on.

"We definitely wanted to amplify the weirdness."

—Jared Rivet, on the *White Zombie* remake

"We turned him into her stepfather, who in a kind of *Lolita* way had been waiting for Mom to die so he could slide in with the young daughter," says Rivet.

They're met at the airport by Neil, who works for Charles, and driven back to the organic food magnate's walled-in, cliff-side property, where he's building a resort. On the way, they interrupt a funeral taking place in the middle of the road and are attacked by locals (the self-aware script has them joke about it being like *Night of the Living Dead*), who are driven off by Legendre and afterward killed by his zombie henchmen, who tear them apart. They're much like Romero's dead, though more nimble, able to use tools, and slaves to Legendre, who controls them with his mind. For the zombies, Hooper had a very specific vision—literally.

"He was struck by all of the shots of Bela Lugosi's eyes in the original movie, and he really wanted to not only have the same kind of imagery with the floating eyes that would waft their way through a room, but he also wanted to show what it looked like when you were becoming a zombie. This was something he was working on, like *Predator* vision but weirder."

The script describes this "zombie vision" as "shimmering whirlpools of dazzling radiances like multicolored fire burning out of control."

As in previous versions of the story, Madeline dies at the wedding and is resurrected by Legendre for Charles, Neil discovers the truth, Legendre turns on Charles and releases the zombies, and Neil fights back with the help of Bruner (who's a young Catholic priest here) and the good voodoo priest Pierre.

That said, it's a very different movie from the original. In fact, it's pretty bonkers. This time, Legendre has supernatural powers and is able to transfer energy between bodies, he experiments with eye drops that cause demonic hallucinations, Beaumont contracts zombiism by having sex with his undead stepdaughter (who later rips his dick off!), Legendre is killed when his own zombies—under Pierre's control—throw him in the diffuser (the machine that chops up the sugarcane), a still-zombified Madeline carries his head around, and Neil absorbs Legendre's powers at the end of the story.

Hooper, a self-professed "hippie," wanted the film to be a surreal trip.

"We definitely wanted to amplify the weirdness," affirms Rivet. "Tobe was in a stage where he was in love with what David Lynch was doing. *Inland Empire* had come out and he was enamored with the idea that Lynch could just grab a digital camera and some friends and just go off and make a feature. And of course Danny Boyle had done the same thing with *28 Days Later*, so he wanted to just make something that was run 'n' gun. But he also just loved the surreality, he loved the weirdness. . . . What we ended up doing was introducing these hallucinogenic drugs that would be deliberately given to people to mess with them. And you would see their point of view, and you would see kind of zombie imagery or drug imagery. And then there were gaseous drugs being administered, so there would be this kind of pink-purple smoke, *Apocalypse Now*–style, that would go wafting through a scene, and no one would know what it was, and then they would start seeing things. We had a lot of that imagery. And then there was Legendre, who was the Bela Lugosi character. Legendre was basically a sorcerer, he was a Bokor. We made it where he was something more ancient, and not necessarily 'voodoo,' but he would bring a lot of surreal [elements]; he had all these powers, all these mystical powers. We would show him distorting reality and causing these weird lightning shapes in the air."

Their script is full of sex, drugs, and rot 'n' roll, and the zombies themselves are just as over the top as the rest of it. In the original film the zombies are more like Cesare in *The Cabinet of Dr. Caligari*—somnambulistic, hollow-eyed slaves—but Hooper seemingly wanted to outdo Romero with a very visceral, Lucio Fulci–type take on the walking dead. The script

> ## "If flesh started to seep off [the zombies], then you know, you would pull it and staple it into a different spot. There was a lot of that imagery that ran all the way throughout."
>
> —Jared Rivet

describes one of them in particularly gruesome terms. "Flies buzz away as the horrible face underneath is revealed: pock-marked and swollen, with flesh that is nearly translucent, rotting away in spots and oozing pus. The flies are joined by maggots nibbling at the leprous sores, leaving stringy residue behind in their wake."

"He took it in a very literal sense," says Rivet. "He said, 'OK, if they're dead, and you're going to use them for labor, they're going to start rotting and they're going to start attracting flies.' So he had them wearing mosquito netting, and as they would rot, the mosquito netting would kind of adhere and grow into the gore of their rotting flesh. So you would have them in these kind of enclosed veils, almost, and then he had all this stuff about artificial limbs and braces and things that were stuck on them that weren't supposed to be there. So just by appearance they were very [Clive] Barker Cenobite-like but in an untidy way. The Cenobites were always very neat and clean; this was like dirty Cenobites—drippy Cenobites. They would come into a scene, and you would just immediately be struck by just how weird they looked and just how surreal they looked, and they would have nails and staples and things. If flesh started to seep off, then you know, you would pull it and staple it into a different spot. There was a lot of that imagery that ran all the way throughout."

Director Tobe Hooper (left) and screenwriter Jared Rivet (right).
Tobe Hooper photo by Lionel Allorge, cropped and used under the terms of the GNU Free Documentation License. Jared Rivet image provided by author. Used by permission.

These zombies also have a nasty habit of dropping out of trees to rip, tear, crush, and generally dismember their victims. At one point, veteran makeup artist John Goodwin—who had worked on Hooper's *Poltergeist* as well as *The Thing*, *Critters*, and *Men in Black*—was asked about doing a makeup test for the creatures. Goodwin used a friend, actor Daniel Roebuck, a regular in Rob Zombie's films, as his model.

"I loved the script," says Goodwin. "A horror film story with characters! What an idea, and the ending wasn't telescoped either. I decided on my own to do a test and Dan Roebuck was game....There were a lot of different characters and neat stuff in the script—it would have been great. I designed the makeup to go on very quickly. [I] worked a lot of days on low-budget films and just did not have the time for long makeup jobs."

Hooper certainly had unique ideas of what the undead could be during this period. Prior to attempting *White Zombie*, in 2005 he directed *Mortuary*, which features black ooze from a well turning people into zombies whose weakness is salt. And in 2006 he directed a *Masters of Horror* episode called "Dance of the Dead" (written by Richard Christian Matheson) about a postapocalyptic biker bar that uses a drug to revive overdose victims so they can gyrate in the club.

The script for *White Zombie* suggests a much more ambitious endeavor, one that required an exotic setting, a sizable cast, intense makeup, and various special effects. However, Rivet reveals that Hooper actually had a particular way he wanted to shoot the movie that would've kept both the budget down and the weird turned way up.

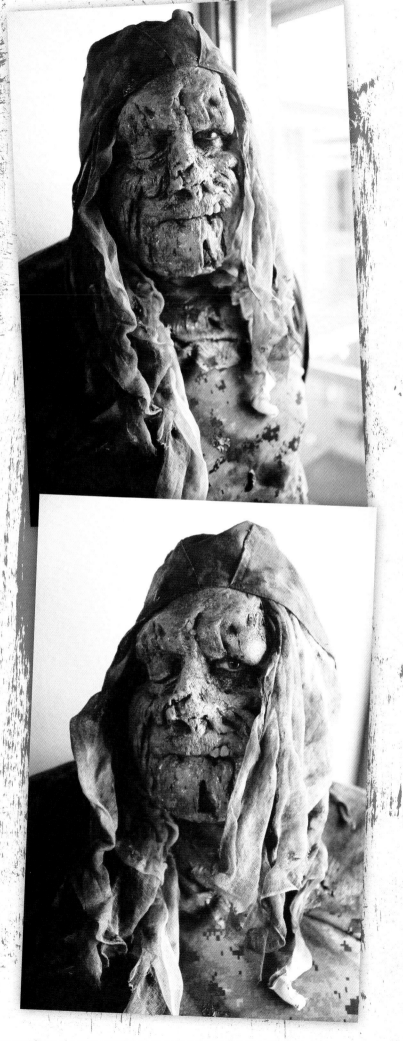

Makeup test photos of a rotting zombie by FX artist John Goodwin (The Thing, Tremors), applied to actor Daniel Roebuck (The Devil's Rejects, Phantasm: Ravager).

"At one point Sid Sheinberg said, 'Does the Swine Zombie need to be a zombie?' 'Well, yes, he does, Sid, it's called *White Zombie*. He's a zombie!'"

—Jared Rivet

"He really wanted to shoot it entirely on stage. He didn't want to go to Haiti, he didn't want it to be real. He was looking at *Bram Stoker's Dracula*, for example, where everything had that stage look and everything was superimposed, that Baz Luhrmann sort of style. I would always bring up [Hooper's 1976 film] *Eaten Alive*. It was shot entirely on stages. . . . On the page there were these really big sequences, very lavish, very budget busting. But he didn't intend them to be budget busting, he intended for them to be shot on stages using in-camera effects that would make it very economical. That was where a lot of the imagery and a lot of the dreamy stuff came from."

Throughout Hooper's career he found himself fighting for his creative vision, usually with producers. He walked off the set of *Eaten Alive* after a dispute with the producers, he famously struggled under producer Steven Spielberg's thumb while making *Poltergeist,* and his final feature, 2013's *Djinn,* was taken out of his hands and reworked by United Arab Emirates producers after—according to an article in *The Guardian*—Abu Dhabi's royal family found it offensive. *White Zombie* saw history repeating itself.

After shopping the script around to various companies, and even changing the title at one point to *The Devil's Breath* ("I warned them that was just a recipe for having critics put in their reviews, '*The Devil's Breath* stinks!'" laments Rivet), in 2009 it landed at former Universal president Sid Sheinberg's company, the Bubble Factory. Rivet says that's when the bad mojo really set in.

"We had this eight-hour production meeting where Tobe and I sat in this conference room with these seven other producers who told us all these things they wanted to do. And not only were they things that were destroying Tobe's vision for it—all of the ideas, all of the passion we had put into it—they were also nickel-and-diming it down to the point where it was going to suck, it was just going to be a terrible movie. . . . There's a scene in the script where [the main characters] come flying in on a private jet to the island for this destination wedding. They basically said, 'It can't be a private jet anymore, it's got to be a limousine,' and I assumed at some point it was just going to be a Lincoln Town Car. Everything was shrinking; we lost our big cliff battle—we had this great sequence where . . . the zombies just walk off the edge of the cliff and keep walking, they defy gravity, like spiders. That was gone."

Rivet was gutted. In addition, he hadn't signed his contract for the film yet because negotiations with Sheinberg were going poorly. And just when things seemed like they couldn't get worse, the emails started.

"Once again, it was seven guys—not me nor Tobe; we were copied in but we weren't replying—changing everything and giving us notes, and the notes were ridiculous," recalls Rivet. "Just to give an example, there was a point where there's a henchman zombie called 'the Swine Zombie,' and in the [original] movie he's kind of the signature henchman to Bela Lugosi's character, and he called him 'the Swine,' so we called ours the Swine Zombie. We were really specific about what he looked like, and we wanted him to be in the cover of *Fangoria*—he was going to be the poster boy. At one point Sid Sheinberg said, 'Does the Swine Zombie need to be a zombie?' 'Well, yes, he does, Sid, it's called *White Zombie*. He's a zombie!' I went out on a limb and I said, 'What else would he be?' And he said, 'I dunno, you're the writer, you figure it out.'"

Despite the project rapidly flying off the rails, Rivet was willing to stay onboard if Hooper wanted to carry on. He says the decision came down to a conversation . . . about gardening.

"Something you should know about the conversations Tobe and I had while we were developing the script is that he would often call me and talk about non sequitur things—he would say he saw something in the sky today that reminded him of this weird thing, and I would realize five or ten minutes into the conversation that he was trying to explain to me something he had in his head that he wanted to see on the page. So I'm telling him now, 'I don't know about this, if you want to continue with this, I will go forward but my guys are telling me not to do it, and if we go forward, I feel like this is gonna be bad for us.' And he had started to tell me about how he had wanted to replace the garden in his backyard with bamboo, and he got into detail about it. He had done all this research about how he was gonna take out this and replace that—very detailed conversation.

Ten minutes: bamboo. I'm baffled. 'Why the fuck are you telling me this?' 'I'm telling you this, Jared, because I'd rather spend the next three months working on my garden than on this movie.' And that was it. So I called my reps and I said, 'I am not taking the deal. Tell them to go to hell, and I'm sorry you're going to lose your ten percent of this. I really wanted to be the guy who wrote Tobe's comeback movie.' This wouldn't have been it. It was heartbreaking because I was a huge, huge fan of the guy and desperately wanted to make the movie."

At this point a Tobe Hooper remake of *White Zombie* seemed dead and buried, but like the cadre of walking corpses in the film, it persisted—albeit without Rivet, of course. Whitney and Menchel continued to seek backing, Hooper remained attached, but an entirely new story was in order. In 2012 then-budding screenwriter Brandon Wyse was approached to take a crack at it. He was told to set the story in Louisiana, as the film would likely be made there to take advantage of the state's tax credits.

Described in Wyse's synopsis as "*The Devil's Advocate* meets *The Serpent and the Rainbow*," it goes even further down the path of a Romero-style zombie film by incorporating hordes of, this time, cannibalistic zombies.

"I wanted to have something new because you had fast-moving zombies in *Return of the Living Dead*, and *28 Days Later* was an outbreak of a pathogen, slow-moving zombies in *Night of the Living Dead*," says Wyse. "I wanted to have it where basically they have a feeding line for themselves and they have a chance to have certain memories rebirthed—one thing Tobe touched upon."

Retitled *White Zombie: Louisiana*, the story has Neil working for his soon-to-be mother-in-law, Mary Beaumont, who heads up the large family company. Shortly before his wedding to Madelyn (yes, her name is spelled differently here), he's sent to the swampy backwoods of the state to meet with the estranged Mr. Beaumont and find out why the family sugar plantation has been doing so poorly. Neil's best friend, Tipton, accompanies him so they can have a party night in New Orleans, during which they have a drunken encounter with the voodoo priest Pierre, a "priest for Papa Legbe," who warns them of the danger ahead. Naturally, they ignore him, get a rental car, and drive out to the remote plantation: a decrepit, aging estate guarded by rednecks and staffed by mysterious figures who seem to work all through the night.

They meet Legendre, a "weird little guy that looks like Zorro"; Charles Beaumont, Madelyn's stepfather, who's described as a George Clooney type; and Charles's right-hand man, Silver. While inspecting the sugar factory, Neil takes a nasty fall and blacks out. When he wakes up, he and Tipton have been joined by Madelyn and Tipton's girlfriend, Mica; they inform him the wedding has been moved to the plantation and the guests will arrive in a few days. (As Silver points out to his employer, the zombies—who subsist on human meat, such as a couple ground-up hitchhikers unlucky enough to be on the nearby road at night—will be difficult to hide from that many people.) Adding to their problems, Madelyn discovers Legendre and Charles's treachery, but is dosed with zombie powder before she can do anything. She's now under the sorcerer's control as she starts to turn into a flesh eater. Just before the guests arrive, she actually dies, turning the wedding into a funeral.

The guests leave, but Legendre has his zombies murder Tipton and Mica as they're on the way to the airport. Neil discovers what's been going on—including finding seventy women imprisoned in a bunch of former slave shacks, who are being used to give birth to populate the zombie army—and narrowly escapes the compound. He goes to the graveyard and finds out there's a dummy in Madelyn's coffin, but before he can do anything about it, the local sheriff, Bruner, arrests him and throws him in jail. Neil realizes Bruner's got a past with Legendre and tells the lawman what's been happening. Neil seems resigned to his fate, but then Pierre arrives and the three of them launch an assault on the compound to rescue Madelyn. They raid the estate and Legendre releases his undead army.

"It does have a lot of voodoo aspects of it. It does come from an occult background, so I did incorporate stuff like the brooms over the front doors, little touches like the gris-gris bags," says Wyse of his take on the zombies. "So they are voodoo to that degree but at the same time they're not just puppets. They eat, they feed [on flesh] too, so I guess they're a hybrid."

As the mayhem unfolds, Pierre subdues the zombified Madelyn, and—having morphed into a powerful voodoo god—fights Legendre, who has the strength of ten men. Oh, and they discover that—gasp!—Legendre is actually Beaumont! Who is a zombie himself but hides it under makeup and wigs! Finally, Neil is able to snatch away Legendre's magical amulet and Madelyn attacks him, tearing out his heart. Pierre dies but Bruner is able to grab a truck and drive Madelyn, Neil, and some of the enslaved women off the compound as they're chased by dozens of the undead.

Having just barely survived, Neil returns to visit Mary, to tell her he's decided to go back to school rather than work for her. After he leaves, we learn that not only does Mary have barrels of zombie dust she's planning to unleash on New York City, she's actually the reincarnation of the voodoo god Baron Samedi! In a final twist, Neil and Madelyn are a happy couple living in the city, but her craving for raw meat has returned.

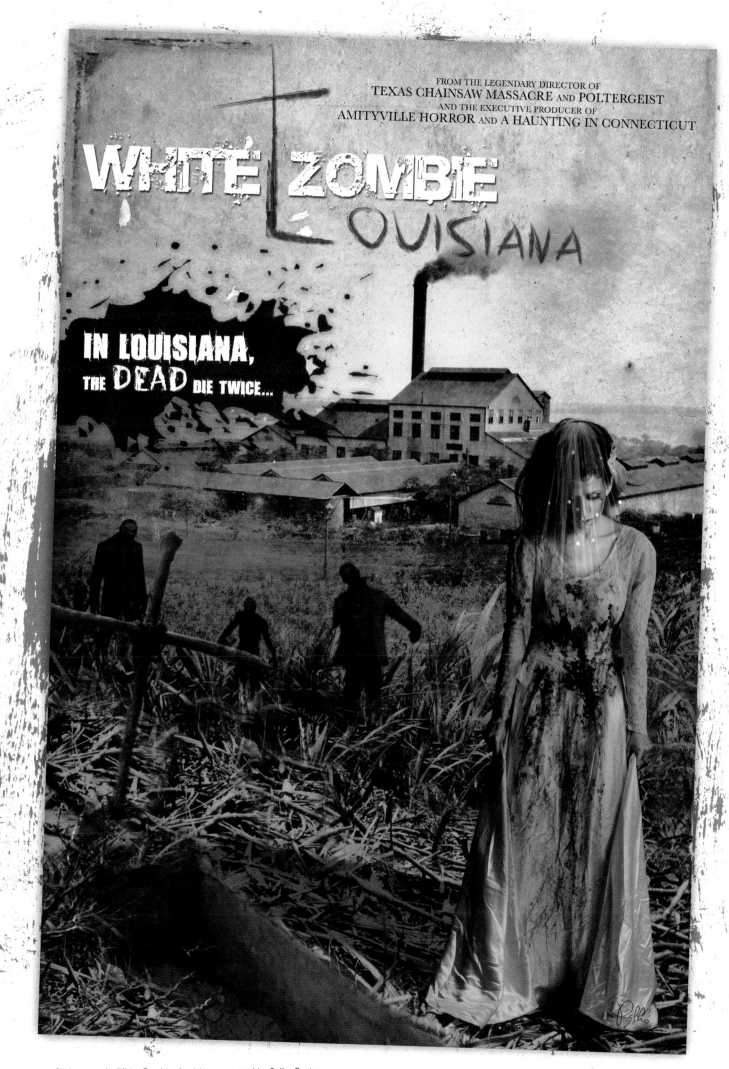

FROM THE LEGENDARY DIRECTOR OF
TEXAS CHAINSAW MASSACRE AND POLTERGEIST
AND THE EXECUTIVE PRODUCER OF
AMITYVILLE HORROR AND A HAUNTING IN CONNECTICUT

WHITE ZOMBIE
LOUISIANA

IN LOUISIANA, THE DEAD DIE TWICE...

Pitch poster for White Zombie: Louisiana, created by Palko Designs.
Copyright Brandon Wyse. Used by permission.

WHITE ZOMBIE
Treatment by Jared Rivet
06/03/07

Based on the film
written by Garnett Weston
and directed by Victor Halperin

ACT ONE

Dirt. Bright sunshine cast shadows of the palms and foliage above. All around are the sounds of the jungle, and in the distance: CONSTRUCTION. Suddenly, a dozen SHOVEL BLADES tear into the smoothed over dirt...INTERCUT WITH

...the CLINKING of Champagne glasses.

A small, private plane glides over the islands of The Commonwealth of the Bahamas. The happy group of Americans inside (now sipping Champagne) stare down at the lush, green islands of the tropical paradise, surrounded by the enormity of the sparkling, emerald Atlantic.

Chief among the passengers are NEIL PARKER & MADELINE SHORT (both late 20's), the happily engaged. Neil is suave in a laid-back, easy-going way, the kind of guy who has gotten further with a flash of his bedroom eyes and a smile than with hard work. Madeline is nothing short of gorgeous, even dressed-down for air travel and the climate. A head-turner with a killer body and a smile that leaves men slack-jawed. Madeline is proud of the fact that she has tamed the "player" out of Neil and turned him into a one-woman man. (At least she likes to think so.)

We learn that they are traveling to Beaumont Island for an intimate, "destination wedding"/honeymoon. The people with them are their wedding party:

SHELLEY JAMES: Mid-20's, extremely pretty. Longtime friend of Madeline's and the maid of honor.

Madeline doesn't notice it, but when Neil leaves her side, getting up out of his seat to stretch his legs, he sneaks a little pat on Shelley's ass. Shelley doesn't protest. She blushes, worried that someone saw him do it. They didn't.

GORDON "BIG GORDO" HARRINGTON: Mid-20's, African-American, barrel-chested, "friend-through-thick-and-thin" type. Neil's closest friend and confidant. The best man.

White Zombie

Written by Brandon M. Wyse

GENRE: Supernatural Horror

LOGLINE: A surprise wedding is turned upside down when the groom has to stop his wife from turning into a zombie under the evil plan of a plantation owner who wants her to be a zombie in his slave labor army.

"The Devil's Advocate" meets "Serpent and the Rainbow."

Neil Parker is ordered by the wealthy owner of Beaumont Enterprises, Mary Beaumont, to head to Louisiana. When he arrives at the Beaumont plantation to investigate the division's losses, he finds things just aren't what they seem. Ghost towns, a lack of workers, and encounters with bizarre people of the night are just some of the things out of the ordinary.

After a nasty fall from seeing something hideous, Neil wakes up to see his lovely fiancé Madelyn by his side. Neil casts off the crazy notions of what he thinks he saw and prepares for his surprise wedding being led by Charles Beaumont, the disenfranchised husband of Mary Beaumont.

Enter… Legendre, the mysterious head of security and voodoo extraordinaire. With the threat of the plantation being closed, Legendre takes drastic measures and begins the process of turning the heiress Madelyn into a zombie that he can control to keep the plantation open.

Neil quickly finds out that this plantation is not what it seems. The factory workers are really zombie slaves used to cut production costs and a breeding ground of enslaved women to birth more children to grow into zombie food for the hungry undead. Legendre has just outgrown the towns around the plantation by exhausting all of the living manpower and is looking for fresh meat.

Neil finds himself in a race against time to find a way to stop Madelyn's transformation, save the beleaguered women from a grizzly fate, and escape with their lives from the powerful Legendre commanding an army of the walking dead. But Louisiana is only the beginning of his evil plans…

"White Zombie" is an updated remake on the cult classic White Zombie that first brought attention of the voodoo culture and zombies to the masses. It will surely give fans of the zombie genre a thrilling originality on a beloved genre, which will leave fans wanting more and realizing… that the dead do die twice in Louisiana.

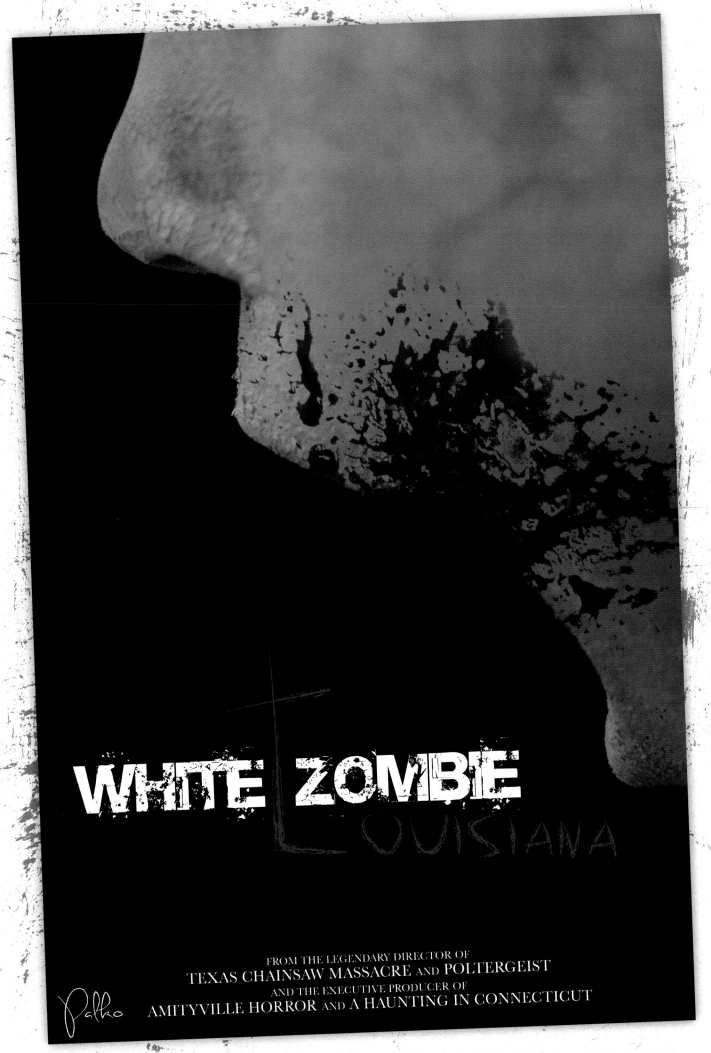

WHITE ZOMBIE
LOUISIANA

FROM THE LEGENDARY DIRECTOR OF
TEXAS CHAINSAW MASSACRE AND POLTERGEIST
AND THE EXECUTIVE PRODUCER OF
AMITYVILLE HORROR AND A HAUNTING IN CONNECTICUT

Pitch poster for White Zombie: Louisiana, created by Palko Designs.
Copyright Brandon Wyse. Used by permission.

Talk about a lot to chew on.

"I wanted to open it up for sequels," says Wyse. "In *White Zombie 2* a shipment of this [powder] would go out like cocaine, and that's what turns people into zombies."

By this time, Hooper was a lot more hands off with the script. Wyse said there were two conference calls between the two of them and Whitney, but he never met with the director in person. Nevertheless, his version was well received.

"Steve Whitney loved it, Tobe Hooper loved it," recalls Wyse. "He probably only changed four or five pages—amp it up a bit more, add some jump scares, things like that. It was very minimal; I got praise, and my head almost turned into a booster rocket and flew off. I mean, to get the compliment 'I really like the script, I don't want to change much.' . . . I was on cloud nine for a week!"

He says that as things moved ahead with the proposed $7 million picture, there was talk of Ron Perlman playing Legendre/Beaumont, and then Tony Todd. Things were moving at a healthy pace. At least at first.

"They said it would be the fastest turnaround, it would be three weeks and we'd be going into preproduction; Tobe Hooper had signed documents and all this stuff," says Wyse. "That three weeks became never. I'd say about every month I'd get an update and it would be 'two weeks' and that went on for four years."

Wyse makes it clear that he didn't see a dime for his work on the project, and actually spent money getting a couple of pitch posters made (courtesy of Palko Designs) to try to help sell it. In fact, he says the only thing he got in return was a cup of tea Whitney bought him at a meeting. His relationship with the producer became increasingly hostile as time went on.

"I didn't threaten him, outside of telling him I'd beat him with his arms if I ripped 'em off—that's it," states Wyse. "He had to know that was just farcical. So that's how that relationship went."

The project got a severe blow when Whitney nearly died of simultaneous liver and kidney failure. In October of 2015, he received a double transplant, and made a miraculous recovery. Currently, he's listed as a producer at the faith-based Sunrise Recording and Films. (Attempts to reach him for an interview were unsuccessful.)

Then it came crashing down when Hooper died suddenly on August 26, 2017, at age seventy-four. At this

point, Wyse says he had still been getting feedback on the script but didn't see a reason to carry on.

"When Tobe died, I just stopped, I wasn't going to fulfill the notes at that time. . . . Finally I set it to rest in my head in 2017."

He cautions inexperienced screenwriters to not make the same mistake he did by working for free.

"No matter who they say is on it, get money upfront—save yourself a thousand heartaches. That's how the machine keeps going: they get the fresh newbies in who just want to take that chance, so they're writing for free or on spec."

Rivet echoes this sentiment: "I was too naive and young and excited to say no."

It's a common problem in the film business in general, but in Hollywood in particular. There are very wealthy people who get a lot of free work out of those who are enamored with the industry and don't want to pass up any chance that will help them make it. Especially if that means working with one of their heroes. The result is an environment where years of work go unrewarded and production companies aren't necessarily motivated to push projects forward at a steady pace if they haven't invested much into them, so many simply fall to the wayside. Horror is particularly susceptible to this, as the genre's robust output makes it more likely to be at the mercy of cycles and trends.

Of course, a proper *White Zombie* feature-length remake will likely happen (due to it being in the public domain, some ultra-low-budget versions are floating around out there), because it's a compelling idea that can be easily updated for the times—exploiting workers never goes out of fashion, unfortunately.

As Goodwin puts it, "One thing that is good: a script like that doesn't get dated, so one would hope it would come to life again."

But whatever the result, it won't be a crazed, psychedelic expressionist fever dream by one of the most iconic filmmakers in the history of horror. And that itself feels like a curse.

Paul Lee's art for an unrealized Dark Horse graphic novel based on Teenage Vampire.

TEENAGE VAMPIRE

Early in his career, the director of *An American Werewolf in London* wanted to make a movie about an American vampire in Ohio

INTERVIEW WITH JOHN LANDIS

Shortly after he wrote one of the greatest werewolf movies of all time, *An American Werewolf in London*, John Landis had American vampires on the brain. He was only nineteen and working in the former Yugoslavia as a gofer on the Clint Eastwood war movie *Kelly's Heroes* when he wrote a script called *Teenage Vampire*.

"The whole idea was to take the innocence of the fifties—because I remember it took place in fifty-eight—and contrast it with real evil," says Landis.

The title is an obvious riff on the campy 1957 American International Pictures release *I Was a Teenage Werewolf*. Starring a young Michael Landon, that film melded the then-popular genres of the monster movie and the teenage delinquent film in what's a thinly veiled, cheaply shot metaphor for puberty.

"You gotta realize, for my generation, we saw a lot of these pictures on television, and as a little kid, they were *scary*," points out Landis. "Seeing it again, it's a strange movie because there's a mad scientist in it. Remember when [the main character] turns into a werewolf when a bell rings? Now there's elements of camp. I remember the Michael Landon werewolf foams up—it looks like he's brushing his teeth or something."

So, inspired by *I Was a Teenage Werewolf* but intent on making a modern monster movie, he dreamed up Louis Grotowski, a (seemingly) teenage greaser who arrives at a high school in small-town Harding, Ohio, when there was still a postwar boom.

"It's Warren G. Harding High School and it's all these Archie and Veronica–style kids: cheerleaders, and all the classic characters," recalls Landis. "[A] new kid comes to school and there's this abandoned, creepy old property at the edge of town, like a haunted house. He moves in there with his uncle, who we never see—no one has seen his uncle. He moves into that house and he starts in tenth grade. But he's much more virile, mature, and catlike than the other kids, and he's got his hair greased back in a pompadour. He's got a black leather jacket, which is very outré, and dark glasses; he always wears dark glasses. And he has powers—he's a vampire. It was outrageous."

Landis's take on vampire mythology saw Louis only occasionally needing to drink blood, being sensitive to the sun but able to walk around in the day with his sunglasses on, and having mental abilities of a particularly sexual nature.

"He forced people to do things by his will," says Landis. "He seduces all the cheerleaders; he had a retinue of slaves. . . . There was one scene I liked very much where the jock character—the good-looking captain of the football team—tries to bully Louis. He goes up to this weirdo new guy who drives a hearse and says something to him, and Louis just puts his hand on the guy's arm and smiles at him, and the guy has an orgasm in the hallway. He comes in his pants and he's so horrified, humiliated, and freaked out that he kind of slinks away."

Eventually some of the teachers catch on. The first one to realize Louis is an undead ghoul is the gym coach, followed by the English teacher, and then the town minister. Louis dispatches the gym teacher, then squares off against the minister.

"There was a scene where he confronts him with a crucifix and Louis pretends to recoil," describes Landis, "and then stops and smiles, and the crucifix bursts into flames, forcing the minister to drop it. There's a line where he says to the minister, 'I predate your Jesus of Nazareth.'"

"Very dark, very sexual, very violent, very sensual, and very disturbing" is how he describes the script. "I wanted to make people uncomfortable. But also it was funny because of the setup; I was taking really broad stereotype characters and playing them, one, as real, and two, as very different from their normal portrayal."

Teenage Vampire could've been the feature to really launch the budding filmmaker's career in Hollywood. There was one problem, however: Arthur Fonzarelli, a.k.a. "the Fonz." The Fonz was a very popular comedic character and took all the danger away from the black leather jacket, rendering that character harmless.

"I wrote it in Europe. When I finished it, I came back to America, and *American Graffiti* had been a big hit movie, and to capitalize on it, there was a new television show called *Happy Days*. And *Happy Days* had the Fonz, a character in a black leather jacket, although greatly castrated [characterwise]—but still, I thought, *oh well* . . . So I just put it away and forgot about it."

"Very dark, very sexual, very violent, very sensual, and very disturbing. I wanted to make people uncomfortable."

—John Landis

In the script's climax, after the minister is taken out, the English teacher and a student manage to torch the vampire's house and believe they killed him. But, as with any classic creature feature, the very end of the story leaves Louis's ultimate fate ambiguous.

Landis notes that he set the story in the '50s as a, ahem, biting commentary on the times in which he grew up. "The fifties had such order and America had won [World War II], and we were so 'good' and we were Christian and powerful, and here comes this greasy guy who is for some reason stronger and more powerful than the average American, and it's very, very disturbing."

With a protagonist who's a calculating, genuinely evil monster that invades small-town America, in many ways *Teenage Vampire* is the reverse of *An American Werewolf in London.* Yet the story seems to have the same sort of balance of blood, horror, humor, absurdity, and reworking of genre tropes that makes Landis's 1981 monster movie such a classic.

Landis hasn't actually seen the *Teenage Vampire* script in decades. Soon after returning to the US, his career continued to take off and it fell to the wayside. Having made the cult classic *Schlock* in 1971, he then directed the hit comedies *The Kentucky Fried Movie* and *Animal House* in 1977 (though the latter was released in 1978), and then helmed *The Blues Brothers* (1980). Eventually he did make a vampire movie: 1992's *Innocent Blood*—about a sympathetic female vamp who accidentally turns a ruthless mob boss into a bloodsucker—though it didn't reach the iconic status of *An American Werewolf in London.*

He feels that letting go of *Teenage Vampire* wasn't difficult because he needed to be able to adapt to the business and not be precious about his writing. "One of the biggest mistakes film students make is that they write something they're in love with, all their marbles are in one screenplay, and that's tough."

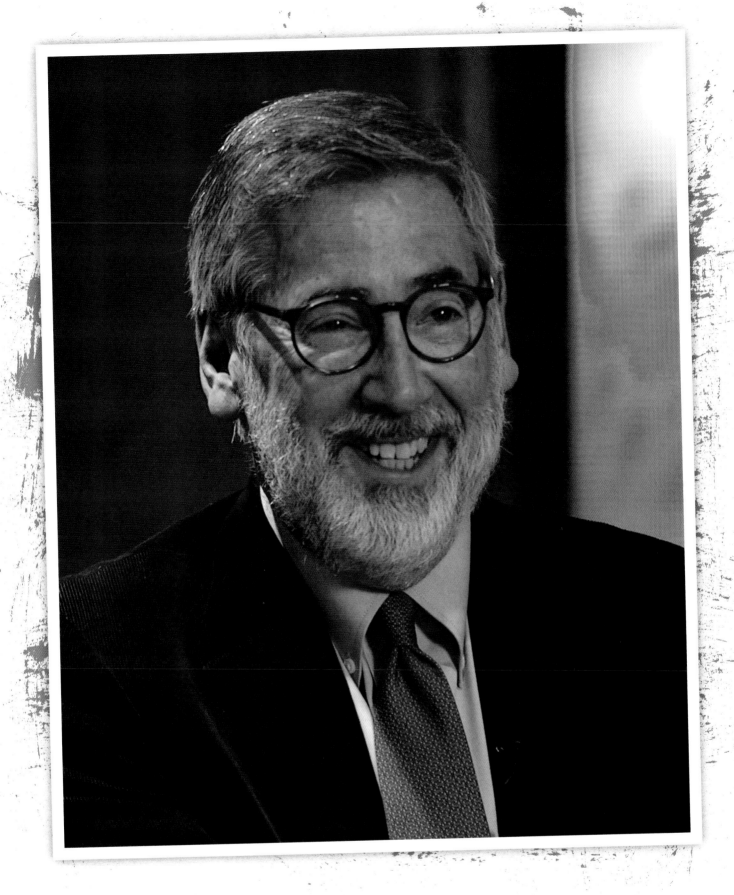

That said, the project would surface again—though briefly—in the 2000s, when Dark Horse Comics founder Mike Richardson asked Landis if he was sitting on any scripts that could be turned into graphic novels. He discussed his *Teenage Vampire*, describing the script, and Dark Horse commissioned artist Paul Lee (*Buffy the Vampire Slayer, Conan, The Dark Horse Book of Monsters*) to do a piece of concept art for it, which was shown at the 2004 San Diego Comic-Con.

However, Landis got busy with other projects, and *Teenage Vampire* fell by the wayside again. Though he'd love to revive it in some form, first he has to find that hard copy of the script, which is currently slumbering away in his files, just waiting to see the light of day—or perhaps the dark of night—once again.

"I wrote it longhand and had it typed up," he asserts. "I have it *somewhere*."

Filmmaker John Landis, who wrote Teenage Vampire *when he was only nineteen. Image provided by author. Used by permission.*

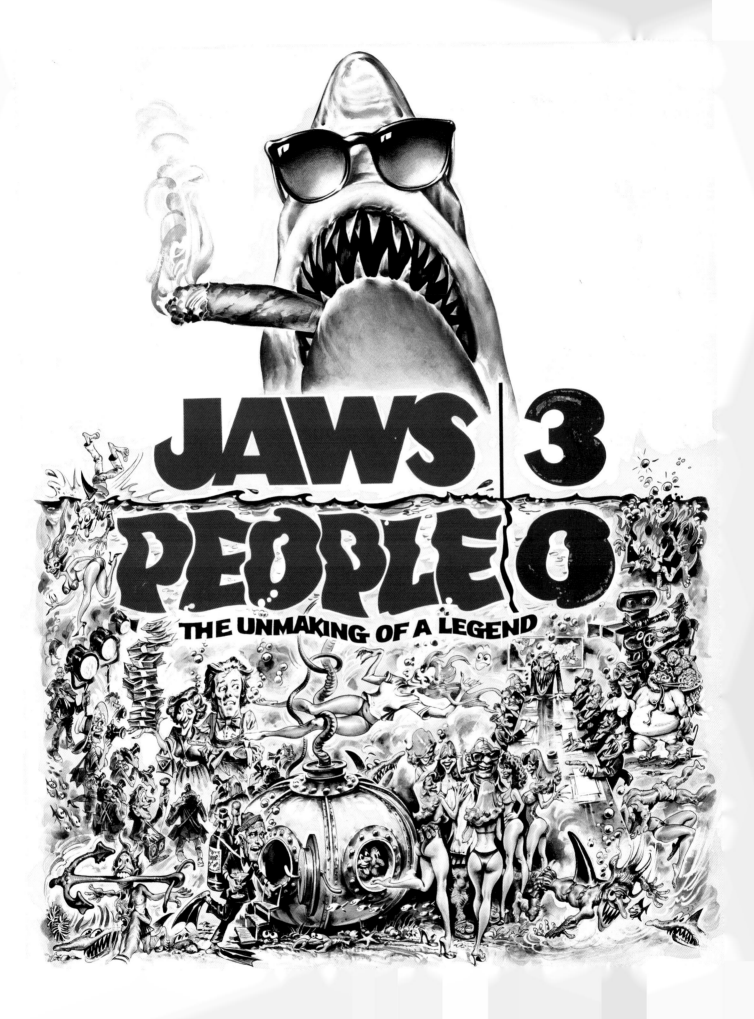

JOE DANTE AND MATTY SIMMONS'S
JAWS: 3, PEOPLE: 0

The director swam with sharks while trying to make a *National Lampoon* version of a sequel to the famous film

INTERVIEWS WITH JOE DANTE AND MATTY SIMMONS

Joe Dante owes his career to a great white shark. In 1975 Steven Spielberg ushered in the era of block-buster cinema when *Jaws*, a $9 million movie for Universal, tore through the box office, going on to earn over $470 million worldwide. Its success chummed the water for numerous imitators, and you can bet famed independent producer Roger Corman wanted a piece of that action. At the time he had a fun script by John Sayles, which he gave to a young filmmaker in his employ named Joe Dante, who had codirected the 1976 satire *Hollywood Boulevard* for him. In the story, instead of a huge shark, the beach was terror-ized by military-grade piranhas that had escaped from a laboratory/hatchery. With ambitious special effects by Rob Bottin (*The Thing*), an engrossing but amusing story, plenty of boobs 'n' blood, and a bud-get of $600,000 (or $770,000, depending on who you ask), *Piranha* turned out to be one of Corman's big-gest hits, earning $16 million in theaters.

The film came out less than two months after *Jaws 2*, which made a fraction of what the first film did, given its $30 million budget. Worried about their diminished returns, producers Richard D. Zanuck and David Brown were trying to figure out what to do next with the fran-chise and saw that the average box-office age was going down and goofy party comedies aimed at the youth were booming—titles such as *The Kentucky Fried Movie*, *Up in Smoke*, and, in particular, John Landis's *National Lampoon's Animal House*, which had earned Universal more than $120 million on a $3 million budget.

Animal House had been produced by Matty Simmons, who had cofounded *National Lampoon* magazine in 1970 (after inventing the credit card!) and was head of the famed humor magazine. The success of the film had made him a hot producer at the time. He also happened to be old friends with Brown, so when they both found themselves in New York, they met up for lunch at the Friars Club. Brown floated the idea of him and Zanuck making a film with Simmons and asked if he had any ideas.

Simmons (who passed away at age ninety-three on April 29, 2020, just weeks after this interview) recalled, "Out of the blue, just as a gag, I say, 'Jaws: 3, People: Nothing,' and as we're sitting there I think of a story: Peter Benchley, who wrote the original story, runs out of his house, dives into his pool, and disappears, and you see a fin swimming around in the pool, and that's the opening scene. And I went on from there, and he's looking at me like I'm serious, and I was kidding. He said, 'I love it! It's great! It's hilarious!' He runs to the phone and he calls Dick."

Zanuck and Brown met with Ned Tanen, the head of Universal at the time, who gave the project a green light, putting Simmons in charge of it under the title *Jaws: 3, People: 0—The Unmaking of a Legend*. He decided to bring Dante on to steer the ship as director. ("I love him," noted Simmons. "He's a great guy, a great guy to work with.")

"*Jaws: 3, People: 0* was the project I was asked to do after *Piranha* was successful and I was getting offers to do aquatic movies," says Dante. "I still had an earache from [shooting *Piranha*] in the Olympic swimming pool for so long, and a number of projects came and went that were aquatic, like *Orca 2* and *Barracuda* and things like that . . . The movie was about a movie company making a movie where it's supposed to be a fake shark movie but there's a real shark. It's a variation on the haunted-house ghost movie where they're scaring people away, but then it turns out there's a real ghost."

The success of *Piranha* demonstrated that Dante understood how to mix comedy with underwater horror, and he had an ally in Spielberg, who had defended Dante to Universal execs who at one point wanted to sue Corman over what they perceived as *Piranha*'s similarities to *Jaws*. (Dante would go on to work with Spielberg on other projects, such as *Twilight Zone: The Movie* and *Gremlins*.)

Jaws: 3, People: 0 would be another script from *National Lampoon* writers. Simmons approached two of his young scribes for the job: Tod Carroll and John Hughes—yes, the John Hughes who would go on to make *Pretty in Pink*, *Uncle Buck*, and *Home Alone*.

Simmons counted the late Hughes among his closest friends, and recalled being dazzled by his talent when the aspiring writer successfully mailed in unsolicited submissions to *National Lampoon* in hopes of joining its staff. "I believe he's the most important comedy writer in the history of films, as far as box office is concerned," noted Simmons.

It was Hughes's first script and was to be part of a development deal with ABC. Speaking in 1985 in an interview with the American Film Institute, he touched on the project:

"[It] was a better situation from a learning standpoint because it was one of those things, when you're just starting out, you really wanna get something made, you just have to get something made. There was a great deal of disappointment involved with that, and it really wasn't very good. It really wasn't about 'Is this a good script?' It was more 'Is this something that they'll make,' which is really the wrong question to ask. But when I was working in that situation, it was really the only question I could conceive of."

No. 00660

EXEC. PRODUCERS: Richard Zanuck
David Brown
PRODUCER: Matty Simmons

NATIONAL LAMPOON'S

JAWS 3/PEOPLE 0

Original Story by
MATTY SIMMONS

Second Revised Final Draft
Written by
JOHN HUGHES
and
TOD CARROLL

Nevertheless, Tanen approved a whopping $2 million preproduction budget, and Hughes and Carroll got down to the business of flipping the famous franchise on its head. As Simmons envisioned, their self-reflexive story begins with the real-life Peter Benchley, who wrote the original 1974 *Jaws* novel and cowrote the movie adaptation with Carl Gottlieb. As Benchley takes a break from writing the sequel, he decides to take a dip in his pool, where he's immediately gobbled up by a shark. He leaves behind an unfinished script for *Jaws 3*. This sets in motion a story that essentially has the fictional *Jaws 3* cursed so that the titular great white spends the movie chewing its way through various people involved with the film, the production of which becomes increasingly ridiculous as the studio—called Mecca—pushes on with the project despite escalating amounts of backstabbing and chicanery from those involved with it.

One scene parodies the beach party in *Jaws*, but this time it's a movie studio party and a bigwig producer named Rutledge Canterberry is eaten while swimming with the film's star. Later, we're introduced to shark hunter Pierre Cockatoo—a cross between Quint from *Jaws* and Jacques Cousteau. One of the biggest gags in the script (as written in the second revised final draft, dated August 24, 1979) features the character and his sidekick Antoine cutting open a shark's stomach and

Title page for one of the drafts of the script, penned by John Hughes and Tod Carroll.

pulling out a variety of outrageous items: "a telephone, bag of McDonald's hamburgers, potted plant, power mower, sports coat, violin, Cuisinart food processor, one of his own Dream Rolls [a snack item referred to in the script], [an] Egyptian vase, bag of pot, a dead raccoon, wallet (Antoine looks in the wallet and puts it under his belt), and a bowl with a goldfish in it."

Eventually, the mounting deaths result in a highly unlikely scenario in which a movie theater ticket taker named Irma is bequeathed the entire studio. This causes a scheming exec named Maven to attempt to wrest back control by sabotaging the production. Things go off the rails to the point where Irma's dimwit offspring Sonny is given the task of writing *Jaws 3* and reimagines the story to be about a space-alien fish who decides to become a small-town chiropractor.

rumor that *Jaws* costar Richard Dreyfus would have had a cameo.

"Richard Dreyfus was going to be in it," confirmed Simmons. "We wanted him in and he said yes."

Apparently the film was also going to make extensive use of footage from classic Universal monster movies, only the climax would actually take place out on the ocean, and "Bruce," the mechanical shark used in *Jaws*, would be back in service. Dante and Simmons had decided to shoot the movie at the Salton Sea, near Palm Springs.

None of that ultimately mattered, however, once the producers were having second thoughts about the comedy.

"The movie was about a movie company making a movie where it's supposed to be a fake shark movie but there's a real shark."

—Joe Dante

Seriously . . .

"It was very, um, hit and miss," bemoans Dante. "It was pretty jokey. There was lots of Hollywood satire. . . . Believe me, that script went through so many iterations. I remember sitting at home with my scissors, cutting and pasting five different scripts into one to try to save it."

Despite the fluctuating script, the movie was partially cast. Bo Derek, who was in the successful *Jaws* rip-off *Orca* (1977), was cast as actress Darlene De Puerque after Simmons saw her in her costarring role in *10*; Emmy Award winner Mariette Hartley would have been Marilynn Sellers, the tough production chief trying to keep the film on track; Stephen Furst, who played Flounder in *Animal House*, would've been Butch Palooso, a leading man who's let himself go; and Roger Bumpass, who voices Squidward on *SpongeBob SquarePants*, would've had his first feature film role playing the aforementioned Sonny.

In addition, the film had numerous star cameos in it, including the role of "Director"—a character whose work helming the *Jaws* franchise had left him with only one arm and one leg—that was obviously meant as a part for Spielberg. There's also a longstanding

"The problem was that there was some tension between the *National Lampoon* people and Zanuck and Brown, who didn't want to essentially make fun of their own cash cow," explains Dante. "On the other hand, of course, the *National Lampoon*, that's *all* they wanted to do. So there were a lot of tense meetings about what kind of a movie it was going to be. So by the time I got there, I was the kid from Corman who was the hired hand, and I was handed my storyboards, I was handed the script, I was told we started casting and there was a part for Orson Welles, and they told me that we can't put him in the movie 'cause we'd have to put his name on the poster, and I thought that was the strangest thing I'd ever heard in Hollywood. I realized what a small cog I was in the studio machine. In the end it was a very useful experience because I really got to see how the machine works, and it was indeed a machine—this was Universal in 1979."

National Lampoon, on the other hand, was a lot more fast, loose, and, well, hazy, as Simmons recalled. "It was crazy—these guys, half of them were certifiably crazy but enormously talented . . . They were nutty; you could walk into the editorial office and get high just on all the pot [fumes]."

It was becoming apparent that what worked for *Animal House* wasn't going to work for *Jaws* in the eyes of the studio. In the July 1984 issue of *Z Magazine*, Simmons aired his frustrations over the conflict. "The concept was that a comedy would rejuvenate what's come to be called the sequel syndrome and generate new life in the series. But Universal rejected the script using the argument that the parody would be a 'Hollywood in-joke,' thus excluding a large audience."

Dante could see the writing on the wall. Doing a *Jaws* sequel was a huge break for a young filmmaker; however, if he waited around while others fought over the flavor of the movie, he'd squander the buzz he had coming off of *Piranha*.

"I mean, there was a way of doing things, and if you fit into that, you could go far, as Steven Spielberg did because he started at Universal in the television department. But given the dissension and the fact that nobody can decide what kind of a movie they wanted to do, I started to get cold feet about the project, and when I got an offer to do *The Howling*, which was the werewolf movie for much less money at AVCO Embassy [Pictures], I was kinda tempted but I didn't want to leave this one. . . . [But eventually] I decided to just take the other job and the *Jaws* thing fell apart."

By October 1979, *Jaws: 3, People: 0* officially went belly up when Tanen decided to terminate it.

Simmons remembered getting the call from him. "He says, 'I gotta see you,' so I go to his office and I swear to you, there's a tear in his eye. He's sitting at his desk and he says, 'I don't know how to tell you this, but I gotta pull the chain on the movie,' and I was astounded. I'd spent months and months and months on this movie at the time when I was the hottest producer in LA because of *Animal House*. I said, 'Why?' He said, 'I can't go into it but we can't do the movie.' . . . It was not a pleasant break. I was furious."

"Steven Spielberg said, 'If you make this movie, I'm out of here, I'll leave Universal.'"

—Matty Simmons

Former National Lampoon *editor and film producer Matty Simmons. Images copyright Kate Simmons. Used by permission.*

There's been a fair amount of speculation as to exactly why *Jaws: 3, People: 0* was canceled. Although it's also been suggested that there was pressure to take Universal in a more family-friendly direction, the disagreement over the tone seems to be at the heart of it. That said, in mid-October of '79 Universal told the *Los Angeles Times* that the project was shuttered because "the script didn't work." In the same article Simmons retorted, "It is very difficult to do business with a studio sitting in judgment about what is not funny, especially when they're not humorists."

Tanen and Simmons publicly feuded over the death of their shark movie.

"We had a big fight in print," said Simmons. "He said, 'Matty Simmons thinks he's Billy Wilder,' and I said, 'Ned Tanen thinks he's Louis B. Mayer'—stupid things. Years later, Thom Mount, one of his right-hand men who eventually became president of Universal, told

me—and this is from his mouth, I've never verified it—that Steven Spielberg said, 'If you make this movie, I'm out of here, I'll leave Universal.'"

In 2013, during a panel at a fan convention, Bumpass agreed with Simmons's version of the story. If it's accurate, Spielberg may have been right to stop the franchise from sliding into parody; however, given the critical lambasting that *Jaws 3-D* and *Jaws: The Revenge* were subject to, perhaps Simmons, Dante, and company were right after all. We'll never know.

In the wake of *Jaws: 3, People: 0*, Zanuck and Brown left Universal (for Fox), Simmons terminated his contract with the studio and went on to produce the massive *National Lampoon's Vacation* series, and Dante made one of the greatest werewolf movies of all time. In that light, the filmmaker's career once again got a boost from a shark—this time the one that got away.

Would-be Jaws: 3, People: 0 director Joe Dante.
Image provided by author. Used by permission.

Pat Carbajal's rendition of Joe Spinell as Frank Zito in the Eibon Press Maniac comics.
Copyright Eibon Press. Used by permission.

MANIAC SEQUELS

The death and attempted resurrection of the sequel to Joe Spinell and William Lustig's sleaze masterpiece

INTERVIEWS WITH WILLIAM LUSTIG, BUDDY GIOVINAZZO, AND STEPHEN ROMANO

Some projects live and die with their star, and the sequel to *Maniac* may be the best example. The original film, shot on the mean streets of New York and directed by William Lustig, stars the late Joe Spinell as Frank Zito, a self-loathing abuse victim turned serial killer who talks to his dead mother and murders women so he can take their scalps for his mannequins. Hammer regular Caroline Munro costars as a photographer Zito attempts a relationship with, and FX legend Tom Savini appears, while also providing some gruesome gore effects, such as his character's head getting blown apart by a shotgun. Released during the height (nadir?) of the city's Forty-Second Street grindhouse era, when grubby theaters showed even grubbier films, it's the epitome of NYC sleaze. The famous poster features a dumpy killer holding a knife in one hand, a bloody chunk of hair in the other hand, with an erection straining against his jeans. It's nasty stuff, and Spinell wholeheartedly embraced the role—his first as a lead.

As Spinell said of the film during a 1980 appearance on *The Joe Franklin Show*, "It's a horror movie in the true sense of horror in that we do all the effects completely on camera, it's kind of unique. So if you don't like a lot of blood and gore, don't come and see it,

but if you're interested in horror movies, it's certainly the scariest of all."

Lustig remembers how it all happened. "Joe Spinell and I met on a movie called *The Seven-Ups*, where I was a production assistant and he was [playing] a thug, and as many people know who are into the horror business, or into horror films in general, when you meet a fellow lover of horror films, there's an instant bond, and Joe and I bonded instantly on the set of *The Seven-Ups*. Following that movie, when Joe was in town—he traveled for work—we would often go together to see horror films on Forty-Second Street. Going to Forty-Second Street and watching horror movies led to us saying, 'Let's make our own horror movie!' "

Lustig recalls that initially they came across a script for a film titled *Slay Ride*, about a pair of father-son serial killers in New Jersey. They started to work on the script but soon realized they were out of their element with it.

"We developed the script but it was a much bigger film than we could raise money for," says Lustig, "so we decided we would shift direction and make a smaller, more contained movie. So then we developed *Maniac*, which was a cop chasing a serial killer."

The keyword is *was*, as the *Maniac* that got made doesn't have the classic showdown with a dogged detective—rather, it's a tortured character study in the vein of *Psycho*. The initial version that Lustig and Spinell came up with was a different kind of story than the one that was eventually attributed to Spinell and one C. A. Rosenberg.

"The original script for *Maniac* was a conventional cop chasing a serial killer in New York City [story], and Jason Miller was gonna play the cop," explains Lustig of the initial plan to have the star of *The Exorcist* get top billing. "When Jason Miller dropped out, we decided not to replace him but to cut the role and just focus in on the serial killer, and it made for a much better movie in my opinion because it got rid of that relief of going to a place of safety. We were with this guy in his dark world and it just became—you're immersed in this character, and I really think it made for a much better movie. . . . I think that if we had gone with a conventional script of a detective chasing a serial killer, I don't think the film would have nearly the longevity that it has today."

An announcement ad in *Variety*, from October of 1979, lists both Miller and Susan Tyrrell (a character actor known for her work on Broadway, as well as in film and television) in the cast. Both were friends with Spinell, who was a coproducer. More intriguingly, however, it also lists Daria Nicolodi, who would've played the role that went to Williams. Nicolodi was onboard because her partner at the time, Dario Argento, was going to produce. She was known for her splashy roles in his giallo films like *Deep Red*. Argento was not only going to bring in the leading lady; he was going to help finance the film and have Goblin do the soundtrack, just as the Italian prog-rock group did for his most famous films and the European version of George A. Romero's *Dawn of the Dead*, which he released overseas.

Argento's hand in the project would've undoubtedly resulted in *Maniac* being less grounded in grimy realism and more informed by the arty surrealism of European genre film that was in vogue at the time.

"Them dropping out made for a better movie," Lustig agrees, pointing to the soundtrack in particular. "The score that Jay Chattaway did for *Maniac* was unlike any score that Goblin has ever done. It was a score that focused on the pain of the killer, versus playing the horror, and it really was a great counterbalance to the movie. The times when it was supposed to be suspense and horror, Jay Chattaway just created sounds and rhythms and concepts that were never heard before, and I don't know if Goblin would have taken that same approach . . . Chattaway played for the audience to feel empathy for someone doing despicable acts, and that's something we hadn't seen before. All the other serial killer movies, or killer movies, are all films where the guy was either a faceless demon, like with Michael Myers, or Jason, or, to some degree, Freddy Krueger. This was a character that you really felt for."

This approach was effective. *Maniac* was immediately controversial when it was released in 1981: women's groups picketed theaters, the *Los Angeles Times* refused to run ads for it (the paper stated, "The film has no socially redeeming value whatsoever, and it is our duty to the community we serve to not even indirectly encourage such violence"), reviewers such as Siskel and Ebert railed against it, and a second version of the poster had to be created for promotion after the first was censored. It's the sort of attention the makers of any microbudget movie dream of, and the $350,000 production made $10 million at the box office, loads more in the emerging video market, and continues to make money for Lustig, whose company Blue Underground has released several special editions of it over the years.

Not long after the release of *Maniac*, a young New York filmmaker named Buddy Giovinazzo was shooting his first feature, *Combat Shock*. Thanks to a mutual acquaintance, he soon crossed paths with Spinell.

Principal Photography
has begun on
the ultimate reflection
of terror...

MANIAC

"Maniac"
Jason Miller
Starring Joe Spinell Susan Tyrell
Also starring Daria Nicolodi
Directed by William Lustig
Produced by Andrew Garroni and William Lustig
Screenplay by C. A. Rosenberg
Executive Producers John Packard and Joe Spinell
Panavision® Color by TVC □□ DOLBY STEREO

In MIFED Contact:
William Lustig / Andrew Garroni / Alexander Beck
Office # 55 Centre Tower
United States & Canada
Magnum Motion Pictures, Inc. / 330 West 58th Street, New York, N.Y. 10019
(212) 582-3041

An early trade ad for Maniac when it was to costar Jason Miller (The Exorcist), Daria Nicolodi (Deep Red), and Susan Tyrell (Cry-Baby).

"All the other serial killer movies, or killer movies, are all films where the guy was either a faceless demon, like with Michael Myers, or Jason. . . . This was a character that you really felt for."

—*Maniac* director William Lustig

"You know, I grew up with *Frankenstein*," says Giovinazzo. "I loved the monsters that were tragic and sympathetic, and didn't want to be monsters, so I loved *Maniac*. I had just finished production on *Combat Shock*; it was a two-year shoot because we were shooting in sections, and my gaffer knew somebody that knew Joe—that's how it worked. He says, 'Joe Spinell's looking for a director for *Maniac 2*.' He said, 'You should call him but he's at this bar; you gotta call him there after eleven o'clock. And the bar's the Olde New York, which is on Eighty-Second Street on the Lower East Side. So I call up the bar and Joe Spinell gets on the phone and he says, 'Come and meet me now.' So I get in my car and I drive up there. It's about midnight, and I meet Joe in the bar, and we just started talking."

They immediately hit it off, and after Giovinazzo showed some edited footage from *Combat Shock*, Spinell decided the young filmmaker should direct the *Maniac* sequel. But first, Giovinazzo needed Lustig's blessing.

"My biggest thing was that I couldn't take Bill Lustig away from *Maniac*," says Giovinazzo. "For me, *Maniac* is such a personal film that you feel Bill Lustig in that film. So I didn't know Bill but I said, 'Joe, why doesn't Bill wanna do this? Bill should be the director of *Maniac*.' He said, 'Bill doesn't want to do it,' and that wasn't enough for me to go on, so I said, 'I wanna talk to Bill.'"

Giovinazzo called up Lustig, introduced himself, and asked for his blessing to make a *Maniac* movie. As it turned out, Lustig was more than happy to hand him the reins.

"We had so many people who wanted to make a *Maniac 2*, and I just never felt the movie was sequelizable—I just never did," says Lustig with a shrug. "I thought we ended the story and it ended properly, so let's not tamper with and try to push the envelope by making another one."

Maniac producer/director William Lustig.
Image provided by author. Used by permission.

Spinell's idea for a sequel was a radical departure from the first film, however. For starters, it wasn't a continuation of the story, which would've been a stretch, seeing as his character committed suicide in the first movie. Instead, Spinell would star as a children's entertainer named Mr. Robbie, who is sent letters from kids, some of whom are being abused by their parents. A demented vigilante, he takes gruesome revenge on them.

"I thought if we were going to call something 'Maniac,' you had to have the same character," reasons Giovinazzo. "But Joe didn't agree."

So Giovinazzo penned the script, following Spinell's story, but made a key addition to the story. It didn't go over so well . . .

"There were always these flashbacks that the main character, Mr. Robbie, was having about a hallway with a doorway at the end of it, and a kid was being abused on the other side of the door," remembers Giovinazzo. "It was Mr. Robbie's sister. So throughout the film it's cutting back to these scenes from Mr. Robbie's childhood, and I wrote this script and at the very end I wanted to go with a very dark, very fucked-up ending, so the reveal at the end of the script was that the door opens to the bathroom and it's Mr. Robbie abusing his sister. He was the abuser, and Joe hated it! He *hated* it! He was just so mad at that ending, but that was the only script we had, so that was the script we were going out with, with the idea that we were gonna rewrite it."

The issue was that Spinell envisioned the film as not just a thematic sequel to *Maniac* but also a response to how the film had been received.

"He wanted to be a nice-guy serial killer," Giovinazzo explains. "He loved his character in *Maniac* but he was really upset because *Maniac* was actually picketed and banned by women's groups, and there were women picketing the theaters, and they hated the character, and Joe was hurt by that because Joe actually loved women. Joe was a gentleman; he was a crazy guy, very eccentric, but he was a gentleman." To help pitch investors on the film, Giovinazzo and Spinell also shot a proof-of-concept short film titled *Maniac 2: Mr. Robbie*. The opening had Spinell as the title character, putting on his clown makeup as he hears the voices of abused children in his head. Later, after his show, he gets drunk at the Olde New York (the owner was interested in investing in the sequel and let Spinell shoot there for free) with a couple of other guys, who shoo away a guy trying to sell them fireworks. After they leave, Mr. Robbie murders the bar's coke-snorting cook by pushing his head into a pot of boiling water, then ramming a knife in his eye. This demented clown putting on makeup in a mirror, then taking violent revenge in a bleak urban environment, feels like it could've influenced Todd Phillips's *Joker*, though much of the rest of it feels amateurish due to the fact Spinell insisted on casting nonactors in the other roles. As Giovinazzo tells it, some of them were shady characters, while others didn't want to be there at all.

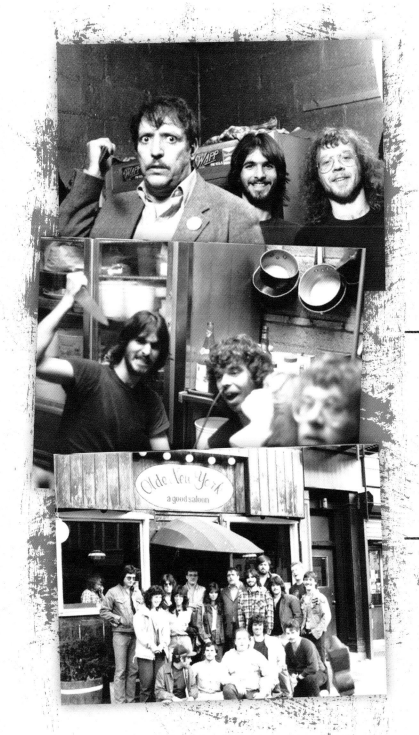

was a financier, and I only had one copy of the script because I had just finished it and didn't make copies yet. He promises me, 'I swear I'll get it back to you, let me take it to this meeting, I want to show these guys we have a script, at least it will help us.' I gave him the script and I never saw it again, and so that script is gone forever."

So, despite the success of *Maniac*, *Mr. Robbie* proved to be a hard sell, mainly, as Giovinazzo asserts, due to the guys trying to sell it.

"Joe, as a producer, was sort of a maniac. Joe's idea of producing was 'Let's raise half a million dollars, shoot it for $250,000, and you and I will split $250,000.'

"It could've been something he saw in a drug-induced state and was just inspired."

—*Mr. Robbie* director Buddy Giovinazzo

And I was young, I wanted to put the $250,000 into the film. I said, 'Joe, first off, it's illegal, and second, let's just put it in the film. Let's make the film for half a million dollars.' And he would say, 'Yeah, yeah, yeah.' But ultimately, when we were meeting with companies and financiers, they didn't trust us as a business entity, and that's why it's so important to have that business guy, that producer who can talk to financiers and let them know, 'OK, I can trust that guy with my money. That at the end of the day I'll have a film.' I don't think they got that trust from me and Joe together when we were in a room with them. If we could have attached a producer, maybe we could've got the money somewhere."

Then again, it may have been a good idea that *Mr. Robbie* didn't get made, because it could've resulted in a lawsuit. While Spinell had a very good reputation in the industry, he also had a reputation for indulging, and both Giovinazzo and Lustig figure that he saw a 1973 film called *The Psychopath* (a.k.a. *An Eye for an Eye*)—which has the same plot and features a main character named "Mr. Rabbey"—when he was drunk and/or high and later thought it was his own idea.

"It could've been something he saw in a drug-induced state and was just inspired," says Giovinazzo.

"The guy he was hanging out with at the bar was a guy he was *actually* hanging out with. That guy was never an actor. The guy who owns the bar in the film was the real owner of the bar. The guy that comes up and tries to sell them fireworks was the coke dealer of the bar, because the bar was a coke den, which I didn't know. . . . The cook was the real cook and didn't even want to be in the film—he was just doing it as a favor to Joe, and then when he realized he was gonna have his face plastered and we were gonna make a mold, he didn't want to do it, he did everything reluctantly. He couldn't act whatsoever."

Oh yeah, and that one script they had? Well, they lost it.

"My biggest regret is that we were in that bar one day and [Spinell] had a meeting with a producer, and I couldn't make it in to the meeting," says Giovinazzo. "It

Behind-the-scenes photos of Maniac 2: Mr. Robbie, featuring (top, from left to right) star Joe Spinell, producer/director Buddy Giovinazzo, and FX artist Brian Powell.
Copyright Buddy Giovinazzo. Used by permission.

At the same time, Spinell started developing yet another "unofficial" *Maniac* movie called *Lone Star Maniac* with a filmmaker named Tom Rainone. Rainone, who died in 2016, directed music videos for Ministry and the Ramones, and did special effects for films such as *Bride of Re-Animator*, *The Guyver*, *Lord of Illusions*, and *Wishmaster*. His friend Stephen Romano—a horror genre fixture known for his work as a novelist, nonfiction author, screenwriter, and visual artist—recalls Rainone discussing the project years later.

"One of his dream projects was *Lone Star Maniac*, which I believe he had written with Joe, and they were looking for funding when Joe died, unfortunately. . . . From what I understand, they had a script and they had worked on it together, and it was going to be set in Texas because that's where Tom was from. . . . He never told me what the story was."

The *Mr. Robbie* idea eventually petered out, but there was yet another official sequel in the works. The script once again had Spinell in the lead role as a maniac, but this time he was a disco DJ on a murder spree. Although the *Mr. Robbie* project was over, he remained close to Giovinazzo and told him about the story, which was his idea.

"Joe described this scene to me where he's on roller skates with a samurai sword and he's skating around the dance floor chopping off people's heads," says Giovinazzo with a chuckle. "I never believed for one second it would be filmed because I knew Joe, and I knew there was no way Joe was gonna be on roller skates. There was just no way."

Regardless, Lustig stepped in to help Spinell make a deal to move this version of a *Maniac* sequel forward.

"We did a deal with a company to allow Joe to go forward to make it," says Lustig. "While Joe was in pre-production on the film, three weeks from shooting, he died."

Spinell passed unexpectedly on January 13, 1989, at age fifty-two, and with him went *Lone Star Maniac*. According to Wikipedia, his official cause of death was exsanguination. He was a hemophiliac, and apparently he slipped in the shower, cut open the back of his head, and then lay down on the couch, not realizing the severity of his injury. Spinell's condition was so serious that he couldn't floss or really brush his teeth, because if his gums started bleeding, they wouldn't stop. On top of this, he was overweight, suffered from severe asthma, and didn't take good care of himself.

"Because he was always committed, he was a great guy, but he always did everything to excess," remembers Giovinazzo. "He drank too much, he smoked too much, he ate too much, he had too many women, he was a guy who just loved life."

Advertisements and promotional pin for Maniac 2.

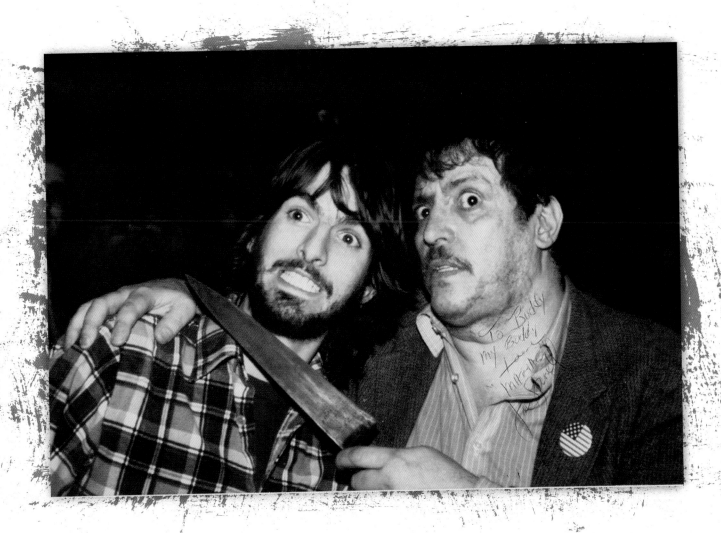

Rainone himself did the last-ever interview with Spinell for the second issue of the zine *Psychotronic*. In it he mentions their project, and while he doesn't discuss the plot of the film, he describes working with Spinell. "He proved to be a great guy and an honest business associate. A deal could be made with a handshake, and he'd stand by it! Joe had an incredible knowledge of horror movies. His taste was wild. He enjoyed everything from James Cagney to Herschell Gordon Lewis movies."

He had appeared in an incredible number of Hollywood films, including the first two *Godfather* movies, the first two *Rocky* films, and *Taxi Driver*. He seemed to be friends with everyone in the business, and his career was on track. The Rainone article mentions that he was to have had a part in *Ghostbusters II* and was up for the title role in a biopic called *Dalí*, about the famous surrealist (who coincidentally died within a month of Spinell). But he was still determined to make another *Maniac* film, and even had *Maniac 2* buttons made, which he would give out.

"In a way he kinda did it; there was a movie called *The Last Horror Film*," says Lustig. "He took a little bit of the *Maniac* character and put it into that." The 1982 film by David Winters stars Spinell as a taxi driver stalking an actress attending the Cannes Film Festival, and does indeed seem clearly influenced by his Frank Zito character.

There were a few halfhearted attempts to make another *Maniac* movie without Spinell, but they fizzled, until the later 2000s, when French filmmaker Franck Khalfoun remade it from a script based on the original movie and written by Alexandre Aja (director of *High Tension*, the remake of *The Hills Have Eyes*, and *Crawl*) and Grégory Levasseur (writer of *High Tension*, the remake of *The Hills Have Eyes*, and Khalfoun's *P2*). Released in 2012, it's shot all from the POV of Frank, who is compellingly played against type by Elijah Wood. It's an effective film, but doesn't have the same impact as the original—there's just no replacing Spinell in that role.

However, that doesn't mean Joe Spinell can't still play Joe Zito. Just ask Romano, who helped bring him back to life in comic book form.

> "While Joe was in pre-production on the film, three weeks from shooting, he died."
>
> —*Maniac* director William Lustig

"We actually have, on the cover of all our comic books, 'Joe Spinell is *Maniac*.' That's the name of our comic series, and it's all for him, every issue is dedicated to him. . . . I knew Joe was very protective of that property, very proud of it, and we wanted to do something he would be very proud of, and Bill [Lustig] basically said, 'Yes, that's exactly what you did.'"

Romano founded Eibon Press with Shawn Lewis—who made the 2007 film *Black Devil Doll*—and the small imprint has been not only adapting classic gore movies in comic book form; they've officially licensed properties and likenesses in order to tell new stories based on them. They started with an adaptation of Lucio Fulci's *Zombie* and then created their own sequel to the 1979 Italian flick (ignoring the several unofficial ones that exist). Then they did *Maniac* using Spinell's likeness, with the full support of Lustig, who approves each issue.

Not only did they make the story significantly gorier than the film—"If Bill and Tom Savini had the budget ceiling to go more over the top with the murder sequences, they would have," says Romano—thanks to art by Pat Carbajal, they expanded on the story, creating a sort of director's cut. "I was looking at it like a novel version of the movie. You're really getting into Frank's mind, adding scenes, expanding scenes— really playing on the idea of being haunted by his mother."

For example, in the film, after Frank kills Rita the prostitute, it cuts away, but the comic book plumbs the twisted depths of the character's mind to show what's going on in there.

"He's not a hero, I want to stress that; we're not making him into some lovable guy," says Romano. "There's a very extended scene where his mother appears and berates him kind of in the style of Norman Bates. You know that he's hallucinating all this—he confronts his mother, his mother confronts him, and then there's a whole army of scalped women that come after him. It's a really elaborate, super-bloody maelstrom of nightmarish weirdness."

In the second issue of the three-issue arc, Romano went full-bore horror-fan wish fulfillment and wrote an entirely new story that sees the world of *Maniac* cross over with the Fulci 1982 slasher film *The New York Ripper*. Set a year after the events of *Maniac*, it sees Zito going head to head with that film's killer. Frank's reappearance is explained by the fact that since you see him open his eyes at the very end of the film, he didn't successfully commit suicide. Turns out—as things have been known to happen in horror sequels—he actually fooled the police into thinking he was dead.

But after this, Romano and Lewis delivered an actual proper sequel to *Maniac*, with a movie-style story that picks up after the first film. Titled *Maniac 2: Roadkill*, it's nothing like the previous versions of the follow-up that were floated and has the kind of scope that likely couldn't have been done on film at the time. In it, Frank continues to fixate on Anna, the photographer. Romano imagined that if there was another *Maniac* tale, it should take the character out of his element.

"We thought it would be cool to get Frank out of the city and onto the road, so he ends up threatening Anna D'Antoni, who was played by Caroline Munro. She survives at the end of the movie. She feels she's threatened by Frank so she hits the road, and Frank hits the road too in search of her, and they end up both running afoul of even nastier serial killers. Insanity ensues. It's a really over-the-top sequel."

There are a lot of lessons to be learned from the attempts to make a sequel to *Maniac*—the importance of a producer, understanding the tone of your movie, and, well, having multiple copies of your script. But, given that Frank Zito lives on in comic book form, the most important one might just be—to bastardize Jeff Goldblum's famous line from *Jurassic Park*—knife finds a way.

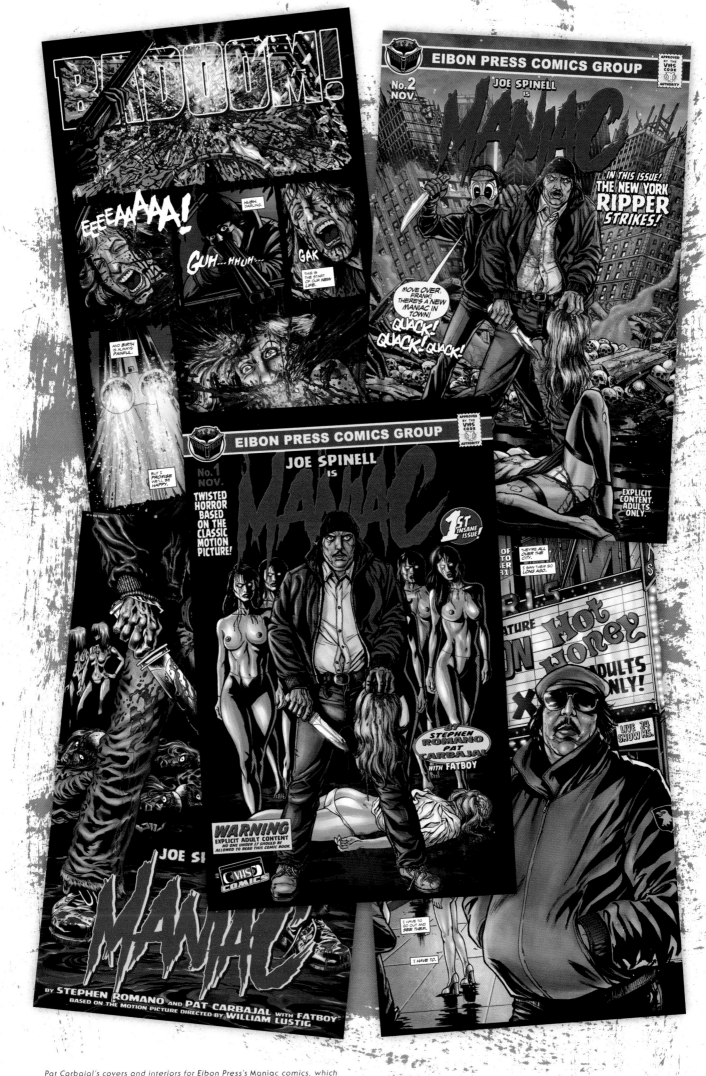

Pat Carbajal's covers and interiors for Eibon Press's Maniac comics, which continue the gory adventures of Frank Zito.

Copyright Eibon Press. Used by permission.

RUGGERO DEODATO
THE DIRECTOR OF
THE RECORD-BREAKING
MOTION PICTURE
"CANNIBAL HOLOCAUST"
IS PLEASED
TO ANNOUNCE
THE START OF
PRINCIPAL PHOTOGRAPHY
ON JULY 15TH, 1983
OF

CANNIBAL FURY

THE TRUTH NO ONE LIVED TO TELL...

OVERSEAS FILMGROUP IN CANNES:
ROBERT LITTLE · HOTEL CARLTON · SUITE 147/PALAIS DU FESTIVAL · STAND 607/810

CANNIBAL HOLOCAUST SEQUELS

The shocking truth behind the sequels that ate themselves

INTERVIEWS WITH PIERRE DAVID, CHRISTINE CONRADT, LEE DEMARBRE, AND DAVID BOND

Four decades on, it remains the most controversial horror film ever made. But when *Cannibal Holocaust* was released in 1980, it was beyond shocking—it was criminal.

The movie was directed by Ruggero Deodato, who'd previously made *Last Cannibal World*, a 1977 exploitation entry in the burgeoning Italian subgenre of gory jungle cannibal movies that began with 1972's *Man from Deep River*. Backed by German producers, and influenced by the cycle of mondo movies (sensationalist pseudo documentaries that focused on a variety of taboo subjects), he wanted to make a film that was a commentary about ethics in journalism.

The plot of *Cannibal Holocaust* revolves around the search for an American documentary crew that went missing in the Amazon jungle while making a film about cannibals. Their would-be rescuers travel deep into the territory of warring tribes and discover both the remains of the filmmakers and the reels of film they shot. They trade a tape recorder for the reels, which they bring back to New York. The footage reveals a litany of horrors. The filmmakers staged scenes for the camera, in the process abusing the tribespeople. The footage shows a hut being burned down with people still in it, the graphic killing of various animals (which, sadly, was real), and the rape of a woman who is later found impaled on a pole, punished for losing her

virginity (the movie's most famous image). In retaliation, the natives impale one of the Americans and mutilate his corpse; beat, rape, and behead another of them; and brutally murder the rest of the crew.

"I make' films that people call 'horror' because I want to make films about real things that happen in the world, and most real things aren't very nice," explained Deodato of his approach to the genre, in a 2009 interview with Jennie Kermode for Eye for Film. "I don't like films with a fantasy element—if I make a horror film I want the horror to come from something realistic, not something made up."

Of course, realistic horror is sometimes downright scandalous, and *Cannibal Holocaust* was either heavily censored or banned outright in many countries. It played for ten days in Italy before it was seized and Deodato was charged with obscenity. In France, he was charged with murder after authorities believed a magazine article claiming he made a genuine snuff film. One of Deodato's actors, Luca Barbareschi, actually had to seek out the other actors, who were bound by their contract to stay off the radar for a year in order to sell the idea that the movie's horrors were real. In England, *Cannibal Holocaust* was one of the key releases that led to the notorious video nasties list—a group of seventy-two video releases deemed so offensive they were banned by the government.

But the movie was also a huge hit in Japan, at the time coming in second at the box office to *E.T.* (earning over $21 million there). Its reputation made it a sought-after cult item, and critics were split on its merits. Some saw its cinéma vérité style (using documentary techniques such as handheld cameras) as groundbreaking, and its critique of Westerners boldly confrontational, while others were disgusted by its violence and animal killing, as well as its undeniably ethnocentric depiction of the tribespeople. Regardless, its influence is profound; *Cannibal Holocaust* not only inspired dozens of imitators, it pioneered the found-footage style that made *The Blair Witch Project*, the *Rec* movies, and the *Paranormal Activity* series big hits.

Given the huge return on the movie's meager $100,000 budget, it's no surprise there was interest in a sequel. One was proposed, and in 1983, during the Cannes Film Festival, a notice appeared in *Variety* for a movie titled *Cannibal Fury*, which read, "Ruggero Deodato, the director of the record-breaking motion picture *Cannibal Holocaust*, is pleased to announce the start of principal photography on July 15, 1983, of *Cannibal Fury*." Listed on the ad is distributor Robert Little, who, before his death in 2018, produced and/or distributed numerous notable films, including the *Prophecy* franchise, *An American Haunting*, the Anthony Hopkins picture *Titus*, and the Oscar-winning drama *Tsotsi*. Aside from this single page announcing the movie, virtually nothing else is known about it publicly.

What is common knowledge is the unscrupulous nature of many Italian genre producers of the era, who often made unofficial sequels to popular movies, or, as in the case of *Cannibal Holocaust*, retitled unrelated movies to sell them as sequels. The 1985 Mario Gariazzo film *White Slave* (a "cannibal romance" story) was distributed in Germany and Spain as *Cannibal Holocaust 2: The Catherine Miles Story*. In 1988, shady distributors did it again when they retitled Antonio Climati's *Green Inferno* (a "cannibal adventure" tale) as *Cannibal Holocaust II*. But the worst of the bunch is 2004's *Cannibal Holocaust: The Beginning*, an ultracheap and cheesy rip-off by veteran Italian schlock director Bruno Mattei, known for making unofficial sequels to *Zombie*, *The Terminator*, and *Jaws*.

Mattei's film came out just before an official sequel to *Cannibal Holocaust* was coming together . . . in Canada, oddly enough. Veteran Canuck producer Pierre David—who's made nearly two hundred films, including the David Cronenberg classics *The Brood*, *Scanners*, and *Videodrome*—teamed up with a fellow Canadian producer and previous collaborator, the writer/director André Koob, to mount a sequel that Deodato would direct.

At the time, David had just produced a movie called *Summer's Moon*, about a family of serial killers stalking a young woman with a connection to them. The straight-to-video title was based on a story by Travis Stevens (director and cowriter of *Girl on the Third Floor*) and written by Sean Hogan (*Little Deaths*) and Christine Conradt, a prolific screenwriter who's penned dozens of TV movies—mainly thrillers, dramas, and romances. Its original title was *Summer's Blood*, but David changed it to *Summer's Moon* in order to capitalize on the popularity of the *Twilight* films, as it starred Ashley Greene from that franchise, despite having nothing whatsoever to do with vampires. In 2007, David tasked Conradt with writing a script called *Cannibals*.

"It was a remake of *Cannibal Holocaust*," confirms David. "We tried to put it together to shoot in Ottawa, as a French-Canadian coproduction."

Christine Conradt on set as director (photo by Roland Massow), and 88 Films'
Blu-ray cover for Antonio Climati's Green Inferno: Cannibal Holocaust II.
Photograph copyright Christine Conradt. Used by permission.
Blu-ray cover copyright 88 Films. Used by permission.

Conradt had never heard of Deodato's film until she was given the job, so she watched it immediately.

"It's certainly a film that sticks with you," she says. "Over the years, I've read and worked on a lot of true-crime stories and am a believer that human evil is a very real thing. *Cannibal Holocaust* taps into that evil, both in subject matter as well as in the making of the film itself, with live animal killings for the sake of entertainment. I personally feel that exploring that evil and trying to understand it is natural, but I don't agree with how the film was made or even the way the film glorifies torture. *CH* has very few, if any, redeeming qualities, in my opinion. It was something that I was definitely eager to forget after watching it, although there are images in that film that I don't think will ever fully leave me."

desperate for the footage, Gary agrees to the deal, but only if Guido takes George and Alexia with him to make sure things go as planned.

The big twist is that George is the real threat. Having committed an actual murder days earlier, he has no intention of returning home, and is ready to kill again. They find Steven, but he's soon assaulted by men who clearly aren't jungle tribesmen. And because his luck wasn't bad enough, George kills him in order to scare the truth out of Guido. They learn that the footage was staged and the filmmakers paid impoverished locals to murder and eat a girl in front of the cameras. Now the local chief is out for revenge, having already killed Nelson and taken the footage. Alexia, George, and Guido decide to negotiate with him for the tape, but he has brutal plans for them.

> ## "It was something that I was definitely eager to forget after watching it, although there are images in that film that I don't think will ever fully leave me."
>
> —*Cannibals* screenwriter Christine Conradt

While doing research for the project, Conradt was looking for a way to modernize the story and hit upon that sketchiest part of the internet, the dark web, which was, as she notes, "still in its infancy in terms of being a part of the zeitgeist."

With that in mind, she wrote a script centered around Gary Sloan, "a shady, violence-obsessed proprietor of an underground website that prints photos and video clips of real murders and mutilations." Gary's best friend, George, is a sociopathic mortician who secretly makes videos of corpses that he works on and sells them as content for the site. Completing the triangle is Alexia, who's in a mutually abusive relationship with Gary and is the site's webmaster. The three of them stoke each other's morbid fantasies, and Gary is increasingly obsessed with securing footage of actual cannibalism. He gets his chance when he's approached by an Italian cameraman named Guido Moretti, who claims to have footage of tribal cannibalism being practiced in Borneo. The rest of Guido's crew, Nelson and Steven, were trapped in the jungle, however, before they could bring the tape back. If Gary will fund a rescue mission to find them, Guido will sell him the tape. Suspicious of Guido's claim but

"I saw doing *Cannibals* as a way to modernize the concept to something that was actually terrifying," says Conradt. "I wanted to keep the idea of a recording of some type being the center of everything, but I wanted to bring technology into it, and the way to do that seemed to be to explore the underground world of snuff films. I also wanted to flip who the antagonist was. Instead of the natives being the savages that capture and cannibalize people from First-World countries, I wanted to show that people in First-World countries can be just as savage—even more so. The idea that civilized people will exploit and murder other people—particularly from Third-World countries who don't have the means to fight back—was even more realistic and horrifying, in my opinion."

David and Koob loved the script. They only had one condition at the time—that the film used no more than two minutes of footage from the original movie.

"That was fine with me," says Conradt. "I wanted the footage from the original to be something that the characters watched as entertainment—something that would further fuel their desires. I didn't want to craft a story around the original concept."

FIRST,
HE SHOCKED THE WORLD WITH
CANNIBAL HOLOCAUST.
NOW,
HORROR MASTER RUGGERO DEODATO
UNLEASHES HIS NEW VISION.

THIS TIME THEY ARE NO LONGER IN THE JUNGLE
CANNIBALS

FROM RUGGERO DEODATO AND ANDRE KOOB AND EXECUTIVE PRODUCER PIERRE DAVID
WRITTEN BY CHRISTINE CONRADT IMAGINATION

"We tried to put it together to shoot in Ottawa, as a French–Canadian coproduction."

—*Cannibals* producer Pierre David

About this time Ottawa cult filmmaker Lee Demarbre got involved, as well. The indie filmmaker behind *Jesus Christ Vampire Hunter* and *Harry Knuckles and the Pearl Necklace* directed *Summer's Moon* (2009) and *Stripped Naked* (2009, cowritten by Conradt) for David and was working on his next passion project, *Smash Cut*, about a disrespected horror director who finds inspiration in actual murder. The movie, which also came out in 2009, stars David Hess of *Last House on the Left* fame, plus former porn star Sasha Grey. Hess also starred in Deodato's *House on the Edge of the Park* (1980) and *Body Count* (1986) and introduced Demarbre to Deodato. Demarbre, a huge fan of *Cannibal Holocaust*, was an obvious choice to shepherd *Cannibals*.

"[David] would always bring me to these meetings when we weren't shooting and say, 'Lee, as soon as you've finished *Smash Cut*, as soon as we wrap in a couple of weeks, can you come to the Philippines? I want to fly you to the Philippines because I need you to work with Ruggero Deodato, because we are making a sequel to *Cannibal Holocaust*.' ... He said, 'Ruggero's English is limited, so, Lee, we need you to come to the Philippines, work with the American actors there, and we're going to shoot the rest of it in Ottawa. And when we come back to Ottawa, I just want you to be on Ruggero's side and help him with the actors.' That's what he wanted me to do."

Preproduction on the film was moving right along. Deodato had found the perfect location in the Philippines to shoot the segment of the film that takes place in Borneo—a location Demarbre describes as "the best part of the movie."

"He found a city that was built on a garbage heap," adds Demarbre. "He showed me photos of this [place where] all the garbage in the Philippines gets put into one spot, and there was a town built on this garbage heap. And the families that lived there would just eat garbage, and they would collect garbage. And there were these huts built on this heap. I mean, it looked disgusting, but it looked like nothing I'd ever seen in a movie before. And I thought the sequel to *Cannibal Holocaust* needed something you had never seen in a movie before."

A poster for the movie was released online, and Deodato started talking about it publicly, calling the film *Cannibal Metropolitan* during a Q&A at a convention where he was a guest. *Cannibals* was shaping up to be Deodato's triumphant return to the world of filmic flesh eating with a story that would rethink the nasty subgenre for a modern audience while preserving his social commentary about outsiders exploiting indigenous populations.

But then David, for financial reasons, decided *none* of the film would be shot overseas.

"Pierre said to Ruggero, 'Nope, we're going to shoot it all in Ottawa now. Forget about the jungle,'" recalls Demarbre. "And Ruggero lost his mind. The whole film fell apart, like that—boom! One day I went into the office, and Pierre David's like, 'We're not making the movie anymore.' They fucked it up."

David maintains the project cratered because Deodato got cold feet.

"We could have financed it with the French coproducer, because as interested and anxious as he was to do it, he found a million reasons not to do it in Ottawa,

Pitch poster for a Canadian-made sequel to Cannibal Holocaust.
Copyright Imagination Worldwide LLC. Used by permission.

or somewhere else, because I think he was afraid of touching his own project. . . . At one point Deodato said, 'No, I don't want to do it in Canada, I don't want to do it.'"

Despite this, Demarbre was determined to keep *Cannibals* alive. He'd become close to Deodato and stayed in contact with Koob, both of whom still wanted to make it the way they'd originally envisioned. So Demarbre sought out private investors in Ottawa. He met one who claimed to have between $1 million and $1.5 million to put into the film. Part of the lure was the promise of working with some big names in Hollywood. But there was a problem.

"Eli Roth and Quentin Tarantino both had agreed to be in the film," reveals Demarbre. "So the guy in Ottawa with this money said, 'Lee, let's do dinner at the Cannes Film Festival. We'll fly to Cannes.' And I put it together. I said, André Koob is gonna be at Cannes, Ruggero Deodato will fly to Cannes if we're gonna go, they're gonna bring Eli Roth and Quentin Tarantino. We'll all have dinner together and we'll get this movie made. All we had to do was get ourselves to Cannes, and the guy with $1.5 million in Ottawa told me that he had his passport taken away because he had recently been to prison." The trip to Cannes never happened, but the investor—who will remain nameless here—still wanted to make the movie, just

without Demarbre, whom he cut out while starting to email Deodato directly, pressuring the director to come to Ottawa to shoot. An email he sent—which, keep in mind, had to be translated into Italian by a third party for Deodato—including the following:

I am a former corrupt police officer, it was alleged that I was in bed with the Italian Mafia, Iranian Mafia, Lebanese Mafia and the two prominent 1% clubs. They suspected that I was importing heroin, cocaine and opium from Iran. They also suspected that I was trafficking in marijuana and illegal cigarettes. . . . I continue to advise and have strong relations and am a very trusted friend within the Italian community. . . . I am a very serious business person. . . . My friends, who pronounce your name beautifully, have arranged for [redacted] to pick you up two hours before your flight at your home to ensure that you arrive on time. This person will merely [be] a driver, be nice to him, it's my understanding that he is a very beautiful person. I may be wrong. . . . If this deal falls through because of your interference, I will fly to Italy and I will deal with you personally (in the courts of course).

Go figure, Deodato decided to stay in Italy, and that was that.

Filmmaker Lee Demarbre, who worked with director Ruggero Deodato on the sequel. Image provided by author. Used by permission.

"I feel so bad introducing Ruggero, who is a bit of a hero of mine, to these people in Ottawa," groans Demarbre. "I only wanted to make a movie with Ruggero; I didn't want him to get a threat like this."

Hopes for another official *Cannibal Holocaust* film faded once again. But with a new decade came a fresh attempt, thanks to another Canadian, this one based out of Edmonton, Alberta: producer David Bond, who had worked with Deodato on a horror anthology.

"We became fast friends in 2012, 2013, and decided we needed to do a feature together," recalls Bond. "Because at that time there had never been an official sequel to *Cannibal Holocaust*, and he liked the way I wrote. I penned a treatment for a sequel."

In classic ripped-from-the-headlines style, Bond's story combined sensational events which took place in Indonesia in 2001 and 2007.

"There was a war between Christians and Muslims that was fought on the southern island of Sulawesi," he explains. "It was called the Poso riots, in particular the massacre that happened in Sampit in 2001. Basically there were tribespeople who were split along religious lines. Some had been converted to Christianity and the others were Muslim. They fought each other and reverted to old tribal warfare, which involved cannibalism, torture, beheadings, and rape. Basically, it was the plot structure of *Angel Heart*, where a man goes searching for a girl he's met, but in Borneo, during a hell-on-earth massacre. I thought this was the perfect landscape to explore the underlying political message the original *Cannibal Holocaust* explores."

convinced one of the original *Cannibal Holocaust* stars to return for the film.

"Because of my friendship with Robert Kerman—star of the original *Cannibal Holocaust*—we thought having him part of the project would have a familiarity that would lend it legitimacy," says Bond. "He was going to play a boat captain that brings the main characters to the island."

The story revolves around a young man making a living in Jakarta as a photographer and documentary filmmaker. He's deeply in love with his mysterious girlfriend, who's shared very little about her past and has only a few friends. One night when they're out at a nightclub, she's attacked by two men who seem to know her. They knock him down and leave, but she refuses to explain how she knows them. The next morning he wakes up to find his hotel room trashed, a bunch of gear destroyed, and his girlfriend missing. He contacts one of her friends and discovers she's from South Sulawesi—a dangerous place that's home to the Dayak tribe, who are warring with the Madurese villagers. After securing an advance in exchange for shooting a documentary news piece on the area, he travels there in the midst of the escalating religious violence—caused by colonialism—in hopes of finding her.

As described in the treatment, "He becomes involved in what can only be described as a Hell on Earth. A riot the scale of which he could never have imagined is taking place, with bodies being dragged through the streets and ritualistic beheadings occurring all around him." He frantically searches for his lover, but he finds himself losing his own humanity when he's caught up in black magic and ritual murder.

"I wanted to show that people in First-World countries can be just as savage—even more so."

—*Cannibals* screenwriter Christine Conradt

The plan was to pen the script with Indonesian filmmaker Timo Tjahjanto, who had written and directed the slasher film *Macabre* (2009), done a segment for the anthology film *The ABCs of Death* (2012), and would go on to do a short for *V/H/S/2* (2013), as well as the insane, bloody martial arts action movies *Headshot* (2016) and *The Night Comes for Us* (2018). In addition, respected Filipino producer Nora Javellana had arranged a location in Laguna Province, and Bond had even

A nineteen-page pitch document, designed in the style of a confidential file, was created. It explains that at its heart, the film is about the colonialism happening now: "The clash between the two factions is not rooted in their tribal past, but in the modern religions with which they were indoctrinated. Namely, the Christian and Islamic faith. As a holy war gains momentum and more blood gets shed, we may be the first Western filmmakers to take on such an important subject."

CONFIDENTIAL

GREEN INFERNO 2 CANNIBALS

AT A GLANCE

Title
Green Inferno 2: Cannibals

Investor Logline:
Harbinger International presents a continuation and development of the infamous cannibal genre, adding an emphasis of social commentary based on events that are more terrifying than any fiction.

Director:
Ruggero Deodato

Producers:
David Bond, Manda Manuel

Label:
Harbinger International

Legal:
Dan Kapelovitz

Budget:
$1.2m

Location:
Philippines

Genre:
Adventure / Action / Horror

Themes:
Kidnap / Riots / Vengeance / Suspense / Terror

Format:
HD / Digital (RED)

Length:
90 Mins

WE STILL DON'T KNOW WHO THE REAL CANNIBALS ARE
BORNEO - Sat. Jan. 17th, 15:33EST

When a young photographer for an international magazine loses his girlfriend in Jakarta, he follows a trail which leads him to the Central Kalimantan province in the Indonesian part of Borneo. Upon arrival, he meets a grizzled ex-pat who explains that Hell is about to break loose. Deciding to stay, the young man continues to search for his missing lover, becoming more involved with the deteriorating society which he finds himself amongst. A holy war and old tribal ways sweep the landscape and he realises that he may have taken a step too far into the darkness.

Green Inferno 2: Cannibals takes the very real instances of The Sampit Incident, along with several other shocking cases of conflict in the Borneo area. It reconstructs them to contain a cohesive narrative, whilst simultaneously highlighting a damaged and paradoxical society in which the Westen means imposed upon an indigenous people.

This is more than an exploitation movie. This is the broken world we live in.

Pitch deck for a 2000s-era Cannibal Holocaust film, made as a sequel to Eli Roth's The Green Inferno.
Copyright David Bond. Used by permission.

Bond says that he wanted to update the story while staying true to the intent of the original *Cannibal Holocaust*. "I still think that if you look at the project, the tribal element of a proxy war between two major religions, during the internet era, still speaks to a modern audience, and ultimately answers Deodato's original thesis: who are the real cannibals?"

There's something particularly unexpected about Bond's pitch that leads us to another important question: when is a *Cannibal Holocaust* sequel no longer a sequel to *Cannibal Holocaust*?

Answer: when it's a sequel to *The Green Inferno*.

Yes, the Eli Roth jungle cannibal movie that hit theaters in 2015. The cover of Bond's pitch package lists the film title as *Green Inferno 2: Cannibals*.

To properly explain, a little context is required. For starters, it's no secret that Roth is a massive fan of Deodato and even gave the filmmaker a cameo in his 2007 movie *Hostel: Part II*, as "Italian Cannibal." Roth made *The Green Inferno* as a tribute to the Italian cannibal movies of the '80s and took his title from the film within a film in *Cannibal Holocaust*. At the time Bond was pitching his *CH* sequel, *The Green Inferno* had premiered at the 2013 Toronto International Film Festival but still hadn't received a theatrical release. Open Road, which had coproduced *The Green Inferno* with Worldview Entertainment, was confident in the film and wanted to get a sequel going.

In fact, after its premiere in Toronto, it was reported that a sequel was already in the works, to be directed by Nicolás López, who had worked with Roth on the 2012 disaster movie *Aftershock*. The September 7, 2013, issue of *The Hollywood Reporter* ran an article about it, in which López said, "After writing and scouting all over Peru, we realized that *The Green Inferno* had an expansive universe and that we would love to visit it again and go deeper into the jungle. Our plan with *Beyond the Green Inferno* is to make a sequel in the tradition of *Aliens*, where the creative team went bigger, darker and scarier into the unknown. Eli has been an amazing creative collaborator and has set the groundwork for an entire universe of stories we're both incredibly excited to tell."

Nothing more came of that proposed sequel, so it seems that the plan was to turn this version of *Cannibals* into part of a larger cannibal universe that started with *The Green Inferno*. Bond planned to meet with Open Road at Cannes in 2014 to discuss his version, which was budgeted at $1.2 million. Unfortunately, that didn't happen.

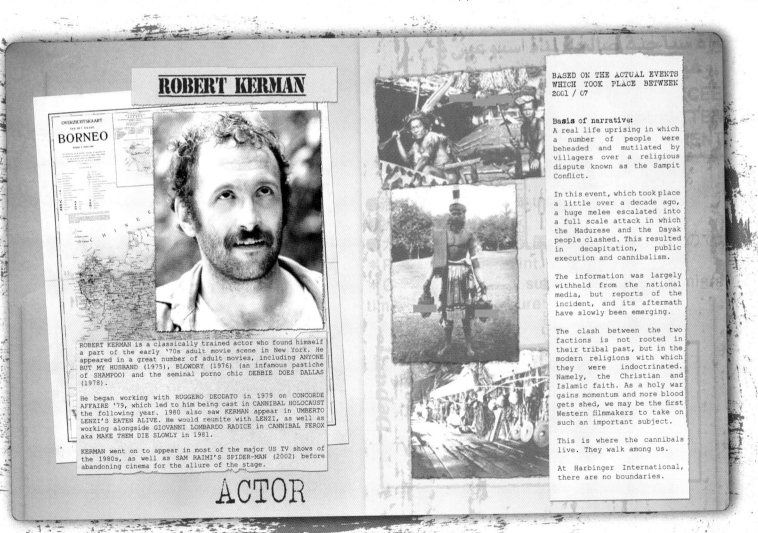

ROBERT KERMAN

OVERZICHTSKAART
BORNEO

ROBERT KERMAN is a classically trained actor who found himself a part of the early '70s adult movie scene in New York. He appeared in a great number of adult movies, including ANYONE BUT MY HUSBAND (1975), BLOWDRY (1976) (an infamous pastiche of SHAMPOO) and the seminal porno chic DEBBIE DOES DALLAS (1978).

He began working with RUGGERO DEODATO in 1979 on CONCORDE AFFAIRE '79, which led to him being cast in CANNIBAL HOLOCAUST the following year. 1980 also saw KERMAN appear in UMBERTO LENZI'S EATEN ALIVE. He would reunite with LENZI, as well as working alongside GIOVANNI LOMBARDO RADICE in CANNIBAL FEROX aka MAKE THEM DIE SLOWLY in 1981.

KERMAN went on to appear in most of the major US TV shows of the 1980s, as well as SAM RAIMI'S SPIDER-MAN (2002) before abandoning cinema for the allure of the stage.

ACTOR

BASED ON THE ACTUAL EVENTS WHICH TOOK PLACE BETWEEN 2001 / 07

Basis of narrative:
A real life uprising in which a number of people were beheaded and mutilated by villagers over a religious dispute known as the Sampit Conflict.

In this event, which took place a little over a decade ago, a huge melee escalated into a full scale attack in which the Madurese and the Dayak people clashed. This resulted in decapitation, public execution and cannibalism.

The information was largely withheld from the national media, but reports of the incident, and its aftermath have slowly been emerging.

The clash between the two factions is not rooted in their tribal past, but in the modern religions with which they were indoctrinated. Namely, the Christian and Islamic faith. As a holy war gains momentum and more blood gets shed, we may be the first Western filmmakers to take on such an important subject.

This is where the cannibals live. They walk among us.

At Harbinger International, there are no boundaries.

Interior pages from the Green Inferno 2: Cannibals pitch deck, featuring Robert Kerman, who starred in the original Cannibal Holocaust. Copyright David Bond. Used by permission.

"In 2014, due to some health issues that I had, the project just ended," states Bond, "and I eventually moved on to other films. It languished, but I remain friends with Deodato, and one day I hope we get to make a movie together."

What likely sealed the fate of a *Cannibal Holocaust* sequel more than anything, however, was the lackluster performance of *The Green Inferno* when it finally was released. Distributed by BH Tilt, an arm of the mighty Blumhouse, it earned less than $13 million at the box office and was criticized for reinforcing colonial attitudes.

So is there even a place for the nasty jungle cannibal subgenre anymore?

"The real question is, can you even make a proper tribal cannibal movie that talks about religion in this modern era?" wonders Bond. "I'm OK with the fact that it didn't get made because that was a different time in my life, but I still think with the right producers and script that this project could be one of the great classic cult films."

Conradt, however, thinks making a sequel to *Cannibal Holocaust* is a Catch-22.

"The die-hard fans of the original, who would be the most likely to go see a sequel or remake, will most likely prefer the original because it has such a cult following. So it's a risk for whoever decides to make it.

I'd love to see my script for *Cannibals* eventually get made but it has so little to do with the original—none of the original characters are even in it. I think the fans of *CH* wouldn't like it, and it would simply appeal to the current generation of moviegoers as a creepy horror film."

David is much more blunt about the prospect of Deodato making another *Cannibal Holocaust* film. "It's becoming old. It would need incredible vision, but I don't see him doing it."

Of course, there's one very important voice missing here. You're probably wondering what Ruggero Deodato himself thinks of all of this. When contacted about an interview for this book and sent a series of questions, he declined to participate, but did issue a statement for publication. It's succinct yet hints at the emotional toll the forty-year journey to make an official *Cannibal Holocaust* sequel has taken on the filmmaker, who is still active but now in his eighties.

"All the questions you asked me belong to a past that I would like to forget. There are names—precisely Bruno Mattei and others that I don't want to specify—that have crippled my film, or have tried to ruin it with hideous sequels. These are black pages forgotten by me and you can absolutely publish my letter which serves to specify that my film *Cannibal Holocaust* is now considered a cult film and I don't want to spoil the new image."

Would-be Cannibals *producer Pierre David.*
Photo provided by author. Used by permission.

GEORGE A. ROMERO'S
COPPERHEAD

In the 1980s, the legendary horror director nearly launched the Marvel Cinematic Universe

INTERVIEWS WITH GEORGE A. ROMERO, JIM SHOOTER, AND BOB LAYTON

As unlikely as it seems, George A. Romero—the god-father of the modern zombie—nearly kick-started the Marvel Cinematic Universe.

Of course, this was during a very different era for the company—back in the early 1980s there was scant awareness of the potential for a vast cinematic empire built on superheroes. Yet there was a growing interest in bringing some of the company's charac-ters to the big screen, if it could find an interested director with the juice to get a project financed.

At the time, Romero was in a lucrative partnership with producer Richard P. Rubinstein. Under the banner of Laurel Entertainment, they'd made *Martin, Dawn of the Dead, Knightriders,* and *Creepshow,* some of the director's most respected and successful movies, and titles that demonstrated a strong understand-ing of the power of genre and displayed a social conscience—and with *Creepshow,* an unabashed love of the comic book format. They seemed like a natural fit for Marvel and its forward-thinking editorial staff.

"There was a period of time where there was this guy, this really sort of progressive guy who I really liked a lot, called Jim Shooter, who was the head of Marvel," recalled Romero in a 2016 interview. "He called us in and said . . . 'I'd like you to try and develop a

screenplay or something we could do on film.' And the character was called Copperhead."

Romero and Rubinstein met with Marvel, and it was decided the director would pair up with Shooter to develop a script that Laurel would then try to get funded. It would be an ambitious, big-budget proj-ect that would also allow Romero to branch out from straight-up horror.

"With Marvel you're probably headed in the superhero direction, and George liked that," recalls Shooter. "He liked the idea of doing a fantasy superhero kind of thing. You see, that's where I live and so that's home base for me."

Copperhead revolved around a cyborg supersoldier dispatched to fight terrorists after his wife dies, only to find out there's a lot more to the conflict than he was led to believe and neither side is living up to the ideals it champions.

Romero did an initial treatment and sent it off to Shooter, whose job was to shape it into the Marvel mold. That meant targeting it for more of a mass audience.

"He gave it the title *Copperhead Conquers the War Hawks,*" recalls Shooter. "I said, 'Oh, I swear that sounds like a B movie.' He really made it a politically left kind

of story, and I said we can't do that, we can't alienate half the country. . . . I came up with the name 'Mongrel,' figuring he was a half human, half robot, and somehow that evolved into *Mongrel: The Legend of Copperhead*, and we were both kind of pleased with that."

Shooter would take drafts of Romero's treatments and, incredibly, write out his own notes longhand on legal pads—as he didn't use a computer or typewriter— then physically cut out parts of Romero's document with scissors, reorder some of the segments, and marry them to his own additions and changes, using tape to stitch it back together.

"George was a genius," says Shooter. "I thought, well, I'll be the idea guy and he's the guy who knows movies so he'll be the structure guy. No, no, no, no—he was the guy crazy with ideas, he was like a machine gun of ideas, and I ended up being the one kind of organizing it."

At one point, Shooter locked himself in a hotel room for four days straight to hash out the story. With each session, he would create a new hybrid treatment to send off to Romero. Then the filmmaker would work off that latest version to create a new treatment. And on it went . . .

"George was a genius. . . . He was like a machine gun of ideas, and I ended up being the one kind of organizing it."

—*Copperhead* cowriter and former Marvel comics editor in chief Jim Shooter

"I spent weeks writing and writing and submitting to Marvel," Romero remembered. "This is the process; it's not just, 'OK, I'll go home and write this, four weeks, boom!' It's not that, it's four weeks, and then you get notes, and then you get notes, so four weeks turns into eight, turns into sixteen, turns into half a year."

He and Shooter eventually agreed on a detailed plot for the sprawling *Copperhead* saga. The story centered on York, a highly decorated soldier (named after real-life American World War I hero Alvin York) who's led to believe that terrorists murdered his wife with a bomb. Seeking revenge, he volunteers to become a cyborg supersoldier designed specifically to take on the antigovernment forces.

"Because robots weren't smart enough to fight the terrorists and humans weren't strong enough, they were trying to create a hybrid," recalls Shooter. "The process was driving the subjects crazy because they were waking up on the operating table and their arms are gone and legs gone and it would flip people out. Finally they figured maybe this guy who's the Medal of Honor winner, maybe he's courageous enough to withstand this. And he does, just barely."

Now known as Copperhead, a nearly invincible fusion of man and machine, York is given the mission to take down the terrorists. The first big twist comes when he's captured by them, only to learn that his wife is not only alive but was saved by the rebels just before the bomb went off—which was actually set by the government to frame them and turn York into a willing tool of the state. Worse, his wife believes he is dead because the government used that story to hide Copperhead's real identity, and now she's shacked up with the head insurgent.

"It's just heart wrenching for York," says Shooter. "A lot of personal drama stuff like that, and what happens is he sort of ends up hating both of them. He finds out the government is just a bunch of weasels and rats, and the terrorists are just ruthless and will stop at nothing. . . . We both wanted it to be a story where there was all this conflict in the world, and almost everybody was a bad guy."

The climax sees York leading the anarchists in a charge against government headquarters, but they tip off the military, which is waiting for him, so they can sneak in the back door. Despite the betrayal, however, Copperhead bests both the government and the terrorists. He chooses neither side and decides to run the country until he can find a suitable replacement.

"The president tries to escape—and this is one of George's wonderful little touches—but there's a computer who runs everything called Equator," says Shooter. "The president is pretty much a useless guy but one thing he insists on is that everyone must be polite, and so if you ask Equator to do something you have to say 'please.' So he is fleeing and people are just about to kill him and he gets into this flying car sort of thing and he says, 'Get me out of here right now! Right now!' but he didn't say please, and so they get him."

By 1982, Marvel and Laurel were ready to start shopping the project around but wanted comic book-style visuals to help bring it to life. They approached Bob Layton and Butch Guice, two younger artists on Marvel's roster, to craft storyboards.

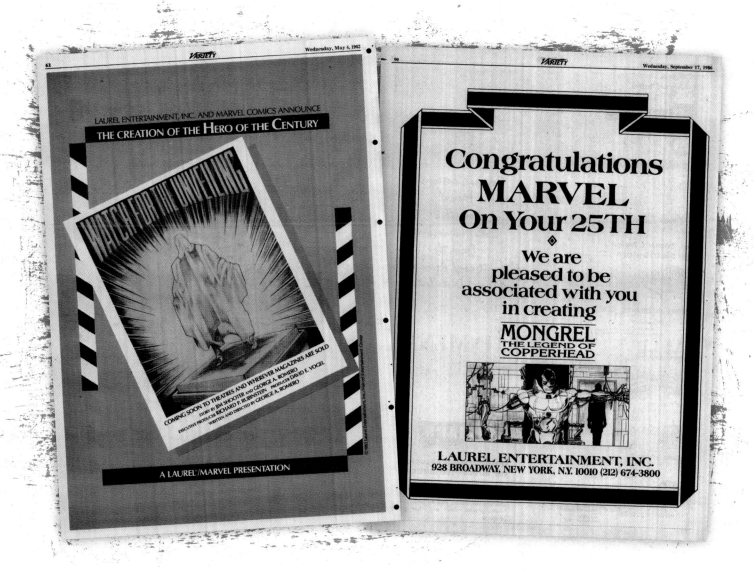

"*Copperhead* was *RoboCop* before *RoboCop* had ever been made," says Layton. "It was a postapocalyptic world, populated by cyborgs, ninjas, you name it. Mad scientists, crazy technology, robots—giant robots. I mean, this movie had everything. It was one of those things that, man, if they had succeeded in getting this made, it would have redefined the genre in a lot of ways. 'Cause there had been nothing like it on the screen. . . . There was some incredible action sequences that we had the opportunity to draw. At one point, in the midst of a battle, Copperhead picks up a horse and throws it at somebody. And that's what hooked me when I read this script. I'm like, 'He throws a horse at someone?! Oh my God. That's amazing.'"

Layton, who had earned a reputation for his work on what are considered some of the most classic issues of *Iron Man*, was told to put his skills to use envisioning a different marriage of man and machine.

"You can see the *RoboCop* elements," Layton points out. "The fact that he's got the killer gun, that he has the superstrength, that face. He was kind of Borgish in a way, I would say. They just said, 'Make him look coppery.'"

Layton and Guice created nearly fifty storyboards, which were used to help shop the movie around. In addition, other notable artists were enlisted to help

with a teaser ad campaign for *Variety*. The concept was to show Copperhead . . . without showing Copperhead. Shooter was perplexed by the request.

"I said, 'How are we going to do that?' and they said, 'How about there is this shape in a shroud and we can't really see it.' . . . I hired a whole bunch of artists: Walt Simonson, Bernie Wrightson, and Jim Starlin, and a whole bunch of guys. I said, 'What we want is this statue that is somehow draped in a way that it looks intriguing but we can't really tell all the detail about it.'"

Despite the best efforts of Marvel and Laurel, and the combined talents of Romero and Shooter, *Copperhead* faced some major problems. The biggest was the scope of the project. The budget and effects needed to pull it off were a big ask from a comic book company with no movie track record and a production outfit whose successes came in the low-budget horror world (at least, low budget compared to the multimillions needed to realize *Copperhead*).

"As far as Hollywood was concerned, they didn't know who I was," admits Shooter. "They knew who George was, but he had never done a big-budget film. What you have to understand is that Marvel Comics was not a big company."

Teaser ads intended to attract investors for Copperhead.

Layton believes that another factor was the horror elements that made for a much less family-friendly film than, say, *Superman.* "With Copperhead, he was a tragic antihero. Against the establishment. He was a Frankenstein monster, as well. There was elements of that in there, you know. There was lots of bloodletting. There was some epic fights in the thing, as well. So what I'm saying is that it is always a great thing to stretch as a creator. And I think this was an attempt to do that. But again, this was the eighties."

And as resilient as the creators were when it came to pitching *Copperhead,* ultimately they were no match for one of 1987's biggest movies.

Shooter remembers, "[Laurel and Marvel] were running ads in *Variety* and they were trying to use everything, use every trick in the book they could, trying to get some big star attached, trying to make it happen everywhere they could, but we ran out of time because then *RoboCop* came out. So we invented a *RoboCop*-type character two years before *RoboCop* but we couldn't get it done."

"I was trying to basically do *RoboCop*!" lamented Romero. "Who knew that *RoboCop* was right around the corner? That's basically what it was—it was almost *Transformers* meets *RoboCop.* That's the way I thought of it! . . . Marvel didn't have the power to get it financed, *we* didn't have the power to get it financed. It just sort of went by the wayside."

Of course, had *Copperhead* gone into production, it likely would've steered Romero's career in a more mainstream direction, which, by his own admission in many an interview, was not where he thrived. (His

last major studio film was 2005's *Land of the Dead,* for Universal, which was such a bad experience for him, he decided to never work in Hollywood again and moved to Toronto permanently to make independent movies.) Not to mention, if *Copperhead* got a green light, the director might not have done 1985's *Day of the Dead,* which many consider one of his greatest films.

As for Layton, he points out that *Copperhead* birthed a vital collaboration. "Butch and I wound up being partners on other projects after that. We became a team, and went on to do *X-Factor* at Marvel, which was one of the best-selling books at the time. We set all-time sales records with that, which wouldn't have happened if we hadn't done *Copperhead.*"

Soon after *Copperhead* died, Shooter left Marvel and cofounded Valiant Comics in 1989, bringing with him Layton, who became a key architect in the company's universe, eventually becoming editor in chief and then senior vice president.

> ## "I was trying to basically do *RoboCop*! Who knew that *RoboCop* was right around the corner?"
>
> —Director George A. Romero

Layton had forgotten all about the project until he received a package in the mail a few years ago. "Out of the blue, I get a manila envelope out of the mail from Marvel. . . . I couldn't imagine what it is. Every so often they'll recover something, and there inside the envelope was the entire forty-eight pages of the *Copperhead* storyboards, and I'm like, 'Holy crap.' I had totally forgotten about it, you know?"

Both Shooter and Layton continue to work in the industry and are frequent guests at fan conventions. Romero died in Toronto, in 2017, of cancer. Shooter remembers him fondly, thanks to their collaboration on *Copperhead*—the movie that nearly launched the Marvel Cinematic Universe.

"He was just so creative and every time you walk away from him it would just be like, 'Oh my God, this guy's incredible,' you know, and I think he liked me too. We got along, and you know, the suits maybe didn't get stuff accomplished, but I thought George and I did some good things together."

Bob Layton holds up one of his sketches during a reunion with George A. Romero at the 2017 Ottawa Comiccon. Image provided by author. Used by permission.

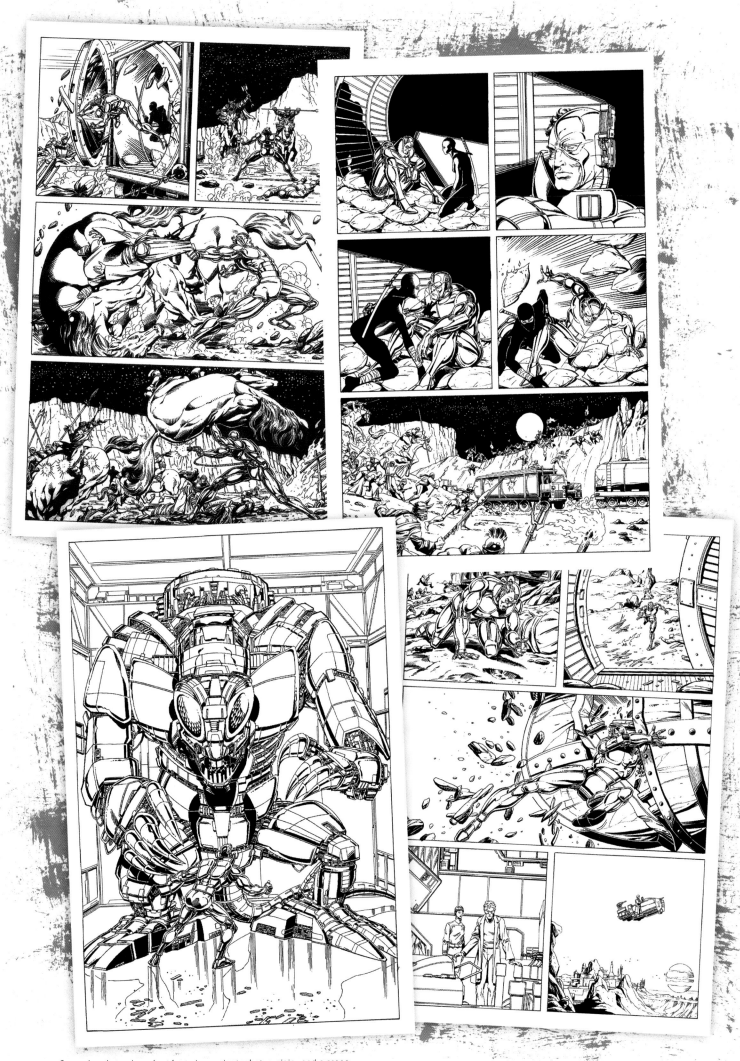

Copperhead storyboard art featuring a giant robot, a ninja, and a scene where the main character throws a horse in the heat of battle.

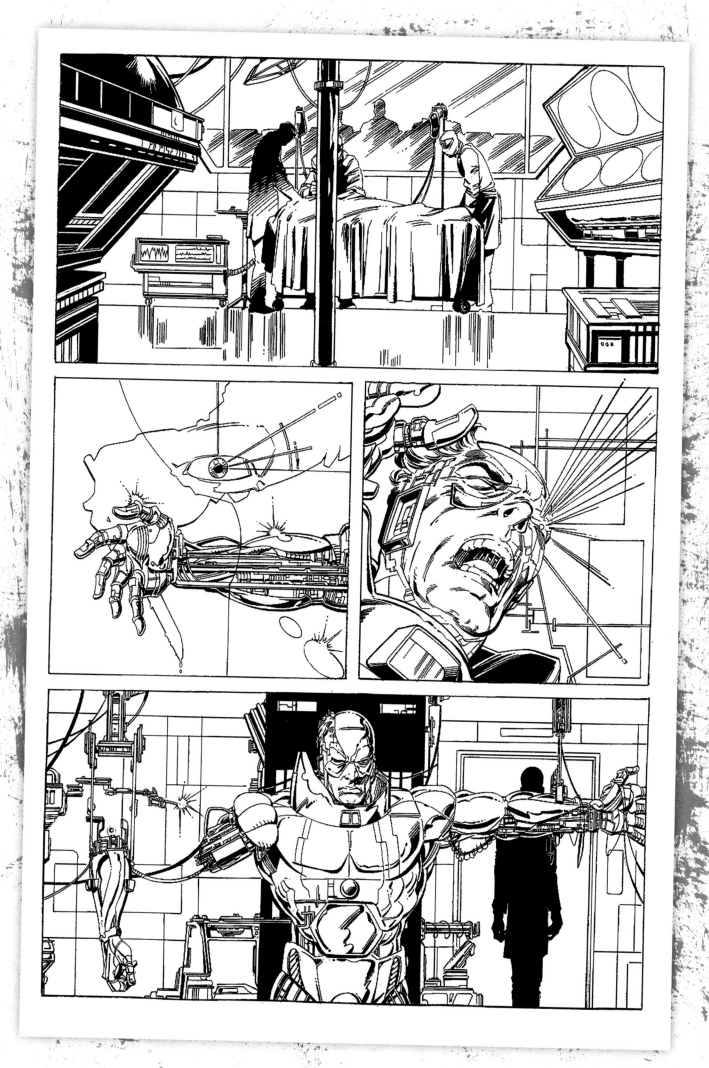

Copperhead storyboard art featuring the Frankenstein-influenced creation of the cyborg hero, plus his encounter with guerrilla fighters.

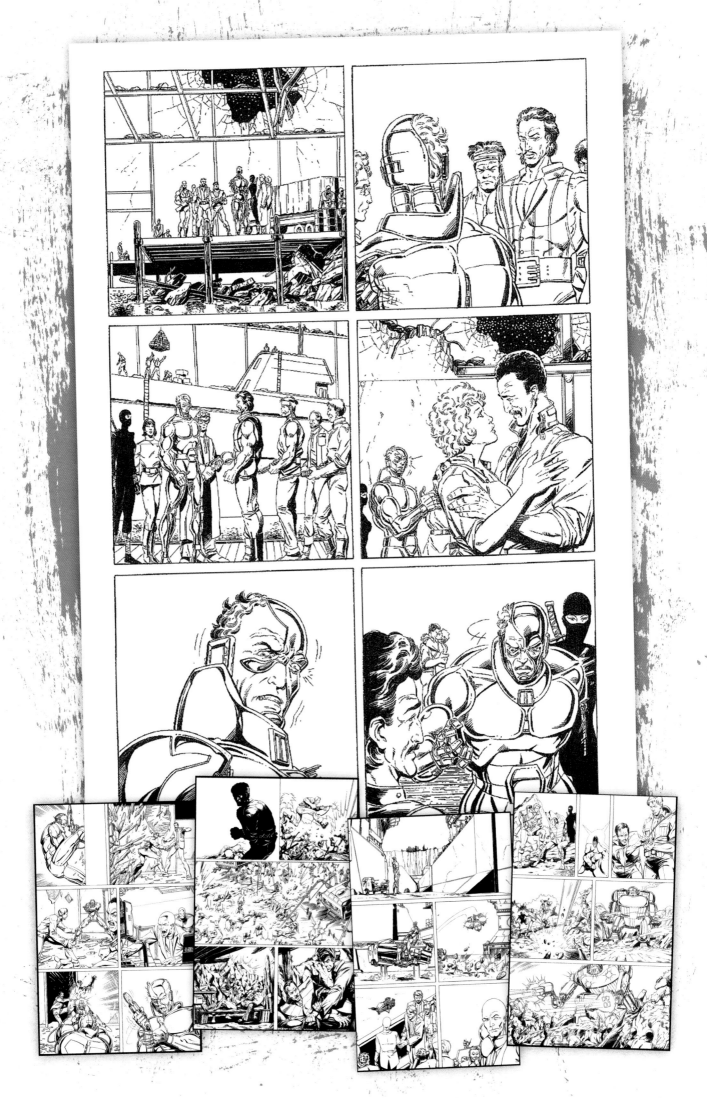

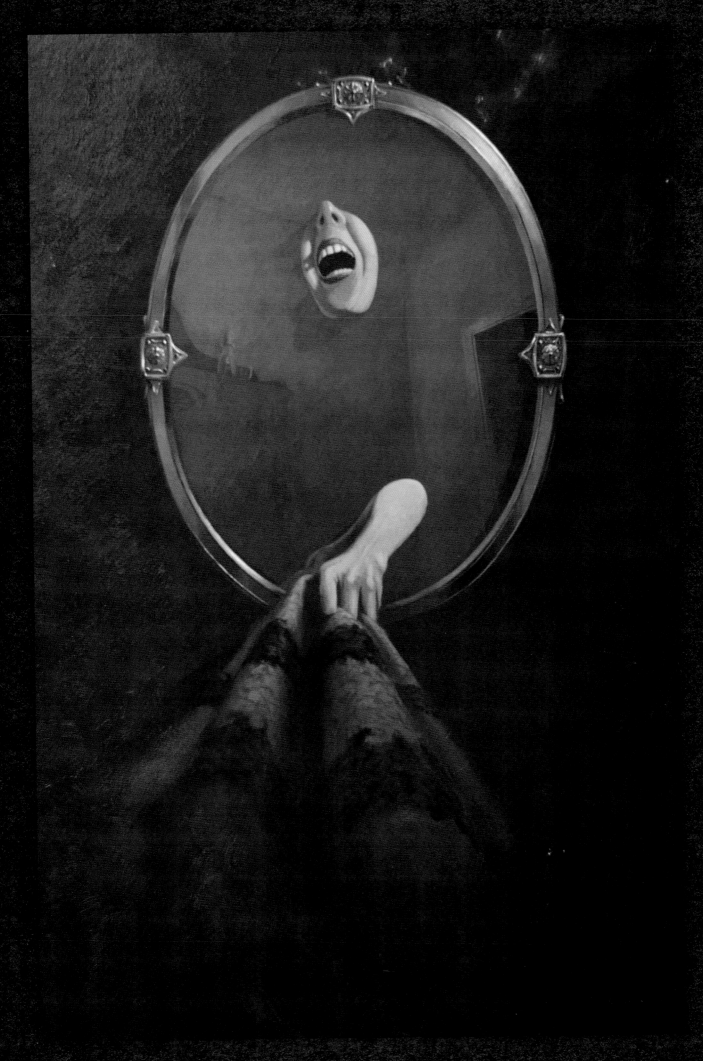

Concept art for The Mirror by renowned painter and stop-motion animator Jim Danforth, created in the early nineties.
All images in this chapter copyright Malone Productions Ltd. unless otherwise noted. Used by permission.

H. R. GIGER AND WILLIAM MALONE'S
DEAD STAR AND THE MIRROR

The filmmaker recalls trying to make *Dead Star* and *The Mirror* with the legendary surrealist

INTERVIEW WITH WILLIAM MALONE

Their friendship started in secret. In the '70s, William Malone was working for the famous Don Post Studios making latex masks. Having already created the iconic Michael Myers mask—by modifying a Captain Kirk design—he was assigned to a film project that incorporated designs from the Swiss artist H. R. Giger.

"Back when I was at Don Post Studios we got the license for *Alien* and I was actually in the basement of 20th Century Fox. They hid us away because it was top secret . . . so I actually went to work at the studio every day in some little cubbyhole in the basement of the executive building. I was designing a facehugger for us to make to sell, and [Giger] came in and was giving me pointers on it, and we sort of became friends."

Not only did Ridley Scott's sci-fi horror masterpiece become one of the biggest hits of 1979, spawning a massive franchise, it redefined the entire genre, thanks in large part to Giger's unmistakable monochromatic, biomechanical aesthetic. Malone—who went on to carve out a career as a horror director, with film and TV projects such as *Scared to Death*, the *House on Haunted Hill* remake, *Tales from the Crypt*, and *Masters of Horror*—was just starting his career in film at the time and was fascinated by Giger's art. He soon grew to appreciate him as a person who was markedly different from his reputation.

"He's actually kind of a contradiction because he's like the perfect Swiss guy," says Malone. "He was very polite and very focused and very . . . I guess you'd say *normal*. . . . He had a good sense of humor. And he really wasn't the dark, brooding guy you sort of picture, because all of his pictures were sort of like that, but *he* really wasn't like that. I found him to be very friendly and personable."

Eventually, he approached Giger about working together on a film project called *Dead Star*. It would be another sci-fi-horror film but this time it would be written and directed by Malone, who was inspired by *Dead Calm*, the 1989 horror-thriller about a grieving couple who rescue a dangerous stranger from a sinking ship, starring Nicole Kidman, Sam Neill, and Billy Zane.

"I thought, that's a really good idea for a science-fiction picture. Let's take that premise and turn it into a sci-fi movie, which is what we did. . . . Basically it had the same things happening, but it was very different in the sense that in *Dead Star* the idea was that death was a real place you could go to. You didn't have to die to go there. And so what happened was, at some distant black hole, right on the edge of a black hole, someone found an alien device that was capable of taking you to, basically, hell. A team of rescue people went to find the ship that had disappeared that had this device on it, and of course that's what happens. We see this rescue boat coming toward them and it's got this device onboard."

Once he'd finished the screenplay, Malone took it to Giger.

"I thought, well, who better to come up with the idea of what hell should be like than H. R. Giger? So I contacted him. The producers who were going to make the film were very keen on having Giger, so they sent me to Zurich to meet with him and I spent, like, ten days there doing designs."

Together, they came up with numerous concepts for the world of *Dead Star*. Giger started churning out imagery.

"He would sketch so fast . . . you'd have to say, 'Giger, slow down, look at that one.' He was a fascinating guy to work with," says Malone.

> ## "I thought, well, who better to come up with the idea of what hell should be like than H. R. Giger?"
>
> —Director William Malone, on *Dead Star*

His environment was manic, as well. Giger didn't separate his studio from his living space; he had taken two adjoining flats and removed part of the wall separating them, built a working train large enough for him to ride through the building, and over the years crammed the space with artwork. (The home can be seen in the 2014 documentary *Dark Star: H. R. Giger's World*.) One particular piece really caught Malone's attention, however.

"All the walls were painted black," describes Malone, "and his artwork—he didn't sell any of his artwork—is stacked maybe seven, eight deep against every wall. But I remember . . . there was one hanging, it was one of his more important pieces, it was very big. I said, 'Giger, one of your paintings has got some holes, somebody damaged your painting—it's got some stains.' And he said, 'Oh no, that's where my girlfriend blew her brains out.' And I learned later that was true, his girlfriend Li [model and stage actress Li Tobler] shot herself in front of the painting, and he left the bullet hole and the blood in the painting. Yeah, that was pretty amazing."

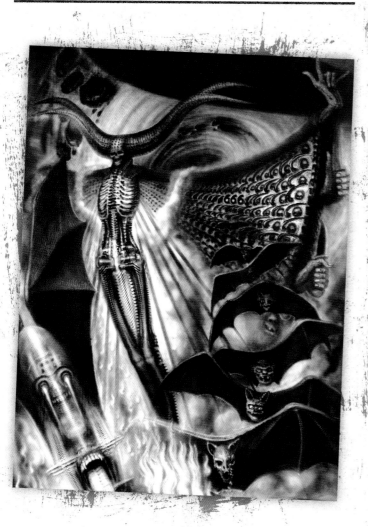

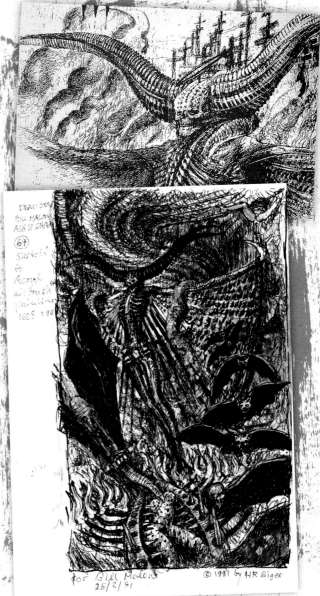

H. R. Giger's painting of Satan, created for *Dead Star* and the sketches the painting was based on.

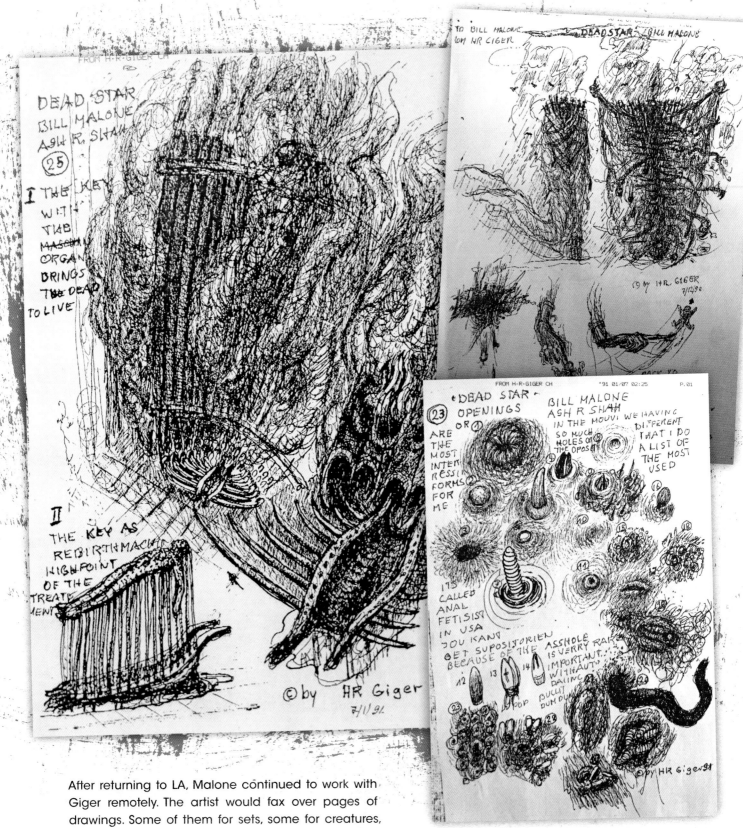

After returning to LA, Malone continued to work with Giger remotely. The artist would fax over pages of drawings. Some of them for sets, some for creatures, and others, well . . .

"I still have a notepad that's about this thick of his designs that he did, which were phenomenal," says Malone, miming a book the size of a small catalog before pulling it out to show in person. "And that's where he designed a page of holes, *assholes*. All kinds of holes. . . . He goes, 'Yeah, I wanted to send you pictures; I drew some assholes.' OK, I'm not sure how that fits into our project, but great. . . . I don't know what that was about. It was a wonderful time."

The book, which is composed of fax sheets, is chock full of frantic-looking black ink sketches of demons, monsters, worms, gnarled appendages, hellish devices, Giger's notes, and, yes, the aforementioned assholes. Giger also created conceptual paintings for the project.

By 1989, the *Dead Star* screenplay was being shopped around to various studios in Hollywood. But it soon ended up in its own hell: Development Hell.

Various Dead Star concept sketches that H. R. Giger faxed to William Malone in the early nineties, including the Thanatron, a device that transports people to hell (left), and various "assholes" the artist believed should be in the film (bottom right).

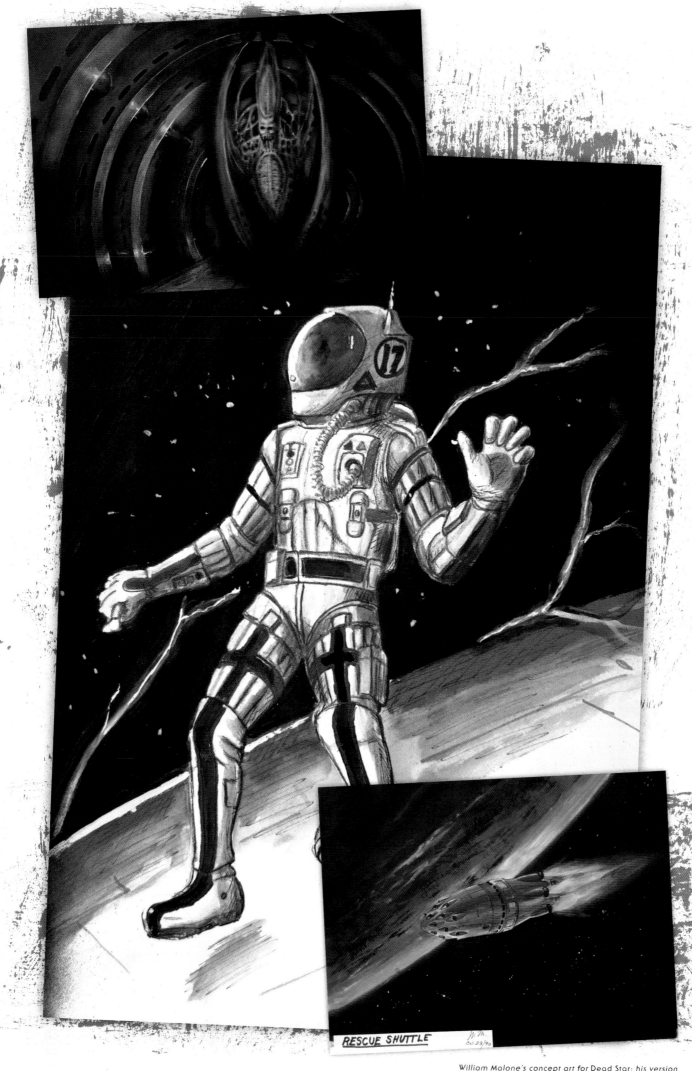

William Malone's concept art for Dead Star: his version of Satan, an astronaut, and a rescue ship.

RESCUE SHUTTLE

"I remember writing the screenplay for it and got a lot of heat on it right away and it was set up at a few places and then, once again, sort of fizzled out," recalls Malone. "The script got kicked around for so long it was mercilessly ripped off by other films. But it was a highly reputed script; for whatever reason, we just couldn't get it made."

It's easy to see shades of *Dead Star* in movies such as *Event Horizon*. But despite this, there was still interest in the story, and finally, around the time he was making *House on Haunted Hill* ("When my star got a little brighter," says Malone), at the end of the '90s, the producers sold the concept to MGM. From there, the studio changed the title to *Supernova* and brought in a bunch of writers who reworked the story (three of them are officially credited) so it was now about a medical ship that responds to a distress signal in deep space and discovers a cargo ship being sucked into a black hole that has a single survivor on it.

Australian director Geoffrey Wright (*Romper Stomper, Cherry Falls*) was initially going to direct but dropped out two months before cameras were set to roll, taking star Vincent D'Onofrio with him. At the urging of new star James Spader, the reins were then handed to Walter Hill (*The Warriors, 48 Hrs., Trespass*), whose extensive writing and producing work on the *Alien* franchise made him a more likely choice. *Supernova* was rushed into production, however, due to an encroaching writers' strike, and the result was a complete disaster by the time it had finished shooting in 1998.

And things just kept getting messier.

Due to rising costs, Hill was unable to get the proper special effects work done that *Supernova* required. When it was shown to a test audience without them, it got a big thumbs-down. Hill quit and MGM then hired Jack Sholder (*Alone in the Dark, A Nightmare on Elm Street 2: Freddy's Revenge, The Hidden*) to reedit the film and do a bunch of reshoots. His extensive changes didn't impress the studio, though, so Hill was reapproached to save the movie but quit for good when the studio turned down his request for $5 million to do some reshoots.

By 1999, however, another $1 million was spent on digital effects and having Francis Ford Coppola oversee a new edit. Test screenings were still negative and MGM sold the film, which was finally released in 2000, with Hill's name taken off and replaced by the pseudonym "Thomas Lee." Its box-office returns fell far short of its final $65 million budget, and currently it sits at a pitiful 10% Fresh on Rotten Tomatoes. Reviewers' comments point out that it's "utterly incoherent," a

"Frankenstein's monster," and "assembled by committee"—none of which is surprising, considering that it also went through five different concept artists.

"I did get a wonderful note from the producer Francis Ford Coppola saying he wished they'd made the original screenplay, so that was very nice," chuckles Malone.

In David Hughes's 2001 book *The Greatest Sci-Fi Movies Never Made*, Giger says, "I was pleased with my paintings for *Dead Star* but everything had been changed by the time *Supernova* was released. . . . I would rather a film was not made at all than made badly."

> **"The script got kicked around for so long it was mercilessly ripped off by other films. But it was a highly reputed script; for whatever reason, we just couldn't get it made."**
>
> —William Malone, on *Dead Star*

Despite the bizarre implosion of *Dead Star*—pun intended—he hadn't given up on another collaboration with Giger, though, and the two of them embarked on another movie project, this time titled *The Mirror*. Like *Dead Star*, it was centered around a hell dimension. Unlike *Dead Star*, it wasn't set in space. More importantly, however, Malone wrote the script based on Giger's art, incorporating him from the very beginning instead of bringing him on later.

"This really goes back to the first time I ever saw Giger's art," says Malone. "I didn't know anything about him, they hadn't made *Alien* yet. I was at a science-fiction convention and there was a table of books. And I remember walking by and picking it up, and I just was blown away, and I had to have the book. It was expensive at the time that I bought it. I remember taking it home and just laying it out on the floor. Just poring through it, and I thought, this is great stuff."

So Malone took a basic concept for a film about other dimensions and dove back into Giger's art to flesh it out, concentrating on *Li II* (1974), *The Spell II* (1974), *Passage Temple (The Way of the Magician)* (1975), *Stillbirth Machine* (1976), and *Death* (1977).

"When I saw his artwork, it just spoke to me," he acknowledges. "The story really came out of his artwork. I was looking at it and thinking, how could any of this even fit in a movie?"

The plot of *The Mirror*—which Malone first started writing in 1980 under the title *Deadly Images*—focuses on Julie Daley, a young woman who's been taking care of her six-year-old sister since their parents were killed in a plane crash. She works at a department store, and on her lunch break visits an antiques store and discovers a particularly unusual, ornate triangular mirror. When she examines it more closely, she sees that the filigree on the frame actually resembles what Malone describes as something similar to "ancient electronic circuits." Captivated, she buys it, not realizing it's actually a portal to another dimension—something we learn from the opening scenes, in which the mirror is recovered during an archaeological dig in the Middle East.

"It was sort of Alice through the looking glass, except like a dark version of that."

—William Malone, on *The Mirror*

It turns out that it's connected to a world that was once like Earth but is two thousand years in the future—a different dimensional plane. Long ago, machines took over and now exist as these gigantic, unmoving entities in search of a purpose. There is only an "organic sludge" left in their world, which they use to try to re-create people, but the results are all wrong, so they decide to abduct a man and woman from the Earth we know to have their own Adam and Eve, essentially. They sent the mirror as a portal between the two worlds, captured a male thousands of years earlier (time passes differently in the machine dimension), and now have their sights set on Julie.

"It was sort of Alice through the looking glass, except like a dark version of that," says Malone. "The film has one of these tragic endings where it winds up all good at the end and you go, 'Wait a minute, how did that

just happen?' It still kind of brings tears to my eyes when I think of it. It's a really cool idea, I think, and one I'm very excited about even now."

Giger got to work designing concept art for the film, and eventually Malone had a slick pitch book using the five aforementioned Giger titles he licensed to show potential investors. The filmmaker had also assembled a team that included producer Jack F. Murphy (*Syngenor, Ticks, Progeny*), who distributed *Scared to Death* in Canada; effects artist Doug Beswick (*Aliens, The Terminator, Blade*); and production designer Michael Novotny (*Flight of the Navigator, Terminator 2: Judgment Day, True Lies*). Their plan was to build the sets full size, about sixty feet high, to fully encapsulate the artist's ideas.

And some of the ideas are wild. Malone still has sculpts in his home that were created for the film, based on Giger's designs. While being interviewed, he disappears into a back room and returns with a dusty sculpt for one of the set pieces, which incorporates Satanic imagery in its depiction of a woman on an upside-down cross—based on *The Spell II*. The model is constructed from a variety of materials, including, oddly, wicker.

"You know, it's obviously got sort of the Satanist goat's head thing going on," he explains while pointing out one of the more Gigeresque elements. "But it's also got a sort of wicker [element]. It's kind of creepy. There's something creepy about wicker, right? . . . One of the things we learned from *Alien* when they did the Space Jockey, is that the stuff looks really great when you really build it, and that was a full-size set and I really wanted to do the same thing," says Malone. "I mean, look, just on a commercial level, you look at *Alien*—what sold that movie? It wasn't the smiley egg poster. It wasn't any of the shots they did of people on spaceships. It was that one shot that they put in the trailer of the Space Jockey, the beautiful shot that Ridley Scott did, pulling back and seeing that thing. And I remember being in that audience in that theater going, *What the hell is that?* And there it was. *I gotta see that movie.*"

Malone then produces another sculpt for one of the monsters: a demon whose pointed, legless back end resembles that of an earwig. He created this one himself.

"The basic shapes are based on Giger; it's fundamentally something I did, but certainly heavily influenced by Giger's artwork. And Giger liked this very much. . . . [The creature is] sort of designed after one of those earwigs we all hate when they come in our house. . . . This was going to be a full-size costume, it was supposed to be a guy in a suit. I think to this day that it's a good idea to marry practical effects with CGI."

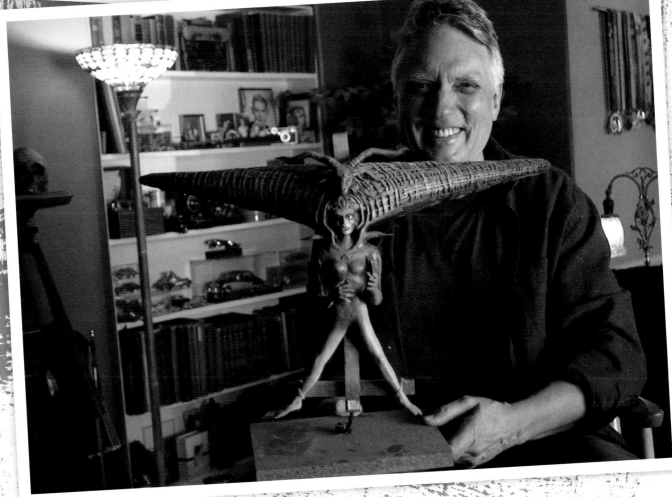

William Malone with polymer clay models he created for The Mirror: an earwig-like biomechanical creature (top), and the Bio Queen, based on H. R. Giger's painting Spell II (bottom).

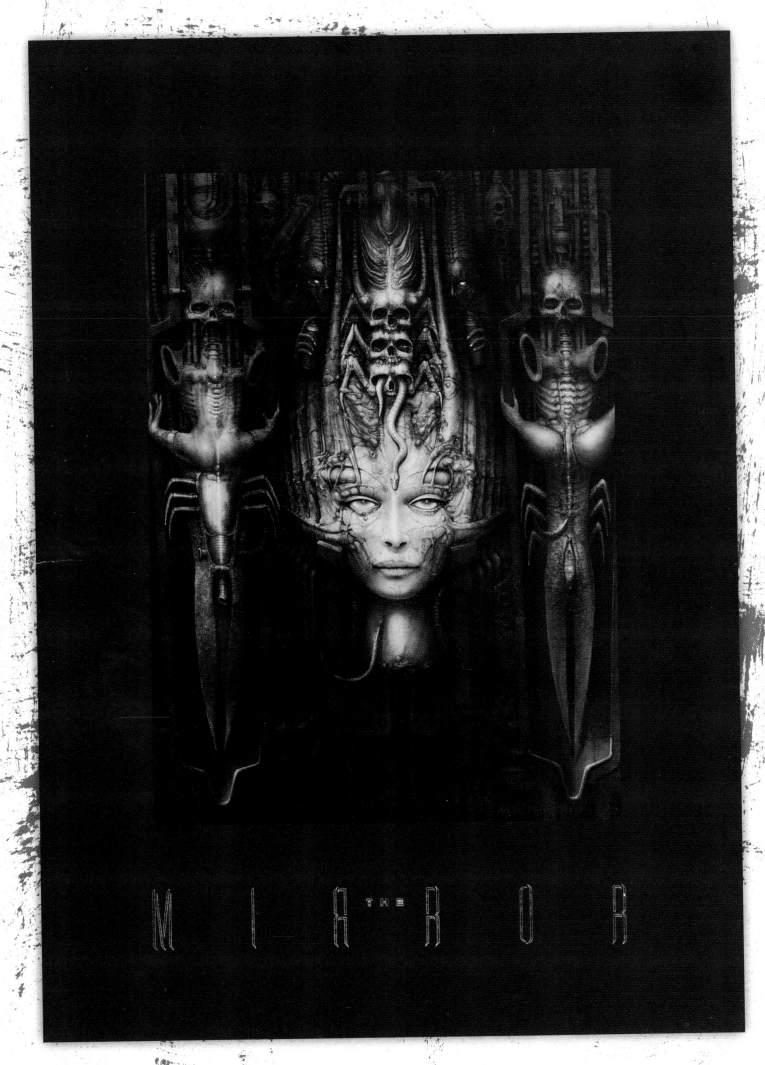

Cover for The Mirror sales brochure (1987), featuring H. R. Giger's Li II (1974),
which was licensed from the artist for the film.

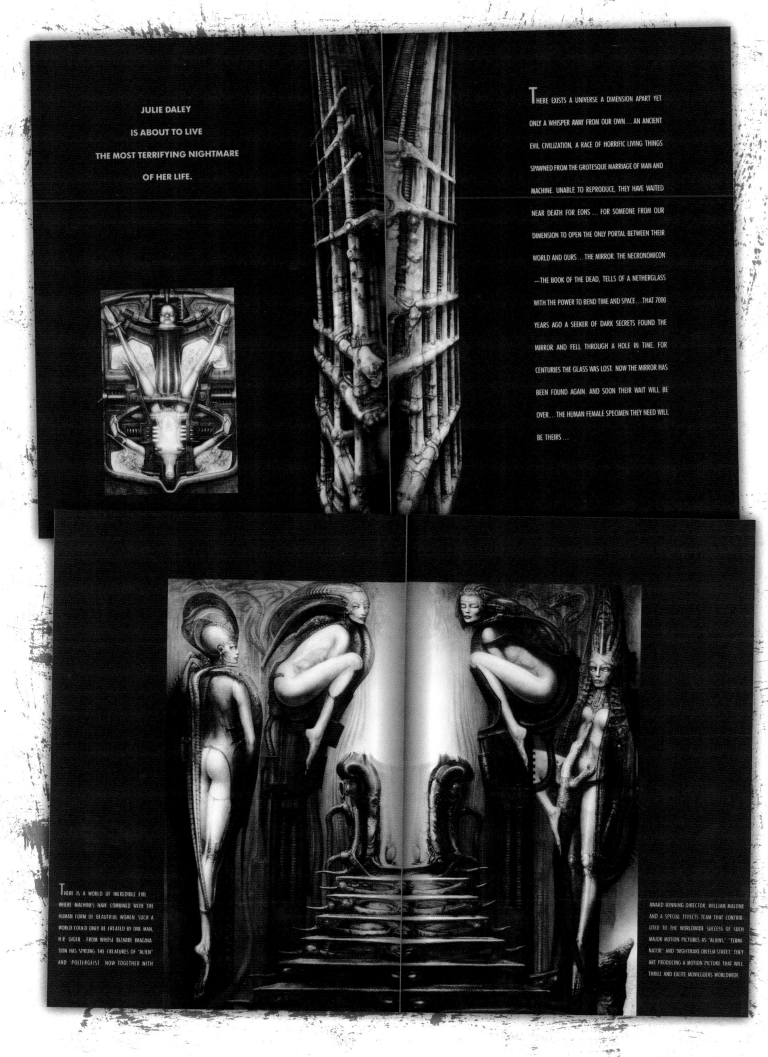

JULIE DALEY

IS ABOUT TO LIVE

THE MOST TERRIFYING NIGHTMARE

OF HER LIFE.

There exists a universe a dimension apart yet only a whisper away from our own ... an ancient evil civilization, a race of horrific living things spawned from the grotesque marriage of man and machine. Unable to reproduce, they have waited near death for eons ... for someone from our dimension to open the only portal between their world and ours ... the mirror. The Necronomicon—the book of the dead, tells of a netherglass with the power to bend time and space ... that 7000 years ago a seeker of dark secrets found the mirror and fell through a hole in time. For centuries the glass was lost. Now the mirror has been found again. And soon their wait will be over ... the human female specimen they need will be theirs ...

There is a world of incredible evil where machines have combined with the human form of beautiful women. Such a world could only be created by one man. H.R. Giger. From whose bizarre imagination has sprung the creatures of "Alien" and "Poltergeist." Now together with

award-winning director William Malone and a special effects team that contributed to the worldwide success of such major motion pictures as "Aliens," "Terminator," and "Nightmare on Elm Street." They are producing a motion picture that will thrill and excite moviegoers worldwide

Interior pages from The Mirror sales brochure featuring (top) the tag line and synopsis of the film, along with the image of H. R. Giger's Stillbirth Machine (1976), and (bottom) information on the creators alongside the image of Giger's Passage Temple (The Way of the Magician) (1975). The artwork was licensed from Giger.

Initially, the plan was to make the film independently for between $15 and $20 million, or as a studio picture for between $40 and $50 million. (Early on it had been pitched to Vista, when it was still titled *Deadly Images*, but the company decided to make *Fright Night* instead.) Just like with *Dead Star*, there was immediate strong interest in the project.

The May 1988 issue of *Cinefantastique* magazine did a feature on Giger and covered the then-upcoming film, which it describes as "a $6 million feature based upon the paintings in H. R. Giger's *The Necronomicon*, set to begin an 11-week production schedule in April." It also notes that half of the film's budget would be dedicated to special effects.

The Mirror was shaping up to be the Giger-influenced film everyone seemed to want. The artist himself was prepared to be hands on with the art, knowing that his ideas weren't going to get radically altered as they did with *Dead Star / Supernova*. He told *Cinefantastique*, "For me it's best when someone takes my images and brings them to life and I don't have to invent another thing. I hope to control everything. Otherwise, it never ends up looking like my stuff."

But then—as is often the case in Hollywood—things went sideways.

"We came very close," says Malone. "Orion Pictures was going to make it [but] I seem to always get in just as regimes are changing. It was going to get made and then [producer] Mike Medavoy—he was a great guy, he was gonna make it—suddenly was out and then things fell apart. It kept going like that. The picture kept getting really close to being made, and then, for whatever reason, it just didn't happen. It broke my heart."

Malone says his attempts to make a movie with Giger taught him several things. One is that, despite being called "the Dream Factory," Hollywood "doesn't have much of an imagination." And the other is that the industry didn't regard Giger in nearly the same way the art world does; the studio heads didn't connect with the confrontational subject matter.

> ## "*Alien* had been a number of years ago at that point, and I think the studios were afraid that there was going to be penises in every shot."
>
> —William Malone, on *The Mirror*

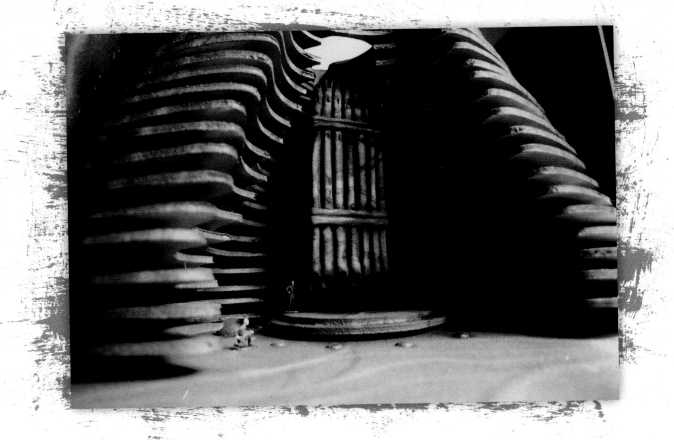

William Malone's now-destroyed model of the Thanatron—based on H. R. Giger's pipe organ–influenced design—was roughly three feet across and eighteen inches wide.



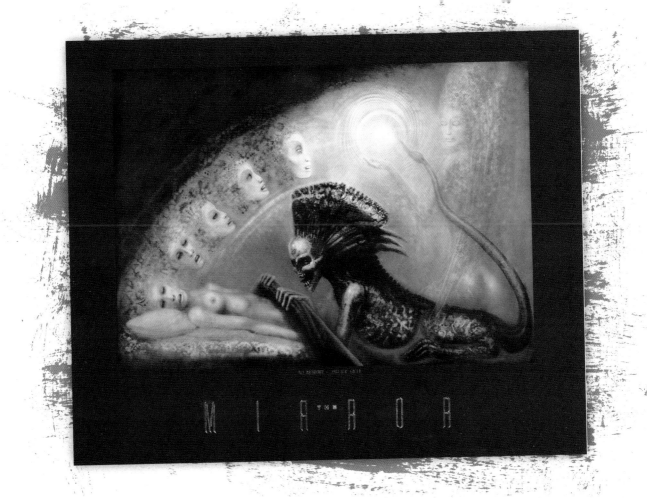

"When we brought this in, usually the executives would kind of give us a blank stare, which I didn't understand because this is, I think, some amazing artwork," says Malone. "Giger, he often felt like he was dismissed, like he was used and then he was just tossed aside, and that, I think, was very sad," he admits. "A lot of people sort of just dismissed his work, and the studios were sadly to blame on some of that too. They would hire him for a little bit. He'd come in and do designs and they'd send them away. And if you look at the best stuff he's done, like the *Alien* stuff, he was there building that stuff. He built the Space Jockey, he was the guy—of course they had a team of people—but he was there painting it and sculpting it and s o forth."

In the decades that followed *Alien*, Giger had be-come increasingly bitter toward Hollywood, and for good reason. Aside from *Dead Star* and *The Mirror*, he was bewildered that he wasn't asked to work in the *Alien* sequels, he had bad experiences working on *Poltergeist II* and *Species II*, and he'd done extensive conceptual art and sculpts for big-profile unrealized projects such as *The Tourist* and Ridley Scott's *The Train* (later titled *Isobar*, and then *The ISOBAR Run*)—from which some of the artist's work was later repurposed for *Species*.

Attempts to find a home for *The Mirror* eventually fizzled, and Malone didn't stay in contact with Giger much in the decade after the door closed on the project. He hadn't talked to him in about a decade when,

in 2014, the artist took a fall and died in the hospital at age seventy-four.

Yet Malone hasn't entirely given up on *The Mirror*. He feels that with current technology bringing down the cost of FX, the cult fan base for Giger's work, and relaxed attitudes toward his provocative visuals, the film is more viable than ever.

"I think it's a better project now for numerous reasons," he says. "I think that when I was trying to make it, Giger had sort of fallen out of favor in Hollywood. *Alien* had been a number of years ago at that point, and I think the studios were afraid that there was going to be penises in every shot. Which wasn't the case. But he's got a lot of phallic stuff in his art, people are afraid of that. I think now it would be a much easier film to get made, because you could do a bunch of stuff with CG that would make it really big, and you could still do the full-size stuff and make a really amazing film out of it."

That said, Malone believes *The Mirror* will always encapsulate the essential disturbing nature of Giger's work.

"I think a lot of the imagery in *The Mirror* is very dangerous," he allows, "and just Giger himself—his artwork is dangerous. I think alone that is enough that people should be making this film. . . . What Giger did was he was able to reach into your mind, pull out those dark corners, and bring them into the light. I think that was his genius, really."

H. R. Giger's Der Tod *(1977), licensed for* The Mirror, *as depicted in the sales brochure.*

BRIAN YUZNA'S
RE-ANIMATOR SEQUELS

The ongoing quest to continue
one of the wildest franchises in horror history

INTERVIEWS WITH BRIAN YUZNA, JOHN PENNEY, RICHARD RAAPHORST, AND STEVE JOHNSTON

Ask any horror movie fan to name the best H. P. Lovecraft adaptation and you'll likely get the answer "*Re-Animator*—duh!" The author's work often relies on ancient cosmic horrors that are unearthly, unspeakable, and largely unfathomable without descending into madness—monstrosities that flourish in the theater of the mind better than they do on the big screen. Instead of tackling cosmic creatures or ancient cults, however, *Re-Animator* explores the concept of bringing the dead back to life through the miracles of mad science.

The film opens at the University of Zurich with Dr. Herbert West (Jeffrey Combs) bringing his professor, Dr. Hans Gruber, back to life with gruesome results. He then ends up in America at the fictional Miskatonic University, where he becomes the roommate of fellow medical student Dan Cain (Bruce Abbott). Together they use Herbert's reagent to bring the dead back to life—albeit as violent, uncontrollable zombies—including Dr. Halsey, who is the father of Dan's girlfriend Meg (Barbara Crampton) and was accidentally killed by one of their test subjects. Their work catches the attention of the depraved Dr. Hill (David Gale), who wants it for his own nefarious uses and ends up going after Dan, Herbert, and Meg—even after getting decapitated!

Re-Animator goes batshit bonkers with the concept, delivering zombie mayhem that's an orgy of outrageous

special effects, unforgettable characters, absurd humor, and perfect pacing. Directed by Stuart Gordon, written by Dennis Paoli, and produced by Brian Yuzna, it became a cult hit after it was released in 1985, finding a loyal fan base in the then-booming home video market. Two sequels followed: *Bride of Re-Animator* (1990) and *Beyond Re-Animator* (2003), both directed by Yuzna.

The roots of the series go back to the late '70s, when Yuzna wrote and directed an amateur (and unreleased) feature on 16 mm called *Self-Portrait in Brains*, about an artist who kills himself, splattering the contents of his skull across a canvas and then becoming a hologram. That stoked the budding filmmaker's interest in making genre projects, which led him to seek out a director to collaborate with on a professional feature.

"I wanted to make a horror movie, and I put an ad in *Variety*—a small ad—saying, 'Needed: a horror movie director,' and I got a whole bunch of replies," he recalls.

This eventually led him to Gordon, who was directing experimental, sometimes controversial, live theater in Chicago. Gordon wanted to turn *Re-Animator* into a TV series at the time and already had a fifty-page script. Although series dominate the entertainment landscape now, back then, features were a booming business, particularly genre material.

"There's a lot of *Re-Animator* stories that will never get shot."

—*Re-Animator* creator Brian Yuzna

"We developed that script into a movie, and within one year we were shooting it," says Yuzna. "So that was the first *Re-Animator* movie, and after that I made the second one, also in LA here. And then I made a third one some years later in Spain."

Yuzna has been the reagent keeping the *Re-Animator* franchise alive over the decades, trying repeatedly to expand even further upon its Lovecraftian misadventures. In fact, there are more unmade *Re-Animator* films than ones that got made.

"There's a lot of *Re-Animator* stories that will never get shot," confirms Yuzna. "I always wished that I could do a comic book, or a graphic novel type of comic book, to include those movies plus the in-between stuff because I spent a lot of time on this and I've had many different versions of how it goes. *The Bride of*

Re-Animator was always, from the beginning, when Stuart and I talked about a sequel, it was gonna be *Bride of Re-Animator*, but at that time it was gonna take off exactly from where this first one ended—well, with an ellipse. Cain is on the lam and he's got the reanimated Meg in a basement where he works as a super, and she's chained to the bed, she's kind of out of control. And then they end up getting grabbed by some men in black and taken to the White House, because the president needs to be reanimated, and it becomes kind of *House of Re-Animator*."

If you've been dying for more *Re-Animator*, you're likely familiar with the title *House of Re-Animator*, which would almost become its own film years later. Though that presidential concept was nearly the locus of *Bride of Re-Animator*, things changed again as Yuzna, Gordon, and Paoli worked on the sequel.

Re-Animator film series creator Brian Yuzna.

"This time it took place in a mortuary, where [Dan and Herbert] had jobs, and once again Meg gets brought back," says Yuzna. "And, as we were working on it, I got the financing requirements for it, which meant that we had to shoot the first week of June—must've been eighty-nine—and this was January."

At that point, the trio had a treatment, but Gordon was busy working on *Robot Jox* (1989) and didn't have the time to see the project through on such a tight schedule. But Yuzna was bound to the timeline due to the Japanese investors who needed the movie completed by the end of spring. The nature of film investment is highly unstable due to many factors, and *Bride of Re-Animator* required not only a less-than-six-month turnaround, but the money also came with other conditions in terms of content, and Yuzna quickly realized the current incarnation of the story simply wasn't going to work.

That's when he went to Woody Keith and Rick Fry, who wrote his 1989 class-critique body horror film *Society*.

"I said, 'Hey, let's come up with something,' and so within probably eight or ten weeks we ended up not only inventing the story but writing a script," remembers Yuzna. "We got a first draft on May first when the office opened for preproduction."

The version of *Bride of Re-Animator* that made its festival premiere in 1989 brings back Abbott, Combs, and Gale in a story that sees Dan and Herbert dodging a suspicious cop while once again experimenting with reanimating agent and discovering that parts of bodies can also be revived. They find assorted corpse bits from the massacre that happened in the first film, which leads to the expected mad-science mayhem, including grave robbing, an attempt to transplant Meg's heart into a stitched-together body, Dr. Gale's head flying around via bat wings, and a zombie army chasing Dan and Herbert into a cemetery.

"I think the only thing that really survived from the mortuary [version of the script] was I had always wanted to do this finger-eye creature," says Yuzna. "I don't know why. You know, in the Lovecraft stories they say that Lovecraft had . . . a sick imagination about messing with body parts, which I ended up calling 'doodling with body parts.'"

That earlier version also didn't have Dr. Hill in it. His character returned thanks to Gale, who got wind that Yuzna was working on a sequel and called him up. He wanted to know why he wouldn't be in the sequel. Yuzna recalls that the actor was undeterred by the fact that there wasn't much left of his character at the end of *Re-Animator*.

"I said, 'Well, I don't know, you were blown up, your head was squished.' He said, 'I got some ideas!' I thought, wow, he's so enthusiastic, let's get him in there. And so he ended up having the bat wings and all that."

Yuzna wanted to continue the *Re-Animator* franchise and finally got his opportunity in the early 2000s when he got involved with the Spanish film company Fantastic Factory and moved to Barcelona, where he'd reside for about a decade, producing movies such as *Arachnid*, *Dagon* (another Lovecraft adaptation directed by Gordon), and *Rottweiler* (which Yuzna also directed). The film that sealed the multipicture deal, however, was a third *Re-Animator* movie, which he got to work on before packing his bags for Europe. Realizing he had mined most of the elements from the Lovecraftian source material, he thought about what could logically happen next to his characters. Yuzna turned to John Penney, who had written one of his previous films, 1993's *Return of the Living Dead 3*.

"The first *Re-Animator* project I worked on was eons ago when I was doing *Return of the Living Dead 3*," recalls Penney. "Brian said, 'Hey, do you have any thoughts on a *Re-Animator* sequel?' And I had one idea of Herbert West being in jail and saying, 'The one thing I haven't been able to do is trap a soul.' . . . And that was the only thing from my original treatment that I wrote which ended up in the third *Re-Animator* movie."

Though Penney's pitch didn't move past the basic treatment stage, Yuzna was inspired by the concept of West in jail and ran with it in a different direction.

"I thought, well, they're gonna get busted," says Yuzna. "They might've gotten away with the first thing, which I call the Miskatonic Massacre—they got out of there, nobody knows what happened—but they're not gonna really get away the second time, with the whole crypt and all that. So I figured they'd get arrested, and then I thought, well, actually Dan Cain should send West up, he should be angry. And so he should go state's evidence in return for the notes and maybe some serum."

In this version of *Beyond Re-Animator*, Dan is a successful transplant surgeon whose secret is that he's using a little bit of the existing reanimation serum so the recipient bodies won't reject the transplants. Despite having West's notes, though, he's been unable to replicate the fluid in his lab.

"It always blows up and it doesn't work, and he's an alcoholic, and he's a womanizer, and he's gotten kinda corrupt," says Yuzna, describing the character's downturn.

The plot saw the district attorney who had kept Dan out of prison now running for office, but her campaign is in jeopardy when her lover is murdered by a serial killer. She then tells Dan he has to reanimate the dead woman so she can tell them who killed her, which forces him to spring Herbert so he can help him.

"It was still based on the idea that in prison West had been doing experiments on rats and finding out that the reason why reanimated subjects don't behave well, no matter how fresh the subject, is because there's this stuff that leaves the body upon death, this nanoplasmic energy, and the nanoplasmic energy just evaporates from the body when your body loses weight, which is actually a fact when you die. So the idea was that this is the stuff that tells the cells how to grow, so if you don't have it in your body, and somebody gets reanimated . . . they're just wearing out, there's nothing creative in their body, they're zombies to one degree or another. So that was the gimmick."

Once Yuzna actually got to Spain, though, he realized the *Re-Animator* sequel he wanted to make might not be the *Re-Animator* sequel that made sense. First off, trying to get that part of the world to pass for the US was going to be difficult, so he decided to reinvent the story as a prison movie. Secondly, he felt that he needed more youthful main characters. ("Twelve

years had gone by, and I thought maybe it's not a good idea to have the movie be about two fifty-year-old guys," he reasons.) *Re-Animator* fans love Combs's madcap portrayal of West, so he had to stay, and that meant replacing Abbott. So a new character named Dr. Howard Phillips (Jason Barry) was brought in as the prison doctor to be West's foil—not to mention an obvious nod to Howard Phillips Lovecraft.

The finished film—scripted by José Manuel Gómez and based on a story by Miguel Tejada-Flores (*Fright Night Part 2*, *Frankenstein's Army*, and the *Revenge of the Nerds* series!)—sees Herbert in prison, where he's been for the past thirteen years. Here he uses what lab supplies he can scrape together to carry out low-level versions of his experiments on rats, in the process discovering that electricity can be used to extract nanoplasmic energy that can be stored in a vial and used to reanimate the dead but restore them to nearly their former selves instead of mindless, murderous zombies. When Phillips arrives as the new prison doctor, his fascination with Herbert's work sees him providing the necessary equipment to take it to the next level. But then the evil warden's attempts to seduce Phillips's girlfriend result in fresh corpses, and things spin out of control as the new reagent is put into action on humans and causes new side effects. The film ends with a full-on prison riot and bodies in various states of reanimation.

Concept sketches for an earlier version of Beyond Re-Animator show Herbert West injecting himself with reagent in an attempt to become immortal (left), and a reanimated prisoner in the electric chair (right).

After this, Yuzna wanted to wrap up the *Re-Animator* franchise with a second trilogy. The first of them would be *House of Re-Animator*, news of which appeared online in 2006. It was to have Gordon and Paoli return as director and writer, respectively, and feature William H. Macy as the president of the United States. In it, Macy would play a George W. Bush–like commander in chief who dies and must be revived by the only man for the job: Herbert West. Combs would return as West and Abbott as Cain.

"At one point we got William Macy to sign a letter to be the president, and we thought, this should be a no-brainer," says Yuzna.

The second film in this new trilogy, *Island of Re-Animator*, was to be a sort of riff on *The Island of Dr. Moreau*. Herbert would be secluded on an island, with a state-of-the-art laboratory, which would lead to horrors on a much larger scale.

Yuzna explains, "Herbert has a lab that has everything he ever wanted and would take us into the Lovecraftian area, because 'Re-Animator' was never really a Lovecraft story, it's just kinda a horror story that he wrote in a mercenary way, and it doesn't in any way tap into the stuff that we identify with Lovecraft."

The filmmaker asked Richard Raaphorst—the concept artist who did title designs for *Faust*, *Dagon*, *Beyond Re-Animator*, and *Rottweiler*—to come up with some concept art for the movie.

"I was really intrigued by the fourth installment because there was no script yet. I got carte blanche, and started to work from scratch with just the title in mind: *Island of the Re-Animator*. I designed an island where Herbert West was using a new technology where he was seeding body parts contained with the reagent so he could grow meat-flesh trees complete with body parts, etc. He could then harvest the different parts to create a new species of undead."

Some of the concept art Raaphorst envisioned anticipates his own 2013 feature *Frankenstein's Army*, while also recalling *Society*. His imagery depicts body parts growing out of the ground, a biomechanical creepy-crawly creature that dispenses reanimating agent, someone whose head is essentially a bundle of needles, people with brains hanging off of their bodies in tanks, a biomechanical behemoth with swappable appendages, a monolith made out of limbs, and even West giving himself a head transplant!

Yuzna felt the designs were just "too out there" for the world of *Re-Animator*, however, and that was the end of that.

Concept art for House of Re-Animator *depicts Herbert West in a suit and tie, armed with reagent guns.*

"Twelve years had gone by, and I thought maybe it's not a good idea to have the movie be about two fifty-year-old guys."

—Brian Yuzna, on *Beyond Re-Animator*

"When Brian doesn't like an idea, he doesn't respond," says Raaphorst, laughing.

This new trilogy would have come full circle with *Re-Animator Begins*, in which a young female doctor rescues an amnesiac Herbert from an asylum and brings him to Zurich. We learn she's the granddaughter of Hans Gruber—from the opening scene of the first *Re-Animator*—and he's still alive in the basement. The intent was to pass the *Re-Animator* torch to her.

Richard Raaphorst created dozens of surreal images for Island of Re-Animator, much of which was simply too much for producer Brian Yuzna, including a cyborg creature with a penis that shoots reagent into its victims, a baby and various body parts grown in a garden or in "walking wombs," and the equine-legged "horse rotorvator," the purpose of which the artist is unsure of but says it came to him "in a bad trip."

"It's kinda a prequel to the original, except she ends up being the one," says Yuzna.

In 2006 news surfaced online that *House of Re-Animator* was in the works with Macy and the original cast and crew, and horror fans went nuts. News stories, speculation on message boards, and fan art all helped create a buzz. Yuzna thought he had a slam dunk on his hands.

"I thought, well, I can finance this," he recalls. "We made up a whole package and I went and thought for *House of Re-Animator* I'll get Stuart and Dennis and get Bruce Abbott and get Barbara Crampton and just bring back the people from the first one, and that would get a lot of attention, and then do the island one and move on from there. I thought I should be able to finance that, and it didn't work out that way. We tried, we went to the markets, we got some interest, but, you know, it just never [worked out]."

Undefeated, Yuzna then tried to get just *House of Re-Animator* made as a standalone movie. It was almost financed but fell through at the last moment, as so many movie deals do. He says that one of the problems was the film's above-the-line costs for cast and crew. Bringing back Gordon, Paoli, and the original core cast, plus adding Macy, made the movie too expensive at the end of the day. And there was a bigger problem . . .

"Then we had the Great Recession, and everything collapsed," says Yuzna, with a sigh.

Ironically, the final nail in the coffin for *House of Re-Animator* was in part Dubya himself, as the Bush administration was responsible for many of the policies that led to the Great Recession of 2007–8.

"I quit with the three and decided I just need something like *Beyond Re-Animator*, where I can do it with Jeffrey so there's only two mouths to feed instead of five or six," says Yuzna. "And then of course it turns out, as things evolved, everything is cable now and so by the time 2010, 2011, 2012 [came around], the independent movie business—which is what I was in for my whole time making movies—it kinda died. Video was dead and everything was streaming, and everything had been consolidated into these big streaming services, cable companies. And so the markets had just shrunk to almost nothing and it was very difficult to finance a movie independently because it was very difficult to show how you could recoup. That's when people started making $100,000, $200,000, $300,000 movies, and of course with the new technology you could really make a movie cheap, technically."

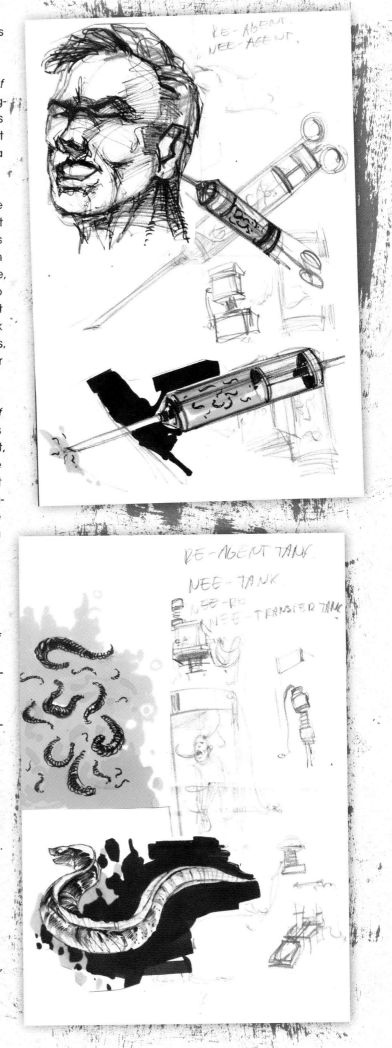

Art for a *Beyond Re-Animator* idea that Brian Yuzna wasn't able to fit into the finished film: a new variant of reagent containing "NEE"—an extract from electric eels.

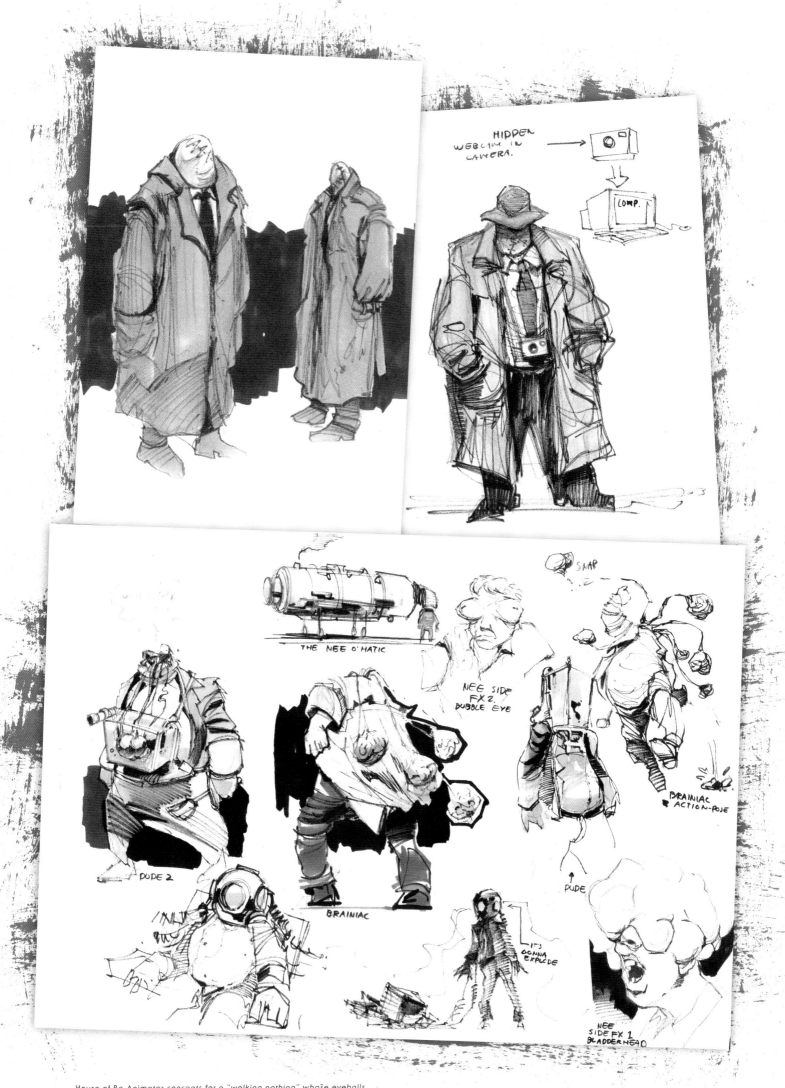

Within the image, the following labels appear:

HIDDEN WEBCAM IN CAMERA.

COMP.

THE NEE O'MATIC

SNAP

NEE SIDE FX 2. BUBBLE EYE

BRAINIAC ACTION-POSE

DUDE 2

BRAINIAC

DUDE

IT'S GONNA EXPLODE

NEE SIDE FX 1 BLADDERHEAD

House of Re-Animator concepts for a "walking nothing" whose eyeballs, ears, and nose were stolen by Herbert West for an experiment. The creature carries some of its external organs and has cameras implanted in it, which West would use for surveillance.

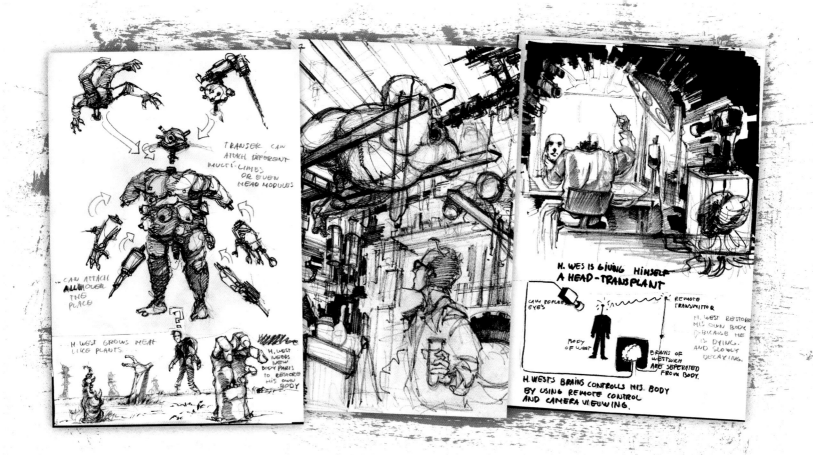

In the image, the following handwritten annotations appear:

TRANSER CAN ATTACH DIFFERENT MULTI-LIMBS OR EVEN HEAD MODULES

CAN ATTACH ALL OVER THE PLACE

H. WEST GROWS MEAT LIKE PLANTS

H. WEST NEEDS NEW BODY PARTS TO RESTORE HIS OWN BODY

H. WEST IS GIVING HIMSELF A HEAD-TRANSPLANT

CAN REPLACE EYES

REMOTE TRANSMITTER

H. WEST RESTORE HIS OWN BODY BECAUSE HE IS DYING. AND SLOWLY DECAYING.

BODY OF WEST

BRAINS OF WEST WEN ARE SEPERATED FROM BODY.

H. WEST'S BRAINS CONTROLLS HIS BODY BY USING REMOTE CONTROL AND CAMERA VIEWING.

If it isn't apparent by now, genre films such as the *Re-Animator* movies don't drive the market as much as they are driven by it. Yuzna understands this better than most, and once again he was faced with a new reality to adapt to in his attempts to bring back Herbert West. Plus, after living overseas for fifteen years, the director realized he'd lost many of his connections stateside. In many ways he was starting over.

So why not start over creatively too, and pitch a reboot?

In the early 2010s, Yuzna called up Penney to help him reimagine *Re-Animator* from the ground up.

"Brian's idea was, let's take *Re-Animator* and *Bride of Re-Animator* and make it one big story," explains Penney. "And I said, well, that's great because I always felt there was more to be said about Dan that happened in *Bride of Re-Animator* in terms of him trying to, you know, get back the lost love of his life. So we kind of took both of those scripts and we sort of broke them all down and rebuilt it as one movie, and it has a pretty nice arc all the way through for Dan, and that worked really well as a reboot."

The idea was to have the film set in the present day with an all-new young cast. The story would follow the new Dan Cain as he loses his girlfriend and then attempts to bring her back to life with the help of the new Herbert West.

"We drew a much closer thread of story between him trying to bring his girlfriend back in the first movie, which is why we started blending in stuff from *Bride of Re-Animator*," states Penney. "That script went all over Hollywood. My manager took it everywhere and we had interest from a few places, one of them was Mosaic and the other was Warner Bros. . . . We took meetings with them and it became really clear, really quick, that what they were interested in doing is taking just the name *Re-Animator* and then basically doing a whole new reboot. Warner Bros. wanted to go much more serious."

Penney says it became clear that most studios just didn't understand what actually makes it work. As he and Yuzna pitched the project over the course of the week, they began to really understand the core of *Re-Animator* and knew they had to preserve it.

"When we were looking at the structure and the plotting and the characters of *Re-Animator*, we realized that if you're going to reboot it, the one thing that makes *Re-Animator Re-Animator* is the tone and the slightly dark comedic [style]. . . . Things start unraveling, one thing unravels and another thing unravels, everything starts tumbling apart. It's sort of a cascading effect. And there's that whole notion of West making these decisions that seem perfectly sensible in his mind. . . . What's unique is the character of West, the tone, and the way that West drives this engine of chaos. What we really decided on that week was that what we needed to preserve was that. And all the feedback we got was 'Well, we don't see that as something we're going to pursue. We don't want to take that dark comedy or that sort of uncomfortably strange and out-there kind of humor. We just want to go with it, completely reimagine it as just a dark horror movie.'"

Richard Raaphorst imagined Herbert West's mad science completely unhinged in Island of Re-Animator and drew concepts for (from left to right) swappable body parts grown in a field, a lavish laboratory in which to make monstrosities, and a scene where the doctor gives himself a head transplant.

"Brian's idea was, let's take *Re-Animator* and *Bride of Re-Animator* and make it one big story."

—Screenwriter John Penney, on trying to reboot *Re-Animator*

It's no secret horror fans are a nostalgic bunch, and they want to see their favorite actors back in those iconic roles. With that in mind, Yuzna decided to turn to something he'd had simmering on the back burner for a while: an all-new sequel that would conclude the series with those familiar characters but also create a springboard for something entirely fresh and hopefully with it a whole new fan base for *Re-Animator*. He enlisted another writer, Steve Johnston, to use his ideas and take a crack at it.

The two of them had met through Mike Muscal, who went to college with Yuzna and was the production manager on *Re-Animator* and a coproducer on *Bride of Re-Animator*. In the first half of the '00s he produced three serial killer movies—*Ed Gein* (2000), *Ted Bundy* (2002), and *The Hillside Strangler* (2004)—that were penned by Johnston. The writer saw exactly how this new movie needed to function.

"This is the thing that's meant to bring the Herbert West story to a conclusion and the story of Herbert and Dan Cain to a conclusion, and also to be a satisfying conclusion for the fans," says Johnston. "You know,

I very much count myself first and foremost a fan. In fact, I remember I saw the very first *Re-Animator* at Rivertowne theater in Southeast Washington DC when I was in high school. . . . So it was always kind of very important to me that I make *that* person happy."

The script was titled *Re-Animator Unbound*, and the concept was shaping up to be the most ambitious entry in the series yet. Yuzna wanted to incorporate some of his previous sequel ideas into the story as well. The beginning of the movie would flash back to West at the White House, preserving a remnant of *House of Re-Animator*, before flashing forward to an island, which would pick up the *Island of Re-Animator* concept.

"I had this kind of idea of going back to the roots of the zombie genre, to the old stuff like *White Zombie* or *I Walked with a Zombie*. . . . I thought there would be something inherently thoughtful about the idea of Herbert West on an island—a Caribbean island, and introducing the original concept of the Caribbean zombies with also kind of a tie-in with *The Island of Dr. Moreau*."

Unused concepts for Beyond Re-Animator envisioned West having a group of pathetic experiments that he'd kept alive, using various junk parts such as a children's bike to keep them mobile. Yuzna loved the idea but couldn't fit it into the film.

Monoliths used for growing body parts in Island of Re-Animator (top), and House of Re-Animator zombies used to attack others with reagent in order to create an undead army (bottom).

Yuzna elaborates: "I always liked that idea, because then he could have this huge compound and I wanted him to have a particle collider and I wanted it to go into the Lovecraftian dimension. And I just wanted to see West with a lab where he's not always scraping, because every movie he doesn't have the stuff, he's gotta steal the equipment, he's in prison, he can only experiment on rats. So this time I wanted him to have every [piece of] equipment he could and see what happens."

The opening scene at the White House would explain how West found himself in such a sweet spot. Because of what he knows about the reanimated president, the government gives him what he wants and sequesters him far away. And what could possibly be more dangerous than Herbert West left to his own devices in a fully stocked laboratory? This concept is how the story could truly live up to its title.

"It's more than a title, it's like a mission statement: *Re-Animator Unbound*!" exclaims Johnston. "Where would West's science ultimately take him if he was truly trying to solve the problem of death? Where would that *really* take him? And so we had this idea of him in this state-of-the-art lab, and just also bringing the whole idea to [its] conclusion that the first one starts with him conducting experiments in this dingy basement. . . . And of course, if you're the United States military, you would have great interest in what Herbert West could do. How might this science be applied to military technology? We toyed around a lot with just the notion of the evolution of his science and . . . attempted creation of basically indestructible soldiers."

Yuzna also wanted to go back to the idea of West needing to capture energy from the body, which he'd wanted to focus on more in the original version of *Beyond Re-Animator*. Here, Herbert again would be playing around with NPE.

"West calls it the nanoplasmic energy," explains Yuzna. "Other people call it the soul. It depends on your point of view. And so I think when the subatomic accident happens in *Unbound*, the effects of it—West has a physics explanation, the indigenous [people] have a voodoo explanation for it—it's been prophesied. It's part of the mythology: 'The Old Ones are coming, the Old Gods.'"

"What was always kind of fun about the original *Re-Animator* was you had this sort of brilliant mad scientist but anytime he had success, there was the law of unintended consequences, where inevitably something would go terribly wrong," notes Johnston. "So with the idea of *Re-Animator Unbound*, if he succeeds on one level, well, what could then

go horrifically wrong? Well, maybe he actually rips a hole in space and time and unleashes Cthulhu."

A government conspiracy, a high-tech lab in the Caribbean, Moreau-like experiments, supersoldiers, the Great Old Ones—something so ambitious needed wrangling, which is where Penney came back in. Yuzna and Johnston gave him what they'd been working on so he could help shape it.

"I said, 'You have about three or four different movies going on in here, it just needs some sort of spine, some way of organizing the ideas, which I think are so fantastic,' and so I basically pitched the notion of sort of like an *Apocalypse Now* kind of structure," remembers Penney.

> ## "I wanted him to have a particle collider and I wanted it to go into the Lovecraftian dimension. And I just wanted to see West with a lab where he's not always scraping."
>
> —Brian Yuzna, on *Re-Animator Unbound*

The first thing he did was change the setting from a tropical island to eastern Europe, not for creative reasons but because this is where potential funding for the film was now becoming available. However, it also felt more natural for his next change: homing in on the military angle. West has gotten a collider to play with and indeed created an interdimensional hole, which calls for a special mission.

"There's this big accident that happens in this facility, and a team of people have to get together and go and venture into this [place]," says Penney. "There's a cyclical storm that's occurring that keeps people out of this area, but there's this government group of people that go in upriver and find the madman, basically, and put an end to all of this, shut it down. So that was sort of the structure. And so we follow the group that goes upriver, and of course one of them turns out to be Dan."

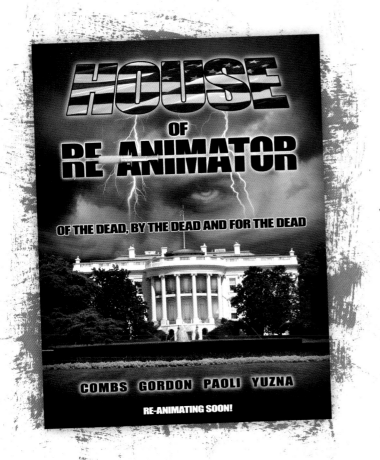

It was important to all of the writers that *Re-Animator* fans finally got the big showdown between Dan and Herbert, but they also wanted to introduce a key new character that would then go on to star in a *Re-Animator* TV series (a reflection of the boom in television over the past decade).

"There's not a scene in that script that doesn't have some crazy thing going on," boasts Penney. "After finishing working on it, I kind of looked back and said, 'Oh . . . what we did was similar to what *The Force Awakens* did, which is it dealt with the original legacy characters. But we also set a path so that the whole series could move forward with *She-Animator*."

That's right: the future of *Re-Animator* is female. And while the timing is appropriate for the rise of female protagonists in the wake of #metoo, it's an idea that predated the movement by several years. Yuzna wasn't necessarily trying to make a big statement either, he just loves the concept—not to mention that satisfying title.

"I think you cannot but reflect the times you're in, but I'm not interested in doing a political movie or a social commentary movie," he admits. "That's not what I'm looking to do. I think whatever era you're in, you're gonna reflect that, just like in the 1950s [when] everything had to do with nuclear atom accidents. . . . I kinda feel like the best entertainment isn't consciously making points, I think that's a different type of movie. Plus, I think that sci-fi deals with politics almost naturally. But horror, to me, deals with psychology, religion, sexuality, mortality. . . . I think *Re-Animator* is a horror

movie. And the *She-Animator* thing, I think, is just a natural thing to do, it's not meant to be—it's just that you're gonna pass the torch, why not pass it to a woman?"

So where does that leave the *Re-Animator* franchise at the time of this writing? As *Re-Animator Unbound* was evolving, the film world was also undergoing seismic shifts, and continues to do so.

"The marketplace has changed so significantly that ten years ago you could approach people, there were companies that routinely would make movies for $7 million or $8 million," explains Johnston. "All of a sudden everything contracted and you have to make movies for, like, $100,000—or for $50 million. Thankfully, with all of these streaming [outlets] like Shudder, Netflix, and all these things, everything's kind of bounced back a little bit. So there is a market for movies that are budgeted more in the few-million-dollar range, but it can still be a hard sell."

Despite having a dedicated fan base for the existing trilogy—people who travel to conventions to meet the cast and crew of the films, who seek out the multiple special edition reissues of the movies, and who buy spinoff merchandise such as T-shirts, action figures, and comic books—Yuzna believes it's never been more difficult to find a new audience for a *Re-Animator* movie.

"I think that the audience for another one probably had never seen any of them," he offers. "They've maybe heard of it. So you're dealing with an audience that knows nothing about it, and if you're only gonna make it for the fans—the hardcore fans that we all meet when we go to conventions and everything—then you better make it for about $250,000, because that's what that audience will support. But if you wanna try to make a bigger budget, then I think you've got to think. There are certain things that you can't do today. Certainly a lot of the more exploitative sexual stuff doesn't play."

Then there's what Johnston calls the "esoteric nature" of *Re-Animator*—the unique blend of horror, humor, gore, and Lovecraftian fiction that makes it a known property yet tough to fit in a nice salable package.

"You end up with this type of appreciation," says Penney. "Everyone loves the title, everyone loves the idea of doing it, but no one knows what to do with it. Except for Brian."

Luckily for fans that have embraced the world of *Re-Animator* over the past thirty-five years, Yuzna hasn't given up on bringing it to both the big and small screen—demonstrating the same crazed tenacity as Herbert West himself when it comes to reviving his franchise.

Film market sell sheet used to pitch House of Re-Animator.

Concept art (not by Raaphorst) for Re-Animator Unbound, including zombie soldiers, Herbert West attacked by his own creations, and even a baby Herbert West.
Copyright Brian Yuzna.

ROBERT PARIGI'S
CHROME GOTHIC

Mean machines, mad science, and vehicular body horror in the wastelands—the twisted metal romance that wasn't meant to be . . . yet

INTERVIEW WITH ROBERT PARIGI

As a producer on the show *Agents of S.H.I.E.L.D.* and a writer on *Helstrom*, Robert Parigi has been helping shape the mighty MCU as of late, but when he first arrived in Hollywood in the 1990s, he spent most of his time behind the wheel. These seemingly endless hours on the road sparked the idea for what might be the wildest cult film never made.

"I was working full time as a production assistant driving all over Los Angeles and just spending hours in my car," he recalls. "And I sort of came up with the idea for *Chrome Gothic* one night when I was driving, maybe three in the morning, when I had to drive around videotapes to deliver them to executives. And I was falling asleep at the wheel, so I suddenly had this strange idea that I had to keep driving in order to live and if I stopped driving I would die, because of course your brain's all messed up with sleep deprivation. And I was thinking, *that's an awesome idea*—that you're driving and your driving is what keeps you alive. And so I got home and I instantly started putting some ideas down on paper for that."

Having moved from pedestrian-oriented New York—where he was doing graduate studies in philosophy

until a double bill of *Evil Dead* and *Re-Animator* reminded him his true calling was cinema—Parigi was struck by just how much the lives of Angelenos were shaped by their vehicles.

"It changes your entire perception of the world and even of your own body," he observes. "Your body envelope expands to include the technology that you use."

He started to think about how literal that concept could be, and, inspired by the body horror of David Cronenberg, Parigi set out to write a genre movie that smashed together several of his own obsessions. Perhaps the strongest of those is automotive. Parigi has long loved hot rods, particularly the Kustom Kulture aesthetic that appeared in the 1960s, embodied by the creations of Ed "Big Daddy" Roth (notably his Rat Fink character), and bled into monster kid culture in the form of Aurora and Revell model kits, the Hanna-Barbera cartoon *Wacky Races*, and the Munster Koach from *The Munsters*.

Parigi also incorporated his fascination with how automobile designers have been influenced by the female form.

"If you look at the cars of the 1950s, for example, the protrusions on the fenders of the cars were called by their designers 'Dagmars' in reference to a Swedish starlet that had very prominent breasts," he explains. "And if you look at the cars in general, with their voluptuous rounded forms, you see a real similarity to the sex symbols of the day, like Marilyn Monroe or Jayne Mansfield. Going into the 1960s, you also have the cigarette-line Cadillacs and things like that. Well, now you have a similarity to the very slim-line pencil sort of dresses and starlets of the time, like Audrey Hepburn. You move into the late eighties, early nineties, and those kind of compact, rounded forms have a very real similarity to the Lycra-clad aerobic bodies that were coming into prominence at the time. So automobiles have always been tied to our concepts of eroticism and even specific ideas of female beauty."

While penning the script for *Chrome Gothic*, Parigi had an array of items he'd keep on hand for inspiration, including vintage Rat Fink stickers and a female anatomical model that he repaired and modified (to look more mechanical) after it was damaged during an earthquake. But that wasn't enough. He needed a more chaotic muse.

"I used to carry a camera in my car just for photographing accidents," he says. "Back before everyone had a phone, it was a disposable thirty-five-millimeter film camera. And every time I'd be stuck in traffic because of some huge accident, just as I got closer I took the camera out as I drove past and I'd snap a few pictures."

Parigi even sought accidents out in order to get a better view of the carnage. He'd leave the windows of his apartment open and listen for the unmistakable sound of a car crashing, then rush over to snap pictures.

"It's kind of thrilling," he admits, "because there's that high-pitch squeal of the tires, someone has slammed on the brakes, then there's an extremely bass-y, low-range crunch that is very hard to describe because you almost feel it as much as you hear it, and then after that there's a very delicate, effervescent, and tinkling noise of the broken glass sprinkling across the ground."

This fetish for car accidents, which he points out was also stoked by Cronenberg's 1996 adaptation of the J. G. Ballard novel *Crash*, formed the core of the concept.

"I thought, you know, if I'm only going to write one script in my entire life, what's it going to be? And so I thought, *this is it*, and I'm going to put in this story everything I loved the most: horror obviously, hot rods, perversion, romance, action, mutants."

Robert Parigi with the repaired anatomical model that influenced his Chrome Gothic script (top), and some of his crash photos (bottom).
Photo of Robert Parigi provided by author. Used by permission.
Car crash photos by Robert Parigi. Used by permission.

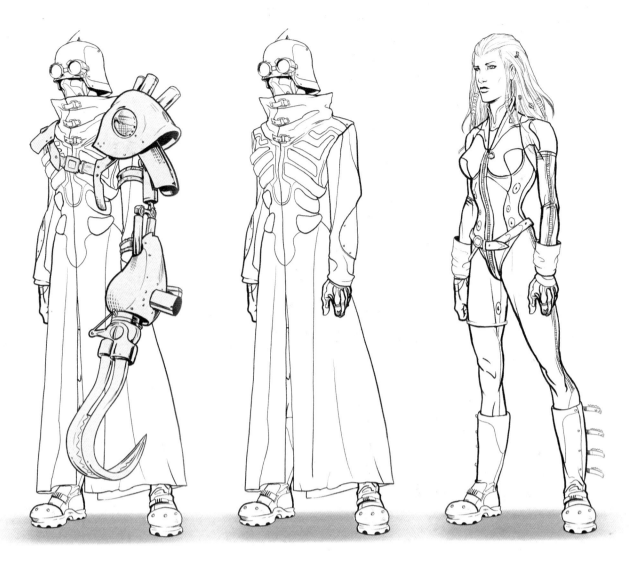

Writing during what little free time he had, Parigi started to shape the plot. Set in a degraded alternate version of our world, it's centered around Alex, a freelance videographer—or "video vulture," as Parigi describes him—who ekes out a living filming gory accident scenes and selling the footage to the news. Police believe many of the wrecks are the work of a mythical monster dubbed "the Leech," who's running people off the road in order to feed on them. First responders find corpses with large holes in the backs of their necks and their spinal fluid drained—hence the nickname.

When we first see the Leech, it's a figure in a heavy cloak, helmet, and goggles, sporting a gigantic mechanical arm attachment—like a *Mad Max* villain on steroids. But then Parigi flips the script when Alex has a literal run-in with the "monster." Beneath all that gear is someone else entirely.

"She is a beautiful albino, whose life support is built into her vehicle," says Parigi. "She lives in the desert between Los Angeles and Las Vegas, so whenever there's a smash-up on the road, she hears about it on her police scanner, races out in her hot rod—which is the fastest car on the road—gets to the wreck, uses a huge mechanical claw to rip open the car, and, with a hypodermic suction drill, leeches out the spinal

tissue from all of the cadavers. Now she hasn't killed anyone, but she needs what she needs. If there are fatalities, she sucks out the spinal tissue, shoves the [drill] gun into her dashboard, clicks it into place, and the spinal tissue transfuses through tubes into her body. Then she speeds off before anyone else gets there."

Her bizarre condition was caused by Gustave Pickman, a modern mad doctor who provides all manner of illegal medical services for anyone willing to pay. He fell in love with her and turned her into what Parigi describes as his "surgical love slave." Now she is being pursued by both Pickman's henchmen and the authorities, and the Leech's life-sustaining car is badly in need of repairs. Alex decides to help, falling for her in the process. Just as she's about to get back on the road, Pickman's henchmen come calling.

"You have this kind of Orpheus and Eurydice situation where she has now literally been captured by the king of the underworld," says Parigi, "and he has to descend into the underworld and rescue her in order for them to ride off into the sunset and fall in love. So it's actually a very romantic, almost fairy-tale love story, but with exploding heads and gore and *Mad Max* action and mutants and surgical love slaves and fetish cults and the whole thing. So what's not to love?"

Character concepts for Elenore/Leech, by Todd Harris.
Image provided by Robert Parigi. Used by permission.

Though Parigi was living in LA and steeped in hot rod culture and monster movie Americana, he didn't want an American to direct the movie. He felt that only a foreigner could fetishize the key ingredients of *Chrome Gothic* in a similar way.

"My ideal director for the project was always going to be a European. The reason for that is that outsiders always have a more poetic or sensitive view of other cultures. And if you look at a hot rod, let's take a classic American hot rod—a souped-up fifty-seven Chevy with big blowers poking out of the hood—if you show that to an American, most people are only going to see an old-fashioned car that's kind of out of date. But if you show that car to someone from Japan, or someone from France, that car is going to be evocative of America."

was unable to get the movie in production, the script advanced his career and got him signed with the prestigious Endeavor Talent Agency (which in 2009 merged with the William Morris Agency, and was then rebranded as simply Endeavor in 2017). At one point director Richard Stanley (*Hardware*, *Color Out of Space*) was attached, and even David Lynch read it.

"The action elements, the physical complexity of the production in terms of makeup effects and stunts and all that—he wasn't very happy on *Dune*. I can't imagine him wanting to sign up for *Chrome Gothic*," reasons Parigi.

But one potential director really got him excited: Vincenzo Natali. After making his cult sci-fi horror hit *Cube* but before making his cult creature-feature film

> ## "We did not see it as camp, we did not see it as a tongue-in-cheek kind of thing. Strange, operatic, stylized, yes, but not played for laughs."
>
> —Robert Parigi

Such a cult movie demanded cult collaborators, which is why Australian producer Andrew Mason came along for the ride.

"He did *Dark City*," says Parigi, "which was just an incredible movie. And at the time he was involved in some of the early preproduction on *Fury Road*, and definitely interested in cars and the car scene, things like that. At the time he also set me up with a meeting with Brendan McCarthy, who was making all of the storyboards for *Fury Road* [and has a writing credit on the finished film]. This was maybe close to twenty years before the movie came out. I was able to see incredible drawings of the vehicles and things that were in *Fury Road*. These guys completely get *Chrome Gothic*, I thought, I have to make it with these guys. There were insane vehicles for *Fury Road* that you never even saw—there was one that was like a 747 fuselage that had been retrofitted onto earth-mover treads, things like that—so I thought these guys would be great."

Parigi adds that McCarthy actually did a concept illustration of the Scavenger, the vehicle that the Leech drives; however, he was unable to convince the artist to let him have it. In fact, Parigi was meeting with a variety of people about *Chrome Gothic* in the early to mid-2000s, and he notes that even though he

Splice, the Canadian filmmaker was looking for new projects. Parigi had seen Natali's 2002 techno spy film *Cypher* and was drawn to elements in it that he feels are in tune with *Chrome Gothic*.

"Action, gunplay, secret agent kind of stuff," says Parigi. "He would have been perfect for *Chrome Gothic* because his stories play with some of the same themes of Eros and technology, unexpected consequences and things like that. . . . On the one hand, *Chrome Gothic* is all lowbrow elements—drive-in movie theaters, hot rods, biker gangs, tow truck drivers, this kind of stuff—but on the other hand, I wanted it presented in an almost high-fashion context. So with the elegance that Vincenzo brings to all the projects that he does, I thought he would've been a really nice director for *Chrome Gothic*."

Natali read the script and the two men discussed it.

"We were pretty simpatico in terms of how we saw the project," recalls Parigi. "We did not see it as camp, we did not see it as a tongue-in-cheek kind of thing. Strange, operatic, stylized, yes, but not played for laughs."

While Natali ultimately did not sign on to the project, *Chrome Gothic* pushed forward.

Concept art depicting the Leech hooked into her muscle car and
hunting for spinal fluid. Art by Todd Harris.
Copyright Robert Parigi. Used by permission.

Robert Parigi's photos from the 2016 Wasteland World Car Show, in Torrance, California, including (top right) one of a replica of the Mad Max V8 Interceptor, a vehicle that influenced Chrome Gothic. Images provided by Robert Parigi. Used by permission.

> ## "I have been living with this story for over thirty years."
>
> —Robert Parigi

While there weren't any actors attached, Parigi had hoped to get Asia Argento for the role of the Leech. The problem was, Hollywood didn't share his vision. The studio executives he met with seemed to be particularly uncomfortable with the character.

"One of the things that was very frustrating when we would go out is a lot of executives would say you can't have an action movie with a female lead, and I was baffled by that, because this was the mid-nineties," laments Parigi. "You had already had four *Alien* movies with Ripley as the female lead, Linda Hamilton in *Terminator*, *Buffy the Vampire Slayer* was a hit show on television, then slightly later *La Femme Nikita* was one of the biggest shows on USA Network. So this idea that a female action lead was somehow not doable just struck me as very, just, wrong."

Nor did they like how *Chrome Gothic* mixed genres.

"The movie has many different aspects," says Parigi. "It's not just a straight-up gore film, it's not just a straight-up car movie, like *Fast and the Furious*, it's not just a paranormal romance, like *Twilight*, it has all of these aspects. And for some reason they seemed to think that was a problem, whereas I thought that these were great advantages. It was my idea of a four-quadrant film. You have something for the guys, something for girls, something for the action market, something for the romance market, so it was strange. No one would pull the trigger."

Eventually *Chrome Gothic* ran out of financing options, so Parigi moved on to write and direct the acclaimed indie feature *Love Object* (about a love triangle involving a life-sized sex doll) and produce a variety of TV shows, from *Dark Skies* to *King of the Hill*, before joining the aforementioned Marvel projects.

Despite this, he's still actively seeking backers for *Chrome Gothic*. Perhaps the best way to describe the tale is that it's every bit as much a part of its creator as the Leech's car is a part of her body.

"I have been living with this story for over thirty years," he muses, "and that's not including my entire childhood of being obsessed with the hot rods of Ed 'Big Daddy' Roth and the whole custom-car culture and horror movies and these tormented monster characters that are as much the heroes as the villains."

Parigi shows off his script for Chrome Gothic.
Image provided by author. Used by permission.

"CUBE" OCT. '94

Clockwise from top: In the Tall Grass concept art by manga artist Shintaro Kago, Splice concept art by Vincenzo Natali, and Cube concept art by Vincenzo Natali.
© Natali. Used by permission.

VINCENZO NATALI'S ORIGINAL
CUBE, SPLICE, AND IN THE TALL GRASS

The master of the New Old Flesh reveals the amazing mutations his most personal projects went through from page to screen

INTERVIEWS WITH VINCENZO NATALI, AMRO ATTIA, AND DOUG TAYLOR

"My love for monsters and horror in general, I can't claim to know where that comes from—I feel like just from my earliest days I was drawn to it, so whatever psychological damage led to that, I'm not really aware," says Vincenzo Natali with a laugh.

The Toronto filmmaker has a reputation for amazing visuals, having put a particularly surreal stamp on his films, most notably *Cube*, *Splice*, and *In the Tall Grass*, which showcase some truly strange scenarios, inventive creatures, and bizarre body horror. They are incredibly ambitious movies both visually and narratively, and it's no surprise the finished versions are markedly different from their initial conceptions. Given Natali's background, it's also no surprise that there's a wealth of eye candy left behind to tell the tales of what might have been.

Like many kids, he grew up obsessing over Marvel comics, *Star Wars*, and drawing monsters. Fortunately he never outgrew the latter, having "lucked out" by getting a job as a storyboard artist with the well-known Toronto animation house Nelvana, working on series such as *Beetlejuice* and *Tales from the Cryptkeeper*. By doing work that was essentially directing on the page, he turned his love of movies (he grew up making Super 8 films with friends) into a career. Before long he was making 16 mm films and attending the

Canadian Film Centre (CFC), where he was accepted into the directors' residency program.

It was here his first feature, *Cube*, was born out of a proof-of-concept short film called *Elevated*, which was written by Karen Walton (who would go on to write *Ginger Snaps*) and produced by Steve Hoban (who also produced *Ginger Snaps* and most of Natali's features). The tense seventeen-minute film features two strangers in an elevator who are joined by a frantic, blood-spattered security officer who claims there are monsters in the building. Unclear what or who is the real threat, they soon turn on each other—anticipating the paranoia, violence, and confined spaces of *Cube*.

During this period, Natali teamed up with Andre Bijelic, who was also in the CFC program, to write *Cube*. Their first draft was dated June 5, 1994.

"The conception of *Cube* came purely from the desire to make a movie for a low budget that would permit me to shoot in one set but still allow my characters movement, so they wouldn't just be trapped in a room," explains Natali. "I came up with this notion that one set could be doubled for many sets, and that inspired the idea of a maze of identical rooms and a symmetrical maze, and therefore a cube."

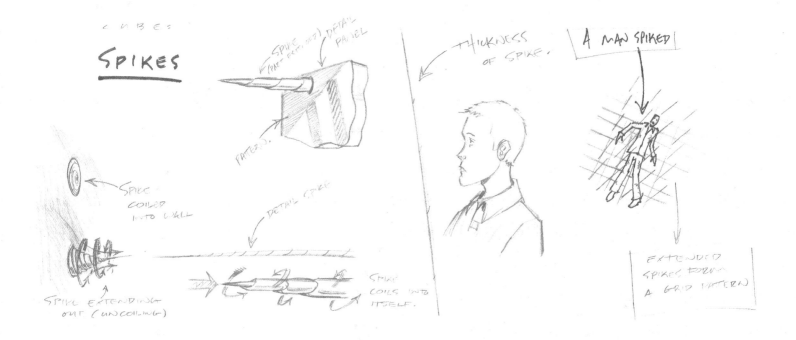

Considered a sci-fi-horror classic, the 1997 film follows a group of strangers from different walks of life who find themselves inside a mysterious giant cube comprising shifting rooms, some of which contain deadly traps. They must work together to decipher a code in order to escape, but mounting paranoia and desperation cause some of them to savagely turn on each other.

Natali had initially envisioned something quite different, however. His early version of *Cube* had a Minotaur-like creature in the maze, as well as another prisoner that was a cannibal. There was an edible moss growing inside the structure that one could subsist on, and a character who was essentially a head in a box. In addition, the main character was male instead of female, and was given a fairly comprehensive backstory outside of the cube. But what was really different was the entire tone of the movie, which Natali describes as "baroque."

"My first crack at it was a considerably more whimsical, an absurd Terry Gilliam–esque kind of script in which all the people trapped in the cube were chartered accountants," he says. "And then there was this thing, this creature that you heard in the cube, which you never really saw until the end, like a monster. And when you saw it at the end, it actually was, if I remember correctly, like an old man. And this is where it's very Terry Gilliam-like: it was an old man in a three-piece suit. There was also a Huck [Finn]–like character, a little mischievous boy who would lead people into traps and had some sort of knowledge about the maze. So it was much more mythological and whimsical but presented through a sort of contemporary lens so that the monster was a businessman."

Natali has long been a fan of Gilliam and even made a documentary on him while the filmmaker was shooting his 2005 film *Tideland* (available as a special feature on the film's Blu-ray). *Cube* might have been much more in the vein of Gilliam's absurdist sci-fi film *Brazil* had Bijelic not stepped in after reading Natali's initial crack at the story.

"[He] said, 'Well, your script isn't very good, but there's a very good idea in here,' and then he very correctly pointed out that the strength of the story was its simplicity," recalls Natali. "He was the one who suggested to strip all of that Terry Gilliam stuff away and just make it about people coming into this place with no resources other than their minds and the shirts on their backs. And I immediately knew he was right. And so together we sat down and we came up with a whole new approach."

Of course, one of the things about *Cube* that really got horror fans' attention was the lethally efficient traps. Everyone remembers Julian Richings's character, Alderson, getting diced by two razor-sharp metallic grids. Acid, spikes, flames—the film offers a variety of ways to meet your demise. If Natali had his way, however, there would've been far more elaborate fatalities.

"We had a whole bunch of ideas for things that we wanted to do to kill people, which would have been really fun, but it was all cost prohibitive," says Natali. "*Cube* was actually a real challenge to make, because it was a Chinese puzzle box in a very literal way— because on its face it seemed like a fairly low-budget, simple idea: six people trapped in one set. But when you really started to analyze what it would take to build that set, which has six functioning doors on each

Vincenzo Natali conceived numerous ambitious and macabre traps for Cube that didn't make it into the final film for technical or budgetary reasons.

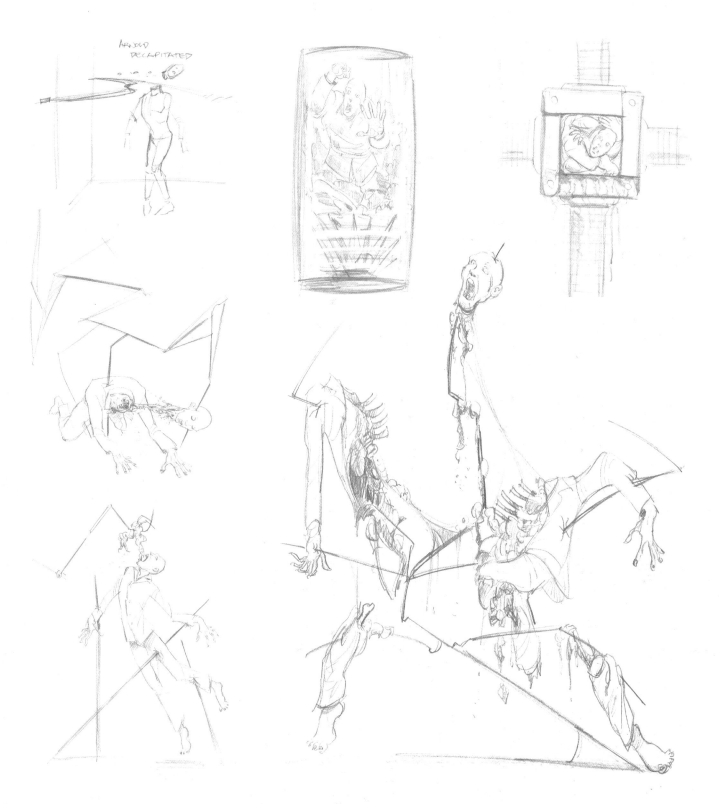

surface that had to light up and change color and do all this stuff, it started to become a bit expensive. And then we had some very ambitious visual effects, like the guy getting cubed, which was there from the very beginning and we would never, ever give up. And so by the time it came to actually shoot the movie we had to drop a number of ideas. That's the nature of low-budget filmmaking."

As evidenced in concept art, there were "wire-like structures, multijointed" that emerged from the patterns in the walls to kill. Some of the nastier deaths saw them pinning people down and impaling them, disemboweling them, tearing off their heads, and ripping them completely apart. Another particularly brutal device saw a victim mashed into a cube shape, while another one had someone trapped in a clear tube full of water while a blade popped up from the floor and blended them—Cuisinart style.

"It was really hard for me to let go of the idea that the patterns in the walls would come out and form different shapes that would then slice you up," says Natali. "I was really excited that the patterns that you see in the movie embedded in the walls would actually take three-dimensional form. . . . If there was anything that made me want to do more *Cube* [movies], it was that."

A promotional minicomic written by *Steve Niles* (30 Days of Night) showcases a Cube tale not featured in the film.

Interestingly, there were additional *Cube* kills realized before the movie was even released. For its festival run, distributor Trimark gave out promotional comic books that depicted a group of people in the cube being electrocuted, beheaded, drowned, burned alive, and crushed by the ceiling. It was illustrated by Roy Lee, who has inked and penciled several DC titles, and written by Steve Niles before he became famous for *30 Days of Night*.

Of course, *Cube* went on to become a success and spawned two straight-to-video sequels, *Cube 2: Hypercube* (2002) and *Cube Zero* (2004), neither of which Natali was involved with, as he didn't want to repeat himself, particularly so early in his career. That said, he has always been interested in expanding the *Cube* universe. He once pitched a game version of the film to Electronic Arts, but they weren't interested (at least one fan-made iPad game made the rounds, however, in 2012), and he was in talks with Syfy to do a *Cube* series for the specialty channel.

Natali recalls, "The concept was that the cubes were bridges between other kinds of puzzles, and those puzzles would be real-world environments, even though it would be questionable as to whether those were actually real places or they were artificial, so you

could actually tell a long story arc outside of the cube. You wouldn't be stuck in one set for an entire TV series."

An "amnesia story," it would've featured a character who wakes up in the cube and slowly realizes he was the architect of it, and then must go on a journey of self-discovery. There would be multiple cubes that acted as gateways between various places, each of which would provide something for his quest.

"You would end up in an airport, for instance, and there would be kind of a puzzle related to figuring out something that he needed, or finding something that he needed in that environment to help him move on to the next level, so it was a little bit like *Lost* that way," says Natali. "And then of course there were other people there, as well. It was pretty heady."

Syfy wanted to move ahead with a *Cube* series . . . well, sort of . . .

"They wanted to do it as a backdoor pilot, meaning they basically wanted a *Cube* TV movie with the hopes that it would become a series but no guarantee," says Natali. "I didn't want to make it. I thought, I'm going to end up making a *Cube* TV movie, which really wasn't of interest to me, so *I* actually backed away."

Natali had another, much more ambitious, project on the brain anyhow, which he'd started developing years before he made *Cube*. It would continue to evolve and mutate as he directed other projects, taking over fifteen years to finally be released as *Splice* in 2010.

The movie stars Sarah Polley and Adrien Brody as Elsa and Clive, married genetic engineers doing pioneering work in their field by splicing together animal DNA to create new life forms (two blobby creatures they call Ginger and Fred) whose cells can be used for medical breakthroughs. In secret, they also splice animal DNA with human DNA and create a female creature that begins to develop rapidly, showing both human intelligence and animal aggression. Played by French model and actress Delphine Chanéac, Dren represents an incredible feat of special effects that combine prosthetics, makeup, and digital manipulation to depict a hybrid that evolves throughout the film and has elongated legs, a tail with a stinger, and, eventually, gills and wings. After she displays dangerous behavior, Elsa and Clive hide her in the country, and while Elsa takes on a nurturing role, a sexual attraction begins to develop between Clive and Dren. Things get increasingly twisted from there, culminating in deaths, a spontaneous sex change, rape, and a pregnancy.

With a budget about a hundred times that of *Cube*, the $26 million movie has the twisted science-experiment concept and laboratory coldness of *Cube*, but also the science off the rails, intense body horror, and twisted sexuality of David Cronenberg's *The Fly*.

"I remember I was following a similar template to David Cronenberg's *The Fly*, which is a kind of chamber piece," allows Natali. "That way by just having a few locations and a few principal characters, you put all of your resources into the creature, and you make a great creature."

In the beginning, however, there was the script for a short film that would become the basis of *Splice*. Written with another Canadian Film Centre participant, Toinette Terry, that twelve-page script, dated November 21, 1995, features the not quite biblically named couple Edom and Meve, who are working on a special project in their genetic engineering lab, creating mutants for their corporate employers—when they're not having sex on examining tables, that is. Their childlike lab progeny only live a few days, which isn't making their boss happy, so Edom throws Meve under the bus by blaming her for their failures. In retaliation, she releases the mutants from their cages.

Another draft, dated December 8, 1995, reworks the story completely and gives the main characters names inspired by *Frankenstein* and *Bride of Frankenstein*. It has Clive and his girlfriend Elsa watching a zombie movie when he gets a call to go in to the secret genetics lab where he works. At the lab there's a creature with whom he's formed an unusual bond. Clive kisses it romantically before returning home. Soon, we find out the creature is dying after being exposed to his germs. However, the final scene has him waking up as if it's all a nightmare. Or is it? He gets out of bed and goes into the bathroom, where he pulls hairs out of Elsa's comb, implying that he's trying to clone her and must start again.

Vincenzo Natali kisses baby Dren on the set of Splice.
Photo by the film's director of photography, Tetsuo Nagata.

"I actually feel like it was the best short film script I ever wrote, but it was kind of an impossible movie to make because of the creature," says Natali.

Terry—with input from Natali—then wrote a feature-length version of the script, which is dated Halloween of 1997. Titled *Mutants*, it's a much bigger Hollywood-style film, rather than the twisted monster movie that *Splice* eventually became. The story begins with a couple—Clive and Jane—that work together at a bioengineering lab, which is full of various animals, including two hermaphrodite mutants they've created. Their boss, Frank, surreptitiously pushes them to splice animal DNA with human DNA so they can take advantage of the potential medical breakthroughs, despite the fact that the company is coming under increased scrutiny in the press for its suspected unethical practices.

One of the biggest differences here is the number of characters. Jane and Clive work with Josef, who has a sister named Elsa, who's doing groundbreaking work on antirejection drugs. Shortly after she meets Clive, they fall in love—a scene in a university clock tower, in which they kiss, evokes Golden Age Hollywood—and Clive leaves Jane, who gets revenge by taking some of Elsa's hair from a comb and using her DNA to create the Dren creature, which is born adult sized and has Elsa's face. Clive gives in to his desire for it, but their contact results in it getting sick, so Clive steals some of the drug Elsa has been developing in order to save it.

"We eventually stripped it down, because in that version, there's a love triangle between the humans, and then ultimately there's a love triangle with the monster," says Natali. "And it was just too much. So we condensed Jane and Elsa into one character."

As a private eye named Stanley Habbit discovers what the company's been up to, a group of militia types show up and start killing everyone, including Jane and Josef, forcing Clive and Elsa to flee to a cottage in the woods to hide the creature. In the film's most Hollywood-style twist, an "old lady" neighbor turns out to be Frank in a mask, who then kills Clive before being savaged by the creature. The entire narrative is wrapped in a conspiracy, packed with action, and loaded with characters who facilitate multiple story lines. The Dren character played a smaller part at this stage.

The script would continue to evolve; it was retitled *Splice* and went into preproduction in 2000 under the prolific Canadian producer Robert Lantos, who was coming off of a couple of David Cronenberg projects, *Crash* (1996) and *eXistenZ* (1999). The movie had been storyboarded, there was a team of designers working on it, and a visual effects test was even shot.

Storyboards for an unrealized scene in Splice set at a candy factory (top, drawn by John Flagg), and one of many early concepts for the Fred and Ginger creatures (bottom).

"The early concepts really explored some amazing iterations of Dren. She was initially very alien-like and much less human."

—Concept artist Amro Attia, on *Splice*

One of the artists hired to work on the project during this period was Amro Attia, a Torontonian who had previously done designs for the films *They* (2002) and *Silent Hill* (2006) and the TV show *Fringe* (2008–13).

"I started on *Splice* when 'official' preproduction began in 2000," he says. "There was already some incredible concept design work created by other artists for adult Dren. When I came onboard, my first assignment was to tackle baby Dren. I worked on *Splice* (on and off) for over two years, so there was quite a few images created to support the VFX studios working on the film. This was a long time ago, but I would roughly estimate around fifty to sixty illustrations were created. . . . I worked on everything from the pod from which Dren is birthed to adult and male Dren and all their physical details and attributes, as well as Ginger and Fred."

Attia would work closely with Natali to determine Dren's nature, and their decisions were key in shaping the nature of the movie. The version of *Splice* that got made is centered around a Dren that's at times animalistic, sometimes childlike, at the end monstrous, and, most importantly to set up the key character

dynamics, sensual. But there were ideas floated that would've skewed *Splice* in the direction of a more traditional monster movie.

"The early concepts really explored some amazing iterations of Dren," says Attia. "She was initially very alien-like and much less human. By the time I joined the film, Vincenzo had a much clearer idea of what she should look like. Same with Ginger and Fred and baby Dren; my designs were approved fairly quickly and sent out for fabrication."

Splice was full speed ahead under Lantos. Until it wasn't. The producer basically got cold feet, which is not surprising, given the ambition behind the project.

"It was an expensive movie, and I think he was nervous about the risk involved," offers Natali. "But that was after a year of intensive development and prep. It was pretty heart wrenching for me." So back it went in the drawer, essentially, until things started to move ahead again in earnest half a decade later. This time Hoban picked up the torch and brought in some heavy-hitter producers, such as Hollywood veteran Joel Silver (*Die Hard, Predator, The Matrix*) and Guillermo del Toro.

One of Vincenzo Natali's early concepts for a more monstrous version of the Fred and Ginger creatures.

The story was changing again, thanks to screenwriter Doug Taylor (*The Carpenter, They Wait, A Christmas Horror Story*), who was brought on to revise the script. A draft dated November 21, 2006, has him listed as the third writer with Terry and Natali. By this time, Terry had moved on to other things (Taylor didn't meet her until years later, when the finished movie played at Sundance), and Taylor worked off a draft she and Natali had completed on February 23, 2006. He did some passes himself, then worked closely with Natali, swapping scenes back and forth, in order to finally "solve" the script.

"From my first reading of the script, I was struck—obsessed—by a recognition that this story is more than just a monster movie; it's a kind of muted satire on underqualified parenting," says Taylor. "If I could point to one major marching order from Vincenzo and Steve, it was to flesh out Clive and Elsa, not just their characters but the dynamic of their relationship. I can't possibly list all the factors we massaged to try to achieve that—and there was already plenty of raw material in those early drafts—but I think that's what I'm most proud of from my contribution. I really worked on that relationship and their challenges to 'parent' a 'child' who is changing so quickly they can't possibly keep up, let alone process their own feelings. I also was keen to bring Elsa's crazy-mother past more to the fore, and let it be as dark as these things are."

Digital concept designs for Baby Dren by Amro Attia.

In order to do so, Taylor cut down on the number of locations. In earlier drafts he worked off of, the story took place in the lab, then a candy factory, then the farmhouse. He cut out the candy factory, as well as a nightclub scene and several scenes with mobs of reporters—all choices that allowed more financial resources to be channeled into special effects.

"Besides being less episodic, I felt it added more emotional resonance for Elsa, given that the farmhouse was soaked in memories of her own upbringing with a control-freak mother," says Taylor. "This tracks with the dynamic change between Elsa and Dren, which becomes so much darker and eventually abusive, once in the environment of Elsa's upbringing."

Elsa became the focus of the story rather than Clive. Taylor developed her backstory and cut his. Furthermore, he delayed telling the audience that Elsa used her own DNA to create Dren, juicing the "sick parental implications" in order to focus more on her arc.

"Elsa instigates the experiment and is ultimately most unhinged by it," explains Taylor. "And in the end, of course, we kill off Clive (unlike earlier drafts). So we're left to digest the whole nightmare through surviving Elsa. She's our final emotional beat."

And while Taylor made Elsa more intellectually monstrous, he also made Dren more literally monstrous with the addition of her poisonous tail stinger. Initially the goal was to add danger and suspense, but that physical change ended up driving the story in a different direction.

"Now, looking at the movie, it's hard to imagine a version of this story without the tail spike," says Taylor. "It drove so many suspense beats, and came to mean so many things. Potential threat, yes. But it also appears during Clive and Dren's surprising 'mating' ritual, though its use is interrupted. And critically, of course, the scene where Elsa, now in fully abusive control-freak-mom mode, cuts the end of Dren's tail off, along with the spike. I think that's one of the most powerful scenes in the movie. It's so . . . *emasculating* is the wrong word because Dren's a she, but you get the idea. And finally, of course, the spike delivers Clive's death."

His death was originally supposed to take place as the farmhouse burned down, which would've felt like a nod to classic monster movies. But more importantly, according to Taylor, it would've wrapped up Elsa's character arc.

"I think every draft I worked on, right up to the start of production, ended with the farmhouse burning down during the big climax," says Taylor. "While it was budgeted for, as production wore on and other costs went over, it was decided that the burning building would be too expensive and difficult to shoot. Of course that's true, but its omission really broke my heart. . . . So much of Elsa's character arc and backstory originated from that farmhouse—its burning down seemed the perfect symbolic stand-in for Elsa's emotional rupture. But alas, that's showbiz."

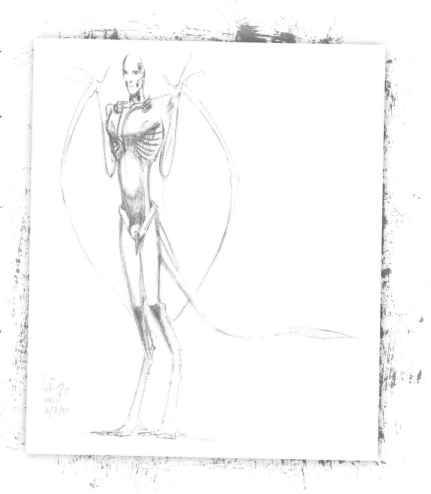

With the Elsa-Dren dynamic becoming a focal point in *Splice*, Dren now had more screen time, which meant she had to be even further fleshed out (literally)—something that would challenge what was possible in terms of special effects. Since the digital world had advanced considerably since Natali and company tried to make the film in 2000, they could be more ambitious with creature design. The director strove to put something entirely new onscreen.

"Humanity has a history of mythologies in which people fall in love with human hybrids," points out Natali. "Thousands of years that's existed, so the idea of a mermaid or a Siren, or even a Harpy, although that's not an attractive creature, those are images that are very deep in our collective subconscious. So I felt with Dren that she should be the scientifically plausible variation on that."

Natali met with biologists and geneticists in order to create a character that was as likely as possible.

"The thing that always shocked me was when I would talk to the couple of geneticists I was using to consult with me—there was very little that I proposed that they said was impossible," he recalls. "I realized that in the realm of genetics, this was very, very valuable, and the potential for what could be done is pretty scary and extraordinary, and by a large extent is just restrained by what is permitted. But if you didn't have any moral constraints, you'd probably end up doing some very *Splice*-like things for real."

Concept for the male version of Dren (top), and a version of adult Dren with hair (bottom), both by Vincenzo Natali.

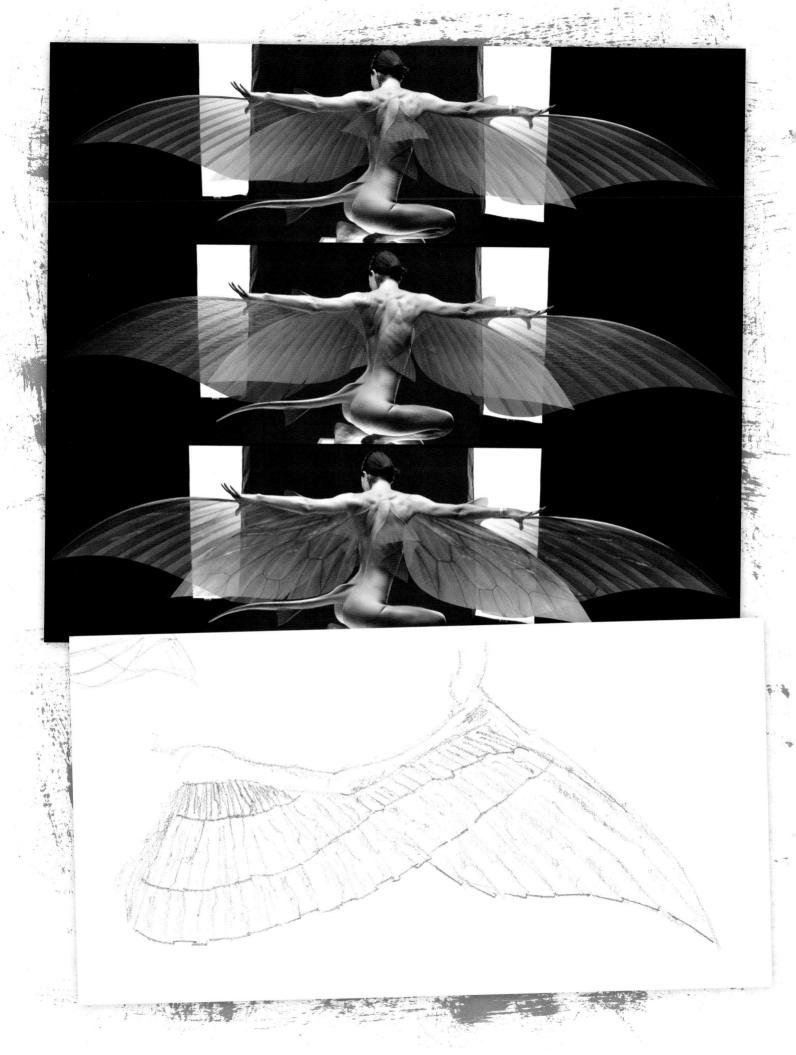

Various types of wings were considered for Dren, as illustrated by Amro Attia (digital designs) and Vincenzo Natali, showing the evolution of the creature design.

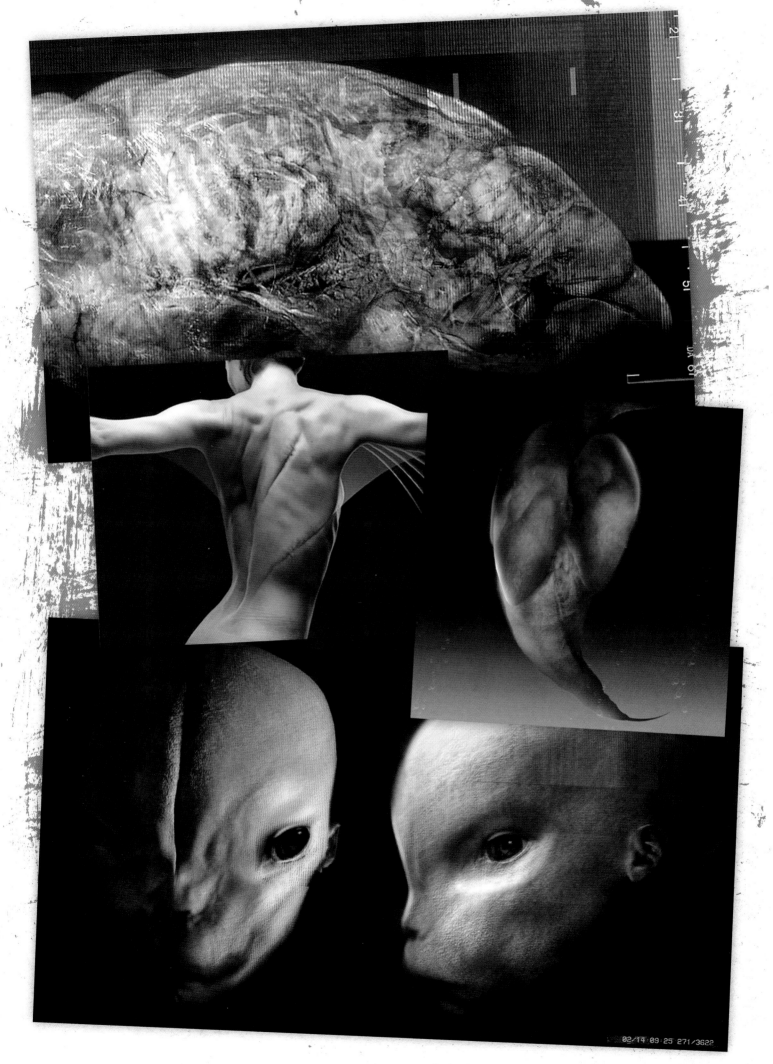

Designs by Amro Attia depict different stages of Dren's life cycle.

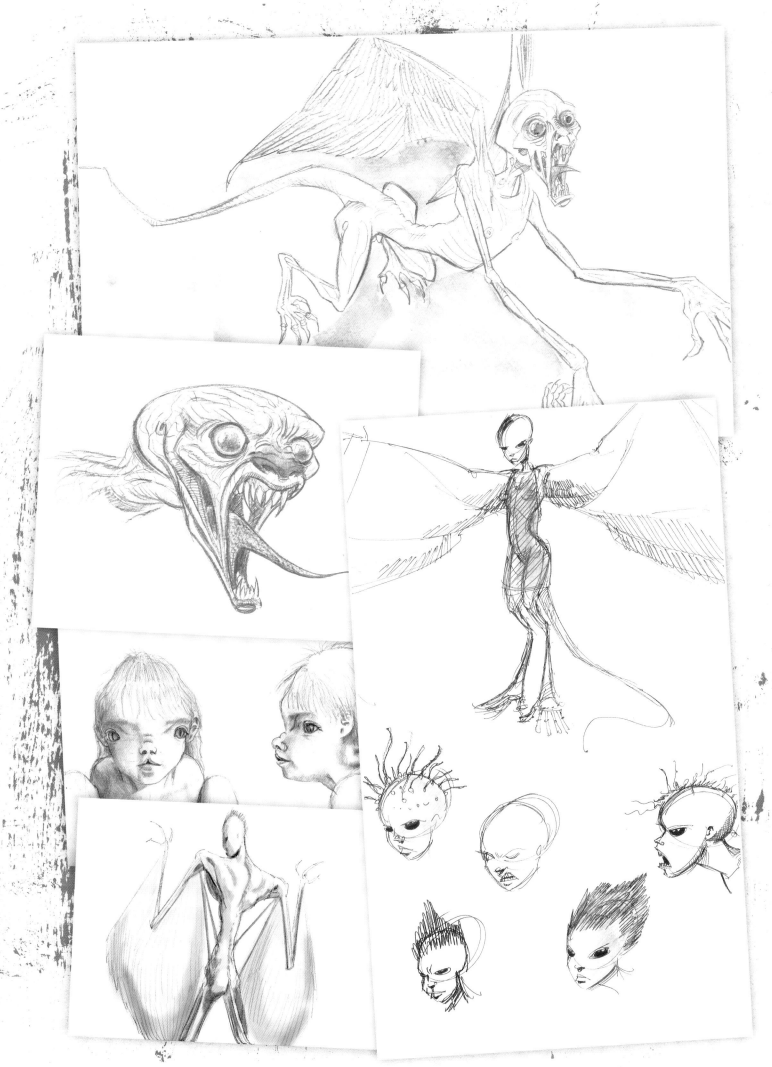

Various pieces of concept art show attempts to balance the humanistic, animalistic, and monstrous sides of Dren. Illustrations by Vincenzo Natali, except for Dren as a child (left, second from bottom), by award-winning animator Chris Landreth.

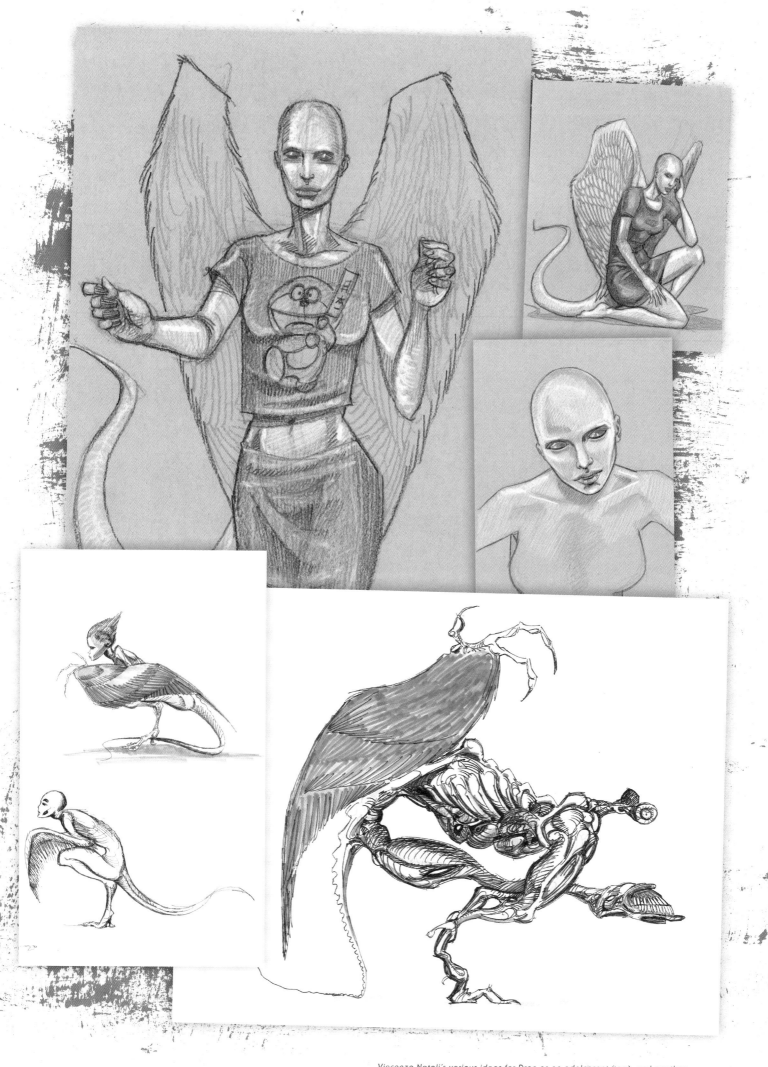

Vincenzo Natali's various ideas for Dren as an adolescent (top), and another one of his monstrous concepts for Fred and Ginger (bottom right).

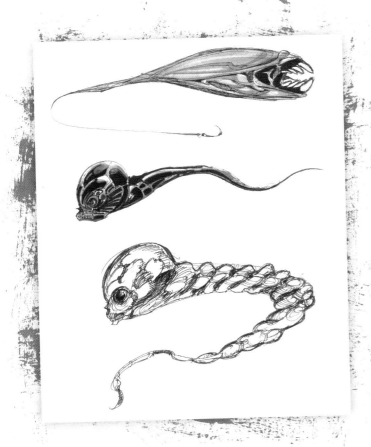

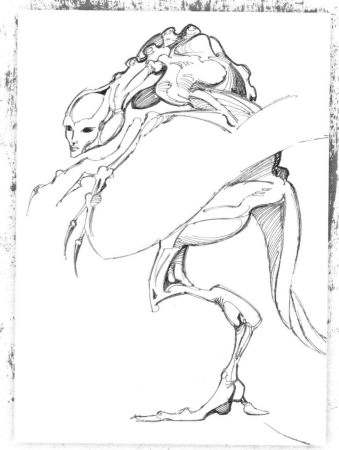

The intensive design work saw the creature morph again as it went through different artists. Aside from Attia's aforementioned concepts, Natali and others tinkered with designs for Dren, as well as Fred and Ginger, that incorporate different amounts of alien, human, animal, and monster. Some are more realistic, others have a comic book feel, and several are even sorta cute. One key influence that ultimately guided the work, however, was the art of H. R. Giger.

"His creatures are very sexualized; they're both repulsive and alluring at the same time," explains Natali. "That was a big part of what we are doing. . . . There's a lot of artists who were involved along the way. She was definitely the child of many parents."

He adds, "Initially, Ginger and Fred were supposed to be partially simian with the idea being that you would get to something that's sophisticated before you moved on to a human, but as the reality of making this film began to, you know, rear its ugly head, we realized that Ginger and Fred were just going to have to be blobs 'cause that's really all we could afford."

While budget is a common dictator of content, in the case of *Splice*, technology was also a huge factor in shaping the heart of the movie. To properly (literally) embody the title, Natali wanted to bring something entirely new to the screen that walked a very fine line between human and monster, attractive and repulsive, realistic and fantastic. The only way to really get the desired effect was with a mix of physical effects and digital artistry. As Natali points out, *Splice* is very much a product of its time from the production side, as well.

> # "There's a lot of artists who were involved along the way. She was definitely the child of many parents."
>
> —Vincenzo Natali, on the evolution
> of Dren's character design

"I think that big shift between those early stages when we were developing her and where we ended up was there wasn't the technology to change an actor's face digitally, or at least I wasn't aware of it. It occurred to me at a certain point, years later, what if you could actually digitally manipulate the actor's face so that it's not a prosthetic? Something that's not additive, where you're sticking something onto an actor, but you're actually changing the architecture of their skull. I just thought that would feel so real. So that was the big leap when we moved into the final version of Dren that we shot in 2008. We knew that we were going to do some digital facial reconstruction on her and were also going to remove a digit from her hands and do various things of that nature."

Vincenzo Natali's H. R. Giger–inspired concept drawings of Dren in various life stages.

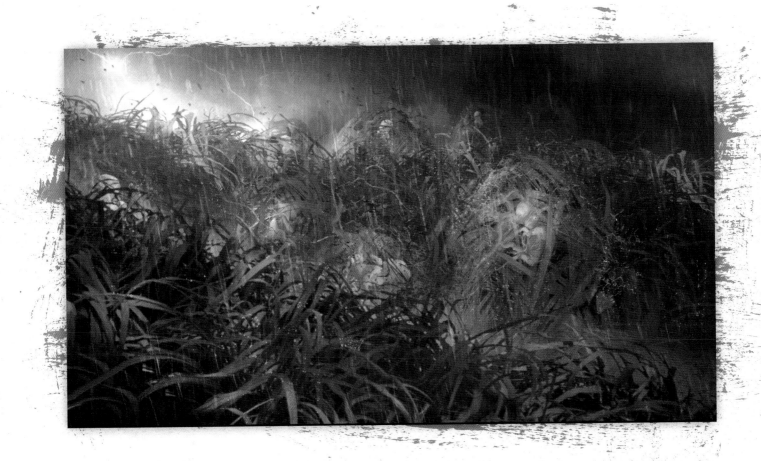

"I really love this idea of a horror film in this beautiful pastoral field."

—Vincenzo Natali, on *In the Tall Grass*

In the decade that followed *Splice*, the world of film changed radically, thanks to further changes in technology, distribution, financing, and, in particular, the rise of streaming services. While Natali continued to work on genre projects for both film (*Haunter*) and television (*Hannibal*, *The Strain*, *Tremors*), he also inked a deal with Netflix to adapt the Stephen King and Joe Hill novella *In the Tall Grass*. Both the setup for the story and the potential for some truly unique body horror excited him.

"I really love this idea of a horror film in this beautiful pastoral field, and when I read the story, it truly had some of the most grotesque imagery I've ever encountered. It was one of the most shocking things I've read, and yet it was going to be [juxtaposed] against this bucolic, beautiful landscape. And so I think it was the marriage of those two things that really excited me, and then, you know, I have a penchant for people getting lost in metaphysical mazes. So if anything, in fact, that gave me pause, because I thought, I've done this a number of times already, but I feel it was ultimately the lure of adapting Joe Hill and Stephen King, combined with the fact that I really do think the story is powerful and

is dealing with some very deep archetypal theme. And the fact that I thought I could probably get it made because, like *Cube* or *Splice*, it still had a small ensemble in one location—or a couple locations."

In the Tall Grass follows Becky (Laysla De Oliveira), a young pregnant woman, on a road trip with her brother Cal (Avery Whitted) to go to meet the family that will adopt her baby. They stop at an old church, which is surrounded by abandoned vehicles, and hear a child crying for help in a giant field full of tall grass. They wander in and realize not only are they trapped; they've been lured in by a family that's also trapped in the grass, and there are multiple timelines intertwined within the impenetrable sea of green. Patrick Wilson plays the father of the family, who wants them to touch a foreboding glyph-marked boulder in the field so they can share in its secrets, and Harrison Gilbertson plays Travis, the father of Becky's child, who comes looking for them. As the group tries to figure out how to escape, things get increasingly stranger. The past, present, and future begin to intersect, hints of the boulder's sinister origin come to life, and malevolent grass people appear.

Unrealized In the Tall Grass *concept art depicting babies growing in the field, by Amro Attia.*

The novella presents a more straightforward, and ultimately darker, story that focuses on the two families' attempts to escape the grass. Natali, who penned the screenplay, added the character of Travis, made the narrative considerably more complex with the parallel timelines, and dove headlong into the arcane history of the site and the beings who inhabit the field.

"There's a point where Becky encounters these people in the grass, the ancient people who worship the rock, who are still in some form existing there, and they grab her and carry her through the field," says Natali. "As she's being carried through the fields there are all these tableaux that in some way represent the cycle of life from birth to death and regeneration, which is fundamentally what the field is all about, and the notion that—which I think is drawn from the Bible in a sense—we as humans are all grass and our corporeal existence is transient and life comes and goes, and life is born from death, and vice versa. . . . It was kind of going to be the apex of that progression because the movie actually starts in a very naturalistic way. As the narrative unspools, that becomes increasingly strange and disjointed, and this was sort of going to be the key to that arc, and it was going to have babies and sort of grass uterus things, and they were going to be born out of these grass people's mouths and land on the ground. It was pretty wild. But, you know, I don't know, maybe the movie's better without it. It was so extreme and crazy. Sometimes if I were allowed to indulge myself, I might be going too far."

While Natali did realize a spectacular "hell" scene in which thousands of bodies are writhing in the dirt beneath the boulder, the grass people orgy and birth imagery only exist as concept art. Some of it was done by him, some by Attia, and then there are the absolutely bonkers concepts Natali commissioned from manga artist Shintaro Kago. If ever there was an example of "going too far," this would've been it.

Amro Attia's concepts of grass figures and a hellscape of bodies beneath the story's mysterious stone marker.

Shintaro Kago's outrageous body horror concepts for In the Tall Grass were simply too expensive—and perhaps too disturbing—to bring to the screen.

"I told him the basic premise and I said, 'Let your imagination go wild,' which is exactly what he did," says Natali. "He produced twenty or so drawings for me and those became the basis for what I was going to do in the sequence, and I storyboarded it out."

The sequence would've had grass writhing and morphing into arms, hands coming out of a face, skin ripping and unraveling to reveal grass beneath skin, bodies spiraling apart, as well as grass people giving birth to babies from both their vaginas *and* mouths. The images are shocking.

"It was simply half a million dollars that we didn't have," laments Natali of why the sequence had to go. "Partway through the shoot we said, 'No way that we're going to do this.'"

Had the sequence been left in, it would've made the ending build to an absolutely operatic madness, might have tipped the movie into a modern-day surrealist vision in step with Luis Buñuel and Salvador Dalí's 1929 film *Un Chien Andalou*, and it most certainly would've made Netflix wonder what the hell they'd greenlit.

Or, like Natali said, maybe it would've been too much . . .

"There was going to be a grass person orgy going on," he says with a laugh when asked for more detail on it. "We were going to have all these people who are basically composed of grass sort of comingling and, you know, provocatively sexual poses, and it can be a real good time."

What is certain is that looking at the versions of *Cube*, *Splice*, and *In the Tall Grass* that might have existed, it's clear that Natali's career is emblematic of an auteur who's always thinking bigger than his canvas—an artist trapped by the realities of budget, time, or technology, much like his most fascinating characters are trapped in mazes, puzzles, or their own bodies. If David Cronenberg's work is associated with the New Flesh, perhaps Natali's is the New Old Flesh: skin, bone, and even genes rendered into something else by the architecture of science, the supernatural, or sheer force.

The filmmaker's description of that particular unrealized sequence from *In the Tall Grass* might just apply to all of his more personal work if he were truly unrestrained . . .

"It would be a very, very expensive orgy."

RICHARD RAAPHORST'S
WORST CASE SCENARIO

The Nazi zombie epic with two trailers went viral but failed to catch on with investors

INTERVIEWS WITH RICHARD RAAPHORST AND BART OOSTERHOORN

Few unmade movies have as strong a cult following as *Worst Case Scenario*—a testament to the artistry of its creators, Richard Raaphorst and Bart Oosterhoorn, who put everything they had into a teaser trailer that went viral back in 2003, before YouTube was even a thing.

The three-minute-and-twenty-one-second clip begins with stock footage of the Nazis invading the Netherlands during World War II, with the declaration FIRST THEY INVADED OUR COUNTRY.

Ominous music rises. War reels give way to soccer footage, and we're reminded, THEN THEY STOLE OUR WORLD CUP.

Next: home movies of vacationers at the ocean, as we're told, NOW THEY'VE TAKEN OUR BEACHES.

Finally: IT CAN'T GET ANY WORSE. OR CAN IT? leads into a decimated beach scene. Tattered tents and destroyed beach chairs sit near barbed wire and blockades in the sand. Then, as the *Worst Case Scenario* title appears, a shocking sight unfolds: scores of white-eyed, stitched-together Nazi zombies with various metal parts and appendages trudge through the surf. Gnarly, terrifying, and comical, the trailer was noticed by genre fans, who shared it all over the internet. It got coverage on major sites such as Ain't It Cool News

and Twitch (now Screen Anarchy) and in print publications, including *Hollywood Reporter*, *Fangoria*, and *Rue Morgue*.

The seed for the film was planted a year earlier, when Oosterhoorn penned an outline for something called *Woensdag Gehaktdag* (Wednesday meatloaf day—a Dutch expression). The next spring he met Raaphorst when they worked together on promotional material for the Amsterdam Fantastic Film Festival (now called Imagine), and they started to develop the idea together.

Raaphorst recalls, "I said, 'Y'know, let's make a movie'—we were very, very naive—and he said, 'Yeah, sure. How?' And I said, 'Let's collect some ideas.' We did, apart from each other, and I had zombies, and he had something to do with Germany. And suddenly he said, 'Shall we do Nazi zombies then?' and it was like, 'No, no, no, no—that's really a bad idea, it's tasteless! It's tasteless . . . so let's do it!'"

That fall, Brian Yuzna, the writer/director/producer famous for the *Re-Animator* series, *Society*, *Dagon*, and *From Beyond*, came onboard. Raaphorst, who went to art school, had been working with Yuzna, doing concept art for *Faust*, *Dagon*, and *Beyond Re-Animator*.

They didn't have a script yet, but Raaphorst was impatient and decided they should shoot a teaser trailer anyhow. Oosterhoorn agreed and used his background in graphic design to set up a slick-looking website (GorehoundInc.com), create poster art, and even make T-shirts. They used the site to announce that they were making a feature ("Absolutely not true," says Raaphorst, laughing) under the banner of Gorehound Canned Film and put out a call for volunteers. The response was huge.

"I'm still amazed by the way all the elements of that production fell into place," says Oosterhoorn. "Without exception everybody was sympathetic to the idea and acted on it. I remember asking Kodak for thirty-five-millimeter stock and getting it for free, then running out of it and asking for more *and* getting it, no questions asked. The night before the shoot of the original trailer, German kite surfers were camping out in the dunes, threatening to be in the frame the next day. A call to the location manager led to a police raid. Problem solved. And when—during the shoot, in very foul weather—one of our hero extras was showing serious signs of hypothermia, the local lifeguards charged in."

"I'm still amazed by the way all the elements of that production fell into place."

—Worst Case Scenario cocreator Bart Oosterhoorn, on shooting the trailer

Despite shooting on what Oosterhoorn describes as a "spectacularly rainy day" on a beach near Rotterdam, they managed to get a cast and crew of over one hundred. A few months and €6,000 later, they had a trailer directed by Raaphorst. But when it was completed, he started having second thoughts about the project.

"We put it online and I thought, no one wants to see this shit," he admits. "I showed it to my parents and they were like, 'Is this what you really want?' So I thought I'd made something really bad."

The internet disagreed, of course. The trailer got half a million downloads, which, combined with the press, landed the filmmakers a financing contract. The widespread hype carried them through to the Cannes Film Festival the next spring, where they found representation through United Screen Artists.

It was time to nail down the story. With strong visual ideas from Raaphorst, Oosterhoorn wrote the script with Miguel Tejada-Flores. Tejada-Flores—whose diverse screenwriting career includes *Fright Night Part 2*, *Revenge of the Nerds*, *The Lion King*, and *Beyond Re-Animator*—was brought onboard to polish the script.

"The basic premise is Nazi zombies vs. soccer hooligans and the tragic and fateful story line of a father trying to find his daughter in all the mayhem," describes Oosterhoorn.

More specifically, the plot revolves around Jake, an American living in Amsterdam with his Dutch wife and their young daughter. They plan to escape the insanity of the soccer fever gripping the country by retreating to the Wadden Islands (a chain of islands in the north of the country) and accidentally end up in German territory after a run-in with a gang of Dutch soccer hooligans. Once on the island, their daughter wanders into a forgotten WWII bunker and switches on a machine in what's essentially a factory for making Nazi zombies. The machine's creator is brought back to life in the process and resumes his mission to stage an invasion with the undead. Soon, an entire army of mutated, customized, partly mechanical fascists escape onto the island and even into the sky via balloons. To make things worse, the soccer hooligans arrive looking for revenge. Jake must protect his family from two different strains of meatheads.

Shooting a trailer for Worst Case Scenario, with (clockwise from top) director Richard Raaphorst, director of photography Gabor Deak, and focus puller Pnansci Puts.
Photos by Rafaél Lachaud.

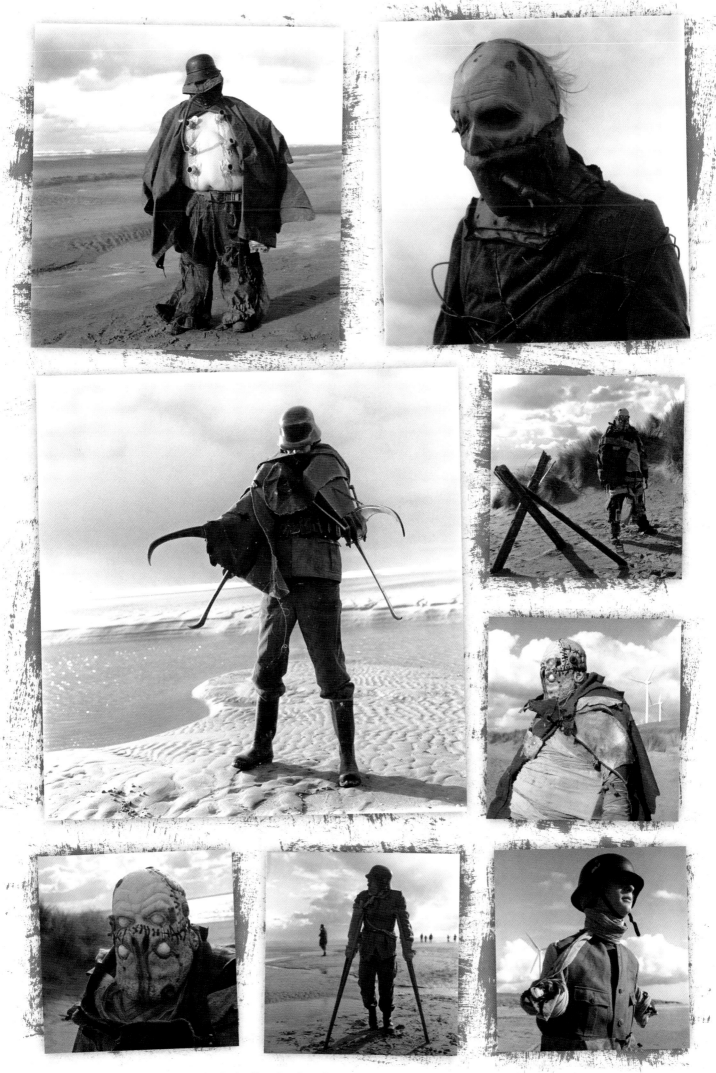

Various zombies (and a mannequin) used in the first Worst Case Scenario trailer, which was shot at the beach near Rotterdam, the Netherlands.

Raaphorst went crazy designing the world of the film, creating hundreds of pieces of concept art, paintings, maps of the island, and even a 3D model of the bunker. Some of the most arresting imagery, not surprisingly, is the buffet of Nazi zombies—creatures with their heads and limbs at odd angles and parts of their bodies replaced with machinery, blades, and other weapons.

"How I see it is this is a soldier who is created just to suffer," notes Raaphorst, adding, "One of my favorites is the balloon guy. He can swell up and he has the gas tanks with helium and he can just float around. He attacks people from above."

One of the strangest and most disgusting is undoubtedly the maggot zombie, which is also one of Raaphorst's favorites. "He's vomiting and collapsing, and his corpse is producing big maggots that eventually infect new people, so they're turning into Nazi zombies. It's a cycle. . . . I was using the phrase 'monsters creating monsters' because I thought that's what war was doing. One of the things that really traumatize me is losing limbs, chopped-off limbs—something that I find quite shocking to see that I got fascinated with. . . . These are basically victims remolded into war machines. And it's also wrong because the machine that produces the Nazi zombies is a bit wonky, it's imperfect, so that's why they are looking more like mutants than perfect fighting machines."

He adds, "I'm not sure if I could create something like this again. I was really embracing the darkness."

Raaphorst took inspiration from some additional deeply personal places while designing the world of the film. Growing up he had a "deep fascination" with robots and almost anything mechanical. Then, when he was about ten years old, he saw a lobby card for Lucio Fulci's 1979 gore classic *Zombie* that changed him forever.

"I developed a really deep fear for zombies," he admits. "I couldn't understand why people would watch this stuff, because it was about rotten walking corpses, and I really didn't see any fun, it was shocking—how can this be entertaining? I was still into sci-fi and I was really drawing robots, robots, robots, and then I just connected those two together, I found a way to merge the mechanical robotic creations with rotten flesh. From the eye of the artist, it looked very expressive, like I could put a lot of emotion in this, a lot of fear. . . . Maybe it has more to do with pop art because it's very influenced by modern culture rather than culture in a historical sense."

The Nazi angle was also a natural fit because Raaphorst's family experienced firsthand the horror of German occupation during WWII. His grandfather would tell stories about the war, one of his uncles was

Concept art for a weaponized Nazi zombie blimp creature.

shot by the Nazis in front of a bakery, and another one actually joined the Dutch SS, much to the rest of the family's disapproval. The prospect of experiencing another war terrified the filmmaker.

With Raaphorst pouring everything he had into pre-production on the project, *Worst Case Scenario* was shaping up to be not only one of the craziest zombie films ever made, but also one of the most planned out. But it didn't seem to matter . . .

The issue was that the American reps, who had essentially promised they'd get a budget of three to six million, were having difficulty pitching it to studios and investors.

"They couldn't compare it to something else," sighs Raaphorst, "and it was all situated in the Netherlands. It was just a weird film, and people were trying to make it not weird, and this was the problem. They should've tried to sell it as a strange European production rather than trying to sell it like they're selling cars. This created a lack of confidence, so pitching was really hard and messy."

Things weren't any better at home, however.

"In Holland we didn't stand a chance," laments Ooster-hoorn. "We were laughed at by the Dutch Film Fund. At film markets in Milan and Cannes, we hardly raised

eyebrows. We were convinced that we could make a unique zombie movie on a Dutch beach with unknown talent. Fat chance. . . . Eventually we received financial backing by the Dutch Film Fund, [but] that turned out to be a dead-end street and only [got us] bogged down by the process. And we were very ignorant in trusting our American 'moneymakers.' It would have been much better to just *make* the movie at whatever low budget. That way we would have proved our vision, and, who knows, we could have gone on to a bigger production."

In 2006–7, despite hitting Cannes with promo DVDs, the project had stalled. Efforts to make a spinoff called *Rotterdämmerung* didn't pan out, a legal battle over the rights erupted with American sales agents, and, after crafting a smaller-budget version of the project (€2 million to €2.5 million) to again apply for financing through the Dutch Film Fund, *WCS* got mired in the bureaucracy of the process.

It was during this period that Oosterhoorn and Raap-horst made a second trailer for the film. This one begins with two children playing in the Dutch countryside. As they dig for worms, it begins to rain maggots, and they look up to see a Nazi zombie attached to a balloon floating toward them. Then it's revealed that hundreds more dot the sky. They used the trailer to demonstrate how to incorporate digital effects into the film.

Concept sketches for various Zombots.

Multifunction Zombots (top, from left to right) designed for attacking enemies and collecting body parts for reuse (sketches by Menno Wittebrood), and Raaphorst's map of the story's fictional island, created to depict the flow of action throughout the story.

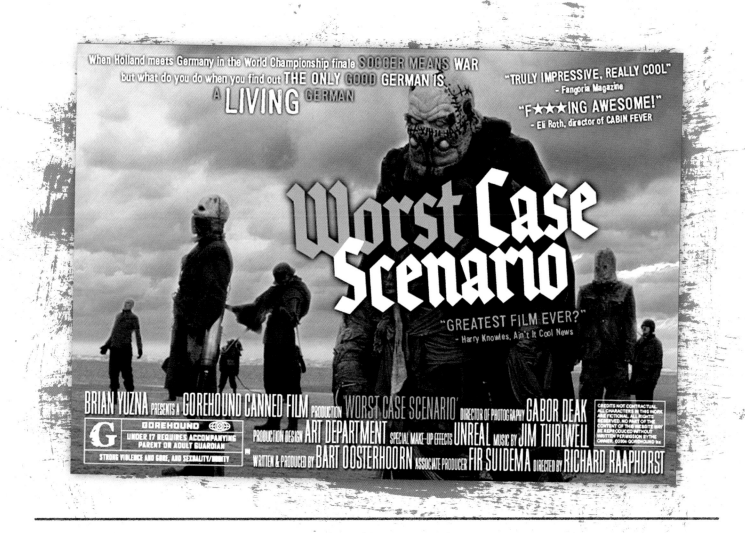

When Holland meets Germany in the World Championship finale SOCCER MEANS WAR but what do you do when you find out THE ONLY GOOD GERMAN IS A LIVING GERMAN

"TRULY IMPRESSIVE, REALLY COOL"
– Fangoria Magazine

"F★★★ING AWESOME!"
– Eli Roth, director of CABIN FEVER

Worst Case Scenario

"GREATEST FILM EVER?"
– Harry Knowles, Ain't It Cool News

BRIAN YUZNA PRESENTS A GOREHOUND CANNED FILM PRODUCTION 'WORST CASE SCENARIO' DIRECTOR OF PHOTOGRAPHY GABOR DEAK

GOREHOUND
UNDER 17 REQUIRES ACCOMPANYING PARENT OR ADULT GUARDIAN
STRONG VIOLENCE AND GORE, AND SEXUALITY/NUDITY

PRODUCTION DESIGN ART DEPARTMENT SPECIAL MAKE-UP EFFECTS UNREAL MUSIC BY JIM THIRLWELL

WRITTEN & PRODUCED BY BART OOSTERHOORN ASSOCIATE PRODUCER FIR SUIDEMA DIRECTED BY RICHARD RAAPHORST

CREDITS NOT CONTRACTUAL. ALL CHARACTERS IN THIS WORK ARE FICTIONAL. ALL RIGHTS RESERVED. NO PART OF THE CONTENT OF THIS WEBSITE MAY BE REPRODUCED WITHOUT WRITTEN PERMISSION BY THE OWNER. ©2004 GOREHOUND BV.

"It was just a weird film, and people were trying to make it not weird, and this was the problem. They should've tried to sell it as a strange European production rather than trying to sell it like they're selling cars."

—*Worst Case Scenario* cocreator Richard Raaphorst

By this point, however, Raaphorst was looking for closure. "I was highly frustrated because I put so much in it and all those designs, I literally created every creature which appears in the story, and I tried to say goodbye to it, and what I did was make a second trailer. I financed it myself, and this was my goodbye trailer. . . . I just wanted to get rid of it."

Not surprisingly, the trailer helped keep interest in the project going. But it was fleeting. Before long, Raaphorst took a job in South Africa shooting second unit for the 2008 Jean van de Velde film *The Silent Army*, while Oosterhoorn kept trying different tactics to revive *WCS*. Another American producer came onboard and approached Rutger Hauer to

star in the film, but according to Oosterhoorn the actor felt it was beneath him (of course, not long after, Hauer took on the title role in *Hobo with a Shotgun*). He also unsuccessfully pitched a spinoff called *Woeste Hoeve* (Bleak manor) and later an ultra-low-budget version of *WCS* titled *Wolfram*. But none of it was working.

By 2009, *Worst Case Scenario* was dead.

Oosterhoorn, disillusioned with his misadventures, had had enough of filmmaking and turned back to his career as a graphic designer. He's currently the art director of the popular Dutch movie publication *De Filmkrant* (The movie paper).

A promotional card created by producer Bart Oosterhoorn for the Cannes film market.

"Do everything opposite, do everything full force, don't look back, just do what you have to do and try to find the opposite—so the negative footprint."

—Richard Raaphorst, on how *Frankenstein's Army* rose from the ashes of *Worst Case Scenario*

Raaphorst, though tired of the film, was not done with filmmaking. He came back from South Africa "a different person," and—inspired by the multimedia agency named 180 that he was working for—turned the *Worst Case Scenario* concept completely on its head.

"Do everything opposite, do everything full force, don't look back, just do what you have to do and try to find the opposite—so the negative footprint," he explains of the concept. "And I thought, what if I do it with *Worst Case Scenario*? What would happen? So the Americans would become Russians, the present will become the past, and heroes will become antiheroes, so everyone has to become a villain, except the villain has to become some kind of good. The one thing I wanted to keep were the designs, because this is the one element that was still my property. But even the title: I thought, *Worst Case Scenario* is a very suggestive title, so I should have a title that really says what it is. It's about an army of Frankensteins, so *Frankenstein's Army*. And the slick camera movements became handheld. Everything is the opposite. Creativity has no borders."

Raaphorst created some key art, a logo, and a poster and put it up online. The next day his inbox was filled with inquiries about the project. He quickly realized he needed a script immediately, so he reached out to Tejada-Flores to write one. Within a couple of weeks, XYZ Films approached Raaphorst with an offer to try to finance the film. But after everything that had happened with *Worst Case Scenario*, he didn't believe it would go anywhere. Nevertheless, he gave them a shot while he continued to develop the script. Unexpectedly, they came back to him with the distributor MPI, who informed him that the only missing piece of the puzzle was a Dutch producer. So Raaphorst started knocking on doors again.

"I went to these producers and they all said, 'Well, you again with your Nazi zombies, who wants to see this shit?' There was only one guy who, after a long stretch, said, 'You know, I can try, I have nothing to lose,' and so he spoke with the Americans, with MPI, and then he realized they were serious, and the rest is history! One year later I was standing on the set and I did *Frankenstein's Army*, and after the Q&A the first question out of the audience is 'Are you still going to make *Worst Case Scenario*?' Ah! It's a curse!"

Richard Raaphorst's art for his 2013 feature Frankenstein's Army, *the "negative footprint" of* Worst Case Scenario.

Frankenstein's Army may be the "negative footprint" of *Worst Case Scenario*, but the creature craft immediately recalls the unmade movie. Bizarre, gruesome, sometimes absurdly hilarious monstrosities with giant metal claws for hands, blades for arms, various metallic body parts—one even has a propeller for a head—have helped give the film a cult audience appreciative of its ample gore and surreal creations.

Since the movie was released in 2013, Raaphorst has been pushing ahead with several projects, all while working as a storyboard artist for film and advertising. Among them are *Children of the Moor*, *Fungus*, *Higgs*, and *The Profundis*, about a terrorist cell using a U-boat to smuggle a biological weapon, which leaks and causes the crew to mutate. As he told *Rue Morgue* in a 2016 interview, "This story continues my fascination with military horror, but also my fascination with creatures, and trying to come up with something I've never seen before."

Horrific mutation runs through all of the aforementioned projects. A teaser for *Children of the Moor* (available on YouTube, as of this writing, though Raaphorst is no longer involved) strongly channels the setting and atmosphere of *Worst Case Scenario*. Clearly it's fed Raaphorst's other work in the past two decades, and even continues to show signs of life on its own. A friend of his created a demo video game based on the film, and more recently, Raaphorst worked on pages for a *Worst Case Scenario* graphic novel.

Fans haven't forgotten about it either. "When I would do Q&As for *Frankenstein's Army* always someone asks about *Worst Case Scenario*," says Raaphorst. "It's stronger than *Frankenstein's Army* and more famous."

Of course, with the passage of nearly twenty years since its inception and the corresponding radical changes to the entire film industry, the question is, how should the movie exist now?

Concept art for Richard Raaphorst's unmade film The Profundis, which also showcases his interest in hybrid monsters and military technology.

"It would be a challenge to make *Worst Case Scenario* now that the zombie movie seems to be exhausted," acknowledges Oosterhoorn. "Besides that, audiences now expect much more action and optical fireworks than we had in mind. I can only envision an updated *WCS* in the vein of, for instance, Issa López's *Tigers Are Not Afraid*: grounded in reality but spiced up with just a hint of fantasy and CGI. I see a man on a personal quest slowly turning into a zombie. I see an unspeakable terror threatening a world that's forgotten the real horrors from wars past. A world that may contain sharks in the mist, immortal jellyfish, and other stuff."

Whatever form it takes, *Worst Case Scenario* has attached itself permanently to its creators. So much so that on May 20, 2020, Raaphorst launched a Kickstarter campaign to make a graphic novel version of the movie. He explained that since his regular film work was on hold due to the pandemic, he wanted to "take that opportunity to show the story how I always imagined it in the form of a graphic novel." He enlisted writer-director Eron Sheean (writer of horror films *The Divide* and *Cold Skin*) to help adapt it and comic book artist Romano Molenaar (*Batman Detective Comics*, *X-Men*) to create the cover.

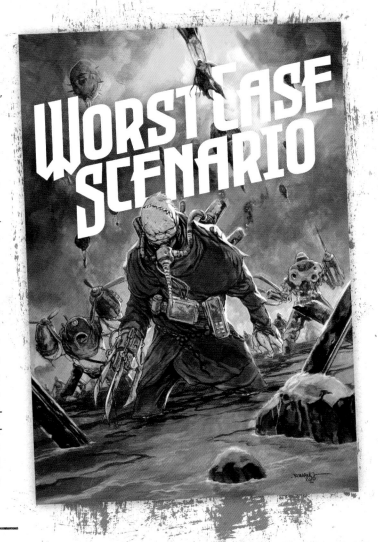

"I love it, it's part of me. It's a very personal project, which is why I can't let it go so easily."

—Richard Raaphorst

The campaign was a huge success, raising about $19,000, allowing Raaphorst to offer extended editions of the graphic novel, planned for a 2021 release. Raaphorst created a bunch of new *Worst Case Scenario* art to showcase his vision, as well as a variety of perks for backers, including art prints, T-shirts, action figures, and even a bust of the four-eyed zombie mutant. The renewed support for the story has reinvigorated him, and is hopefully a step closer to realizing the film. If not, at least the story is finally told, lifting a giant weight off the filmmaker.

"I love it, it's part of me," enthuses Raaphorst. "It's a very personal project, which is why I can't let it go so easily. It's more related to art than film. . . . It's really coming out of your gut, like 'bleeeeeeeegh' and there's this ugly thing, and that's what you wanna have. . . . *Worst Case Scenario* is a dream."

Cover art for the Worst Case Scenario graphic novel, and a Zombot bust made for the graphic novel Kickstarter campaign. Both created by Richard Raaphorst.

Clockwise from top: watercolor paintings for the Worst Case Scenario graphic novel, and Raaphorst's Eva bust and Dr. Stam action figure, both created for the Kickstarter campaign.

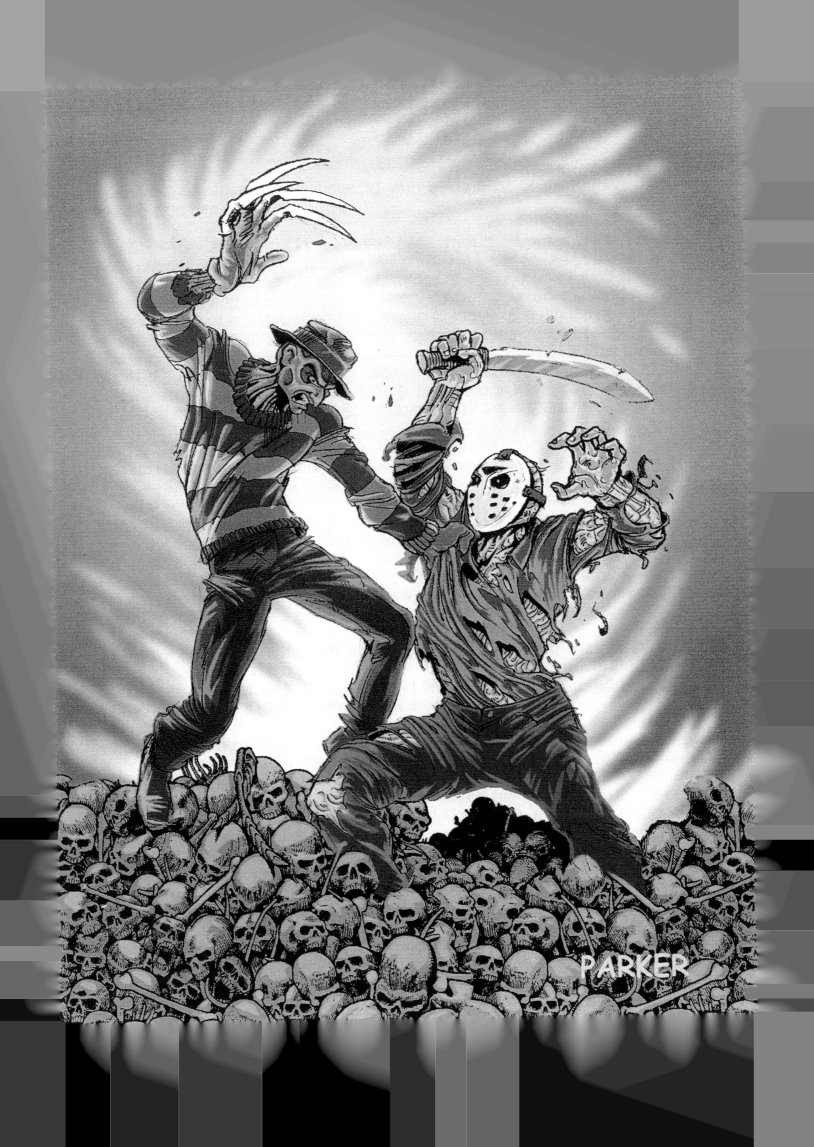

TIM SULLIVAN'S
BROTHERS OF THE BLOOD
AND FREDDY VS. JASON

The vampire movie that's tried to come out of the coffin for decades and how it led to a stab at some horror icons along the way

INTERVIEW WITH TIM SULLIVAN

Tim Sullivan's personality is all over his filmography. There's an appreciation of campy gore in *2001 Maniacs*, his remake of H. G. Lewis's *Two Thousand Maniacs!*; the homoerotic undertones in the coming-of-age terror tale *Driftwood*; and the unabashed queer-fear creature comedy of his "I Was a Teenage Werebear" segment of the *Chillerama* anthology. They showcase a filmmaker comfortable to be himself in the horror genre.

But it wasn't always that way . . .

Growing up in working-class New Jersey in the 1970s and '80s, Sullivan fell in love with monster movies, rock 'n' roll, and . . . guys. But it wasn't a place or time conducive to gay culture, so like many young people who realize they aren't straight, he stayed firmly in the closet. As Sullivan recalls, that door started to open when he decided to study film in New York.

"I was not 'out' when I had grown up in New Jersey, I was pretty sheltered. So suddenly I'm taking the train every day to NYU to film school, and it was like in *Wizard of Oz* when Dorothy goes from black-and-white Kansas to Technicolor Oz, because this was the

beginning of MTV, the beginning of the New Romantic music, and Billy Idol and Duran Duran. I was wearing flannels and corduroy in New Jersey, and I'm taking the train and suddenly I get off and it was, like, MTV, so I literally transformed myself. Got a Macy's credit card and went and got a whole new wardrobe that kind of looked like Simon Le Bon and Flock of Seagulls."

During this period Sullivan saw Francis Ford Coppola's 1983 teen rebellion movie *The Outsiders* and Tony Scott's 1983 arty, androgynous vampire film *The Hunger*, featuring David Bowie, both of which made a huge impression in his rapidly changing world.

"Suddenly I found myself as a young man of interest to some of my older, male, gay professors," explains Sullivan. "It was a new experience for me, being invited to get-togethers and screenings, and I remember at one point we all went to see *The Outsiders*—how much more homoerotic than that can you get—and on the one hand I thought it was cool, being thought of as attractive by other guys, and on the other hand, I was like, hmmm, I don't know if I like this, because I wasn't sure who I was."

Like any good filmmaker, he channeled these experiences into an idea for a movie. During his commute back and forth from the city, he made extensive notes, and then started to shape it into a treatment. The result was *Brothers of the Blood*.

Originally set in New York, and then later in Dublin, it features a vampire named Luke, who's been a "teenager" for decades after meeting Sebastian, an older vampire artist who looks to be about forty. Flashing back to the 1950s, when Luke is a tortured mortal rejected by his parents for his sexuality, they fall in love. After Sebastian turns him into a vampire to prevent his suicide, they travel the world together, feeding on the locals. Now in Ireland's capital, Sebastian strikes a deal with a priest to prey on some of the street kids that stay at his shelter in exchange for covering the expenses needed to run the place.

But Luke tires of their nomadic, predatory existence and feels renewed when he meets a social worker named Charlotte, who's also in an unhappy relationship. The two of them feel an immediate connection and decide to run off together, even though it means Luke will cease to be immortal once untethered from Sebastian. Meanwhile, her boyfriend, a detective named O'Donovan, has been investigating the deaths of local street kids whose bodies have been found drained of blood, and the trail leads right to Sebastian and Luke.

> ## "I knew that I preferred the boy next door to the girl next door, but I was not in a place at the time where you were able to express that openly."
>
> —Tim Sullivan

Sebastian, enraged that his longtime companion has found someone else, decides to punish Luke, which leads to a bloody climax between the lovers, O'Donovan, and some recently turned teen bloodsuckers on a killing spree.

"The underlying theme of it is that if you try to chain or possess the one you love, it will go bad and will probably result in somebody becoming a monster and somebody becoming a victim," says Sullivan. "I knew that I preferred the boy next door to the girl next door but I was not in a place at the time where you were able to express that openly, so when I was in film school, after I had seen *The Hunger*, I got the idea that this would be an interesting way to express myself. But by having it be vampires, it wasn't gay or straight, it was *hey, they're vampires!* So I originally wrote this kind of from the viewpoint of the younger vampire."

Sullivan submitted the treatment for one of his screenwriting courses and was shocked by the reaction. In front of the entire class, his teacher handed back the assignment and told him he should just come out of the closet already. Sullivan was mortified.

"All that handwriting I had done, that original treatment, the original notes, I practically threw it away," he recalls. "I was ashamed; I wasn't ready to come out. I was embarrassed, and I just felt that pursuing that project was outing myself, and I wasn't ready to do that. In fact I never officially came out until I was twenty-seven, when I moved to California in 1991. It wasn't an identity issue, it was a truth issue. I realized I probably could have come out but I had lied to my family for so long that it was just very tough for me."

So instead of pursuing *Brothers of the Blood* as his first script, he wrote a creature feature (essentially "*Stand by Me* with monsters") about the Jersey Devil, yet to be produced.

Tim Sullivan in 1982, for the cover of Cinemagic. Photo by John Dods. Copyright John Dods. Used by permission.

"It took place in 1969 and involved his character, Nancy's father, as a young detective investigating a [Charles] Manson-like cult where a teenage Freddy Krueger was a cult member," says Sullivan. "It was really, really good but completely different in tone and vibe and topography from the series, so it never went further than John's hand-typed pages (which I still have)."

But it did spark an idea for a "Cult of Freddy" concept. Sullivan made a connection between the cult-like devotion to Manson as an antihero and Krueger, both of whom emerged as pop culture icons in the '90s, appearing on T-shirts, posters, and lunchboxes (!) and becoming the topic of songs.

"What if there really was a devoted group of followers, almost like followers of Aleister Crowley and Anton LaVey?" posits Sullivan. "Every religion has an icon associated with it. Christianity has the cross. Judaism, the Star of David. So of course a 'religion' that worshiped Freddy Krueger would have . . . his glove!"

Sullivan wanted Freddy actor Robert Englund to play the Manson-like leader of a Krueger-worshiping cult who dons the glove and morphs into the burned monster, in the style of Jekyll and Hyde.

"The idea of seeing Robert Englund physically transform into Freddy excited the hell out of me; I had a feeling it would excite fans as well," emphasizes Sullivan.

Things really started to change when Sullivan made his way to Hollywood. By 1992 he was working at New Line Cinema, thanks to Mike De Luca, who was running the studio—the two of them had gone to film school together. The company is now best known for the *Lord of the Rings* films, *The Conjuring*, and *It*, but at the time was often referred to as "the house that Freddy built" because of its emergence on the strength of the *Nightmare on Elm Street* movies. The studio also had acquired the rights to fellow slasher icon Jason Voorhees and was looking for the right script to team up the merry murderers for an epic kill fest. Sullivan's love of monster movies found him assigned to the project's development team.

"It seemed like everybody and their mother had come up with a concept," he recalls. "Some were quite good. Most sucked. . . . Many of the concepts being considered were basically *King Kong vs. Godzilla*—just a series of wrestling matches between Freddy and Jason with a bunch of naked kids having sex and being slaughtered in between. Both series were so tired and redundant at this point, literally parodies of themselves."

Unexpectedly, one of the better ideas came from the legendary genre actor John Saxon, who appeared in the first and third *Elm Street* movies, as well as the 1994 metasequel *Wes Craven's New Nightmare*.

Father Saxon douses Jason's grave with holy water (top), and Freddy actor Robert Englund was envisioned as the leader of a Freddy-worshiping cult (bottom).

PARKER

With classic monster movies in mind, Sullivan saw Jason as a Frankenstein's monster or golem-type creature—a hulking, sympathetic brute initially being controlled by someone else. His March 1999 treatment for the film lays it out: "At this point, Freddy Krueger and Jason Voorhees exist in the same pantheon of classic monsters as Dracula and Frankenstein. . . . In order for Freddy Vs. Jason to work, the film should evoke themes and ideas exhibited in classic horror films, the gothic and the mythic. We can and should rewrite the Freddy/Jason mythology, relying heavily on Craven's original interpretation, thus lending a backbone to both series that was only heretofore hinted at."

Sullivan's story begins with Freddy slicing and dicing his way through a teen slumber party when he hears whimpering coming from a closet. He flings open the door to find a young Jason. As he brings his bladed glove down on the child, we cut to an adult Voorhees waking up in an abandoned cabin, tormented by the nightmare. He hears Freddy laughing in his head and follows the sound outside to a car parked at the edge of the woods. Trying to purge Freddy from his mind, he brings his machete down on the roof of the vehicle, in the process splitting the head of one of the teenagers sitting inside of it.

In homage to Saxon, Sullivan then introduces a priest named Father Saxon, who, going forward in time, watches over Jason's maggot-ridden corpse, which is harmless as long as the heart is removed. (According to the treatment, "The scene should play like the opening of Frankenstein where Colin Clive and Dwight Frye steal the corpse from the graveyard.") Here, Jason is under the control of the church.

"The concept was that sometimes you need a greater evil to defeat a lesser evil," says Sullivan. "That's where the concept of Jason being 'used' to defeat Freddy came in. But how does one harness Jason? Those old monster flicks came into play once again: The Golem, the Jewish horror legend and silent film in which the golem is conjured and used to defeat foreign invaders—turned on and turned off, if you will, by putting in and taking out his heart, like a supernatural battery. So what if some secret 'monster fighters' somehow got hold of Jason's corpse and had it under their control the way Dracula has Frankenstein under his control in Abbott and Costello Meet Frankenstein, holding him in an arsenal in wait of an evil to be conquered?"

The evil, of course, is the Krueger cult, a "Scientology-based" group operating out of Hollywood that lures in

Concept art illustrating how anyone who dons the glove is transformed into Freddy.

lost souls and uses the famous glove to slash them in an initiation ceremony. After their latest victim—a young woman named Melanie—is rescued by the friends who grew up with her on Elm Street, she's brought to Father Saxon, who understands the horror that lies ahead if the cult brings Freddy back into the world. Their worst fear comes true when the cult leader puts on the glove and transforms into Freddy, in order to go after Melanie.

As Sullivan's treatment states, "Nothing can stop an evil of Freddy's magnitude . . . except another evil of Freddy's magnitude." Father Saxon realizes he must revive Jason (which he does by giving Jason the heart of a mortally wounded younger priest), setting the stage for the monsters to fight each other, which of course they do. But, as the opening of the film suggests, it isn't the first time they've met. (Sullivan admits that subconsciously there was a mentor-student dynamic at play influenced by Brothers of the Blood, not to mention the theme of things going bad when you try to control someone.)

"I had one of those amazing 'eureka' moments every writer prays for," recalls Sullivan. "What if an acne-scarred teenage Freddy Krueger had been a counselor at Crystal Lake? What if his predilection for pedophilia

began then? What if an eight-year-old, deformed Jason Voorhees—so ashamed of his face that he always wore a hockey mask to hide it—was actually an early victim of Freddy's depravity? And what if it was teen Freddy who purposely let Jason drown in the lake to escape being caught? So now, when Jason confronts Freddy, all those memories come flooding back in Jason's own nightmares, which Freddy invades?"

As the titans duke it out, the backstory unfolds, showing how Freddy actually created Jason all those years back. In the treatment, Sullivan continued the comparisons to classic monster movies: "FLASHBACK to summer, 1960. Little Jason and Freddy sitting by the lake, staring at their ugly reflections, much like the scene in Frankenstein with Karloff and the little girl, except with none of the beauty . . . and only half the innocence."

The finale of the film would have involved Freddy inhabiting Jason's body and creating a Freddy-Jason hybrid, an exorcism performed by Father Saxon, and Jason's body being entombed once again, with Freddy's soul trapped inside of it. Two genies were to be put back in one bottle.

But that wasn't all . . .

Father Saxon presides over Jason's body (left), and a Freddy/Jason hybrid (right).

A teenage Freddy Krueger corrupts a young Jason while at summer camp.

Sullivan had a final twist in mind.

"I still wanted to have that 'button' at the end, that equivalent of the end of *Jason Goes to Hell*, where we see Freddy grab hold of Jason's mask. New Line had acquired the rights to *The Texas Chainsaw Massacre*, and now owned Leatherface. Going back once again to *Abbott and Costello Meet Frankenstein*—in which, after surviving Dracula, the Wolfman, and Frankenstein, Bud and Lou end up encountering the Invisible Man—I thought, how cool if at the very end, our battle-fatigued protagonists stop for well-deserved snacks and beverages at a roadside gas station, where they encounter—you guessed it—Leatherface, the final shot being Leatherface in the doorway powering up his chainsaw!"

older relationships with a mentor and the mentored. . . . I would say that among my generation, and I'm fifty-six, that there are a whole lot of gay men who never got to be gay teenagers, gay kids. They never got to go to a prom; they never got to have a boyfriend or a soulmate in college—it had to be hidden. And things that are hidden become dark and mysterious. You kind of have to hide who you are and you have to live in the shadows."

So while *Detroit Rock City* was moving ahead, Sullivan approached Simmons to work with him as a producer on another project, called *Night Songs*, about "rock 'n' roll vampires and paranormal romance." It was envisioned as a teen-targeted musical drama series centered around an undead rock star. Though strongly

> # "I had one of those amazing 'eureka' moments every writer prays for. What if an acne-scarred teenage Freddy Krueger had been a counselor at Crystal Lake?"
>
> —Tim Sullivan, on *Freddy vs. Jason*

To flesh out his ambitious pitch for the studio, Sullivan enlisted artist Brad Parker, who had worked with Sullivan on art for a KISS-themed project for *Famous Monsters of Filmland* magazine and did storyboard art for *Jeepers Creepers*. Parker created seven pieces of *Freddy vs. Jason* concept art depicting scenes such as Father Saxon presiding over Jason's body, the cult leader morphing into Freddy, the Freddy-Jason hybrid, and Freddy corrupting a young Jason at Crystal Lake.

While this was going on, Sullivan had used his long-time friendship with Gene Simmons to set up the KISS-themed feature *Detroit Rock City* at New Line and was working on that with Adam Rifkin (*The Chase*) as director. With newfound confidence and success in the industry, and being exposed to a thriving gay culture on the West Coast, Sullivan found vampires creeping back into his brain.

"As I got older, it got very interesting to me because I saw how very much the gay culture really is very vampiric. There are so many parallels—good and bad," he muses. "There's an obsession about youth and staying young, and this goes all the way back to Oscar Wilde's *Picture of Dorian Gray*—that aspect of it really lends itself to storytelling in the milieu of vampires. There's also a very strong case of younger and

homoerotic, it wasn't as overtly gay as *Brothers of the Blood*, but it did make Sullivan resurrect *Brothers* and start pitching it again as well. With the success of the 1994 adaptation of Anne Rice's *Interview with the Vampire*, the time seemed right for him to put his own spotlight on the classic creatures of the night as iconic figures in gay culture.

Meanwhile, *Detroit Rock City* had scored very well with test audiences, and Sullivan hoped to use the film as a springboard to get his other projects in production. He figured reteaming with Rifkin as director on the proposed *Freddy vs. Jason* was the right move, so he prepared to formally pitch New Line on the idea with the director attached.

"This excited me," remembers Sullivan. "This was something that had never been in any pitch. . . . Our feeling was *just wait till they get a look at the treatment*. Wanting to truly be special and stand out, I printed out two treatments and put each one in a box wrapped in black paper. On one, I glued a Jason mask. On the other, a plastic Freddy glove. To top it off, I dripped red candle wax on each. I decided I would place them on Mike [De Luca]'s desk the day *Detroit Rock City* was released, which ironically was Friday the thirteenth of August, 1998."

Issue 2211 >> January, 2019

Rolling Stone

XANDER LUST

THE BRANDED
FRANCHISE UNLEASHED!
PAGE 10

PARANORMAL
ROMANCE

DEBUT SINGLE GOES
RED & PLATINUM
PAGE 8

THE
ROCK PRINCE
OF DARKNESS

PILOT EPISODE &
SERIES OVERVIEW
PAGE 32

NEW REBELLION
ENTERTAINMENT

THE TEAM BEHIND
THE SHADOWS
PAGE 18

He's Hot. He's Sexy. He's Undead.

Night Songs

If everything went according to plan, the success of *Detroit Rock City* would result in a green light for a Sullivan/Rifkin *Freddy vs. Jason*, which would then give Sullivan the clout to get *Night Songs* and, finally, *Brothers of the Blood* made.

But it didn't . . .

"*Detroit Rock City* came out, up against *The Sixth Sense*, *The Blair Witch Project*, and *American Pie*," groans Sullivan. "It bombed. Yeah, it's become a beloved cult classic of which I am proud and grateful. But, let me say this one again, it *bombed*. Rifkin and I were politely—and pretty much immediately—told that a 'pin' was being put in our follow-up project. Everyone in Hollywood knows that when you are told by a studio that they are putting a 'pin' in your project, it's the equivalent of a stake through the heart: 'Don't call us, we'll call you.' I never placed those packages on anyone's desk at New Line, and Rifkin and I have never worked with them since. But hey, that's Hollywood. My story is far from unique. And I honestly and sincerely remain truly indebted and thankful to all the opportunities Mike and New Line provided me."

That said, Sullivan's time at New Line did build a relationship between him and Englund that led to a collaboration. And when *Freddy vs. Jason* finally was shot in 2003—with Ronny Yu (*Bride of Chucky*) directing a script by Damian Shannon and Mark Swift (both of whom would go on to write the much maligned *Friday the 13th* remake)—he got an invitation to visit the set.

Sullivan's studio experience is far from unique; in fact, it's a classic tale of how the Hollywood Machine kills more projects than it creates. Overall, Sullivan says he was more bothered that his vampire projects couldn't get any traction with any studio.

"Simultaneously I was trying to get *Night Songs* done and *Brothers of the Blood* done, and even with Gene Simmons attached to *Night Songs*—pardon the pun—we didn't get a bite," says Sullivan. "Everyone was afraid of the material; it was OK to have veiled references—going all the way back to *Dracula's Daughter* or *The Lost Boys*. . . . People were more than happy to let me have fake heads flying around and all this, when it was done as sort of wink-wink black humor, that was OK, but when it was going to be more dramatic and real, and operatic, no one was interested."

So once again, *Brothers of the Blood* crept back into the shadows. Sullivan turned instead to directing his first feature, which couldn't be further from gay vampires in Dublin. His writing partner, Chris Kobin, acquired the rights to remake any H. G. Lewis film, so the two of them tackled *Two Thousand Maniacs!*, about a town of cannibalistic redneck sadists who torture and murder anyone who crosses their southern-fried path. With the title tweaked to *2001 Maniacs*, and starring Robert Englund, the film was released in 2005 and did well, which led to the sequel, *2001 Maniacs: Field of Screams*, in 2010.

As his career as a horror filmmaker was taking off, and queer culture becoming more mainstream, Sullivan created a fresh pitch package for *Brothers* and started shopping it around to see if there was renewed interest.

"Every time I did a film, and it did well, and I was asked to do the next one, I would bring out *Brothers of the Blood*—every time," he says. "I had no problem being accepted, except when it came to the stories I wanted to tell. I had so many people I worked with, actors, crew members, friends, always saying, 'Wow, this is the best thing you ever wrote, you gotta get this made.' So it always frustrated me. . . . Nobody ever actually said, 'This sucks.' They said, 'This is great, but we can't sell this, we can't buy this. We don't think you should promote yourself this way.'"

Sullivan realized that while companies were willing to talk the talk, they weren't ready to walk that walk. The resistance he met when trying to make his passion project confirmed something important for him: he'd grown far beyond the anguished, closeted youth who first conceived *Brothers of the Blood*.

"I spent so much time with this in the filing cabinet that every time I tried to tell the story, I was told, 'Oh no, you don't want to do that' and 'Nobody wants

Rolling Stone–inspired Night Songs *pitch book art featuring August Etienne.*
Image provided by Tim Sullivan. Used by permission.

to see that,' 'You don't want to make a fool of yourself and pigeonhole yourself as a gay filmmaker,'" scoffs Sullivan. "Well, I'd rather be hated for who I am than loved for someone I'm pretending to be for your comfort."

Brothers of the Blood had evolved in tandem with Sullivan throughout his entire life as a filmmaker, and he wasn't going to let it go now. Or rather, as the cliché goes, it wasn't going to let him go.

"I still have my handwritten notes, and ideas and dialogue and sketches that I came up with when I was in my late teens, early twenties, taking the train back and forth to NYU. From 1985 up until 2000 it changed a lot, and I think that one of the ways it changed is having more empathy, and layers and textures to the characters. . . . I really related to that idea of Sebastian, the older vampire, really caring for Luke, but then somebody else comes along and you suddenly don't exist anymore. But I also understand from Luke's point of view, it's like, 'Hey man, I can't help it; I care for this person.' And I think that has changed, it's become more of a drama. It has a lot of horror in it, and it has a lot of blood and sexuality but it is more of a character-driven story than it is a blood-and-guts horror film, which it started out as."

The horror genre is cyclical and trends come and go, but it certainly doesn't exist in a vacuum. It's true what they say: horror is a funhouse mirror reflecting the world back at us. So as the world changes, the genre is ready for us. Sometimes it waits years, or, in Sullivan's case, three and a half decades.

Over the past few years the film industry has done more than talk about diversity; it's actively sought out projects and creators to embody those ideals. And that's spurred the filmmaker on to push harder than ever to get *Brothers of the Blood* made. Sullivan says he sees a place for the movie in the worlds of arthouse and elevated genre.

"In the wake of films like *Hereditary* and *Midsommar*, and having Jordan Peele make horror films that win Oscars, and then having someone like Luca Guadagnino coming from [the gay-relationship-themed] *Call Me by Your Name* to *Suspiria*, there is what's considered 'arthouse horror.' It's actually a thing where these horror movies are considered artisan films, and they're made to tell social stories and relationship stories in a horror medium. It goes back to *Frankenstein* and having a gay man like James Whale tell the story of *Frankenstein* but having the pretty obvious element of God, your creator, rejecting you just as so many parents have rejected their queer children. So I think right now the climate's right."

In fact, Sullivan has had talks with the Irish Film Board, which is interested in helping make his movie. With that support he's in a position to finally have his untold horror project told—the way he wants it to be told.

There's just one thing . . . While he's penned a very detailed "novel-sized" treatment for the movie, he's never actually completed a proper script for it. Now he's finally confronted those things that held him back.

"This has been with me for so long, and quite honestly I don't know why I took so long at a certain point," he says. "I think I needed to tell other stories and stake my claim as a filmmaker. I always felt this was gonna be the one that showed another side of me that was not splatstick, and not tongue in cheek, and not wink-wink, and I have just never been ready to do this. And now I am."

For better or worse, Sullivan's got something else on his side as of this writing: time. Thanks to a global pandemic, he's finishing the *Brothers of the Blood* script, which has been thirty-five years in the making. Hell, it may even appear onscreen before Freddy or Jason do again . . .

"I'm encouraged by the marketplace and having a lot of free time right now, thanks to the apocalypse," jokes Sullivan. "I'm writing it now, but writing it with an endgame."

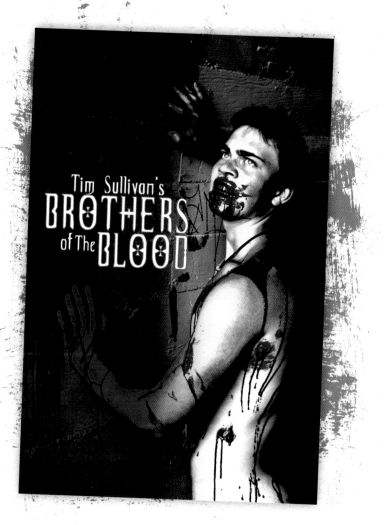

Brothers of the Blood pitch book art featuring Victor Frolov. Copyright Tim Sullivan. Used by permission.